Bridge to Understanding

Bridge to

Understanding

The Art and Architecture

of San Francisco's

Asian Art Museum–

Chong-Moon Lee Center for

Asian Art and Culture

The Asian Art Museum of San Francisco–Chong-Moon Lee Center for Asian Art and Culture is a nonprofit public institution whose mission is to lead a diverse global audience in discovering the unique material, aesthetic, and intellectual achievements of Asian art and culture.

Published in conjunction with the opening of the new Asian Art Museum, spring, 2003.

Main text, editing, and production supervision: Thomas Christensen
Design and typesetting: Dana Levy, Perpetua Press, Santa Barbara
Asian Art Museum photographer: Kaz Tsuruta
Printing and binding: Toppan, Japan

Grateful acknowledgment is also made to the many people and organizations that have helped in the production of this book. Credits are listed on p. 223, which constitutes an extension of this copyright page. Every effort has been made to locate copyright holders of images in this book; if any oversight has been committed, it will be corrected upon notification in writing in subsequent editions.

ISBN: 0-939117-19-3

9 8 7 6 5 4 3 2 1
First Edition

Contents

The principal reason my collection was given to the City of San Francisco was that San Francisco seems to be the gateway [to Asia].... Perhaps here San Francisco can play a leading role. No one can study the magnificent works of art displayed in this museum without gaining new respect for the people who conceived and produced them.... This project, therefore, presents a wonderful opportunity for San Francisco and its people to become leaders in a search for the new understanding, so desperately needed, for a bridge of international knowledge and respect. Such a bridge ... can be as important as those over the Bay and the Golden Gate, and even more significant internationally. This will be San Francisco's contribution to a happier and more peaceful world.

— Avery Brundage, June 10, 1966

Chair's Preface

THE OCCASION THIS BOOK COMMEMORATES—the opening of the new Asian Art Museum–Chong-Moon Lee Center for Asian Art and Culture—was the product of years of work by many people sharing a common goal: to realize Avery Brundage's vision of a "bridge to understanding" between East and West. Though more work remains to be done, that vision, with the completion of architect Gae Aulenti's reworking of the former main library building, is now fulfilled.

The reworking of the historic beaux arts library building is an architectural triumph. The museum's new home in Civic Center makes it possible to display more of its collection than was possible at Golden Gate Park, to present more special exhibitions, and to offer a wider range of educational programming.

Citizens joined civic and government leaders in supporting the new museum. Bond measures in 1989 and 1994 provided $52 million toward seismic retrofitting of the old library building. And with Chong-Moon Lee's donation of $15 million leading the way, thousands of individuals contributed to the Campaign for the New Asian. Thirty-two donors contributed $1 million or more; the Campaign has now reached a total of more than $157 million. Donors to the new museum are listed at the back of this book, and we offer our thanks to each and every one of them.

Some supporters have chosen to participate in such auxiliary groups as the Jade Circle, the Connoisseurs' Council, and Monsoon. The Society for Asian Art also deserves mention for its longstanding support of the museum. These groups bring together like-minded people for a variety of activities; more importantly, they help to coordinate and stimulate community support. Many individuals have volunteered their time and expertise to the museum, and to them we also extend profound thanks.

Thanks to this support, the museum is now better able to fulfill its mission as a public institution leading a diverse global audience in discovering the unique material, aesthetic, and intellectual achievements of Asian art and culture.

JOHNSON S. BOGART

Director's Preface

THE OPENING OF THE NEW ASIAN ART MUSEUM at Civic Center is the realization of a dream of some twenty-five years on the part of commissioners, trustees, and staff of this institution. During that quarter century, there were those who doubted a move could ever be made; those who hesitantly recognized the need to grow and move out of the park; and those who fully committed their energy, faith, and money to ensure the completion of this monumental undertaking.

This commemorative publication contains a history of the Civic Center site, as well as an account of the museum in Golden Gate Park, the transformation of the former Main Library into the new museum, and a survey of the collections. The City and County of San Francisco—its citizens and its mayors, from George Christopher (1956–1964) through Willie L. Brown, Jr. (1997–present)—have been steadfast in their support of the museum. Dianne Feinstein (mayor from 1976 to 1988) together with her deputy mayor, the late Peter Henschel, initiated a plan for the revitalization of the Civic Center and offered the former Main Library to the Asian Art Museum as its new home.

The Asian Art Museum exists because of its collections, now numbering more than 15,000 objects. Nearly 8,000 of these were the founding gifts Avery Brundage made in 1959 and 1969 to the City and County of San Francisco. The museum's primary interest in having a new building was to better showcase the pan-Asian scope and depth, and the superb quality of these collections. The new Asian presented us a unique opportunity to reinstall the collections at one time with an overall plan for an organization following a consistent story line for the emergence of Asian cultures, the development of particular unifying features, and the characteristics that mark individual distinctions among the diverse peoples of Asia.

At this critical juncture of globalization in the beginning of the 21st century, our goal is to make Asia accessible to our regional, national, and international audiences. We are, therefore, pleased to be in this prominent location in the heart of downtown San Francisco, with multiple choices in public transportation. Our new facility has increased space for education classrooms, an educational resource center, dedicated special exhibition spaces, and two floors of galleries to display the permanent collections. A shop, restaurant, elevators, and escalators provide essential amenities and easy access to the gallery displays.

The transformation of a 1917 beaux arts library to a museum is a challenging adap-

tation. A library is a single-point destination building. The visitor gets a book, sits down, and reads. Quite the opposite in an art museum—there visitor circulation is key. One learns by moving through space, encountering art. In spite of these challenges, the project has succeeded admirably, thanks to the efforts of a talented team of designers, Dott. Gae Aulenti with HOK, LDA, and Robert Wong Architects, as well as George Sexton Associates, who designed the permanent gallery casework and installation of the collections. The staff of the Asian Art Museum rallied behind the project and performed at high levels of productivity and determination to accomplish the planning, the move, and the installation of art. My gratitude and thanks to all of them is accompanied by enormous pride.

Together we hope to realize in this new building in the Civic Center our promise of excellence, quality programs, and a user-friendly environment. We hope to better serve our longtime supporters and visitors, and kindle interest in Asian art and culture among those who have yet to experience historical objects in a museum setting. Through accessibility, information, and the opportunity to encounter art that defines the philosophies, religion, aesthetic tastes, and technical skills of Asian peoples over thousands of years, we hope to become a true bridge of understanding between East and West.

Emily J. Sano

Bridge to

Understanding

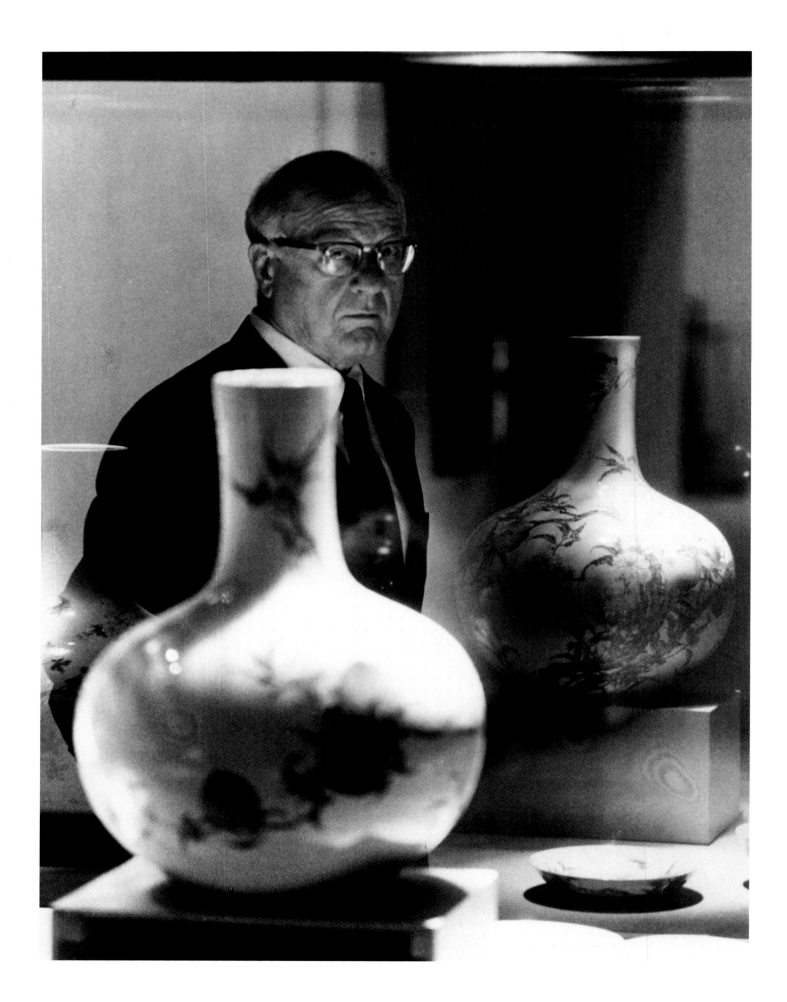

A City Museum

IN THE MIDDLE OF THE NINETEENTH CENTURY, San Francisco—like Shanghai across the Pacific—was transformed from a village into a city in the blink of an eye. In 1846, at the beginning of the U.S.–Mexican War, the city, then part of the Mexican province of Alta California, had a declining population of only about two hundred people. Two years later, after United States troops under General Winfield Scott occupied its capital, Mexico was forced to cede nearly half of its territory, including Alta California, in the Treaty of Guadalupe Hidalgo, accomplishing U.S. President James K. Polk's goal of obtaining a port on the Pacific.

Before the ink on that treaty was dry, news spread of the discovery of gold at Sutter's Mill, and by the end of the year San Francisco was home to twenty-five thousand people. Within another twenty years that number would multiply sixfold, with around eight percent of the total Chinese, according to the official Census (a number that is probably low). Because of its substantial Asian population and its role as a Pacific port, post–Mexican San Francisco has been profoundly influenced by the cultures of Asia, so it is fitting that it would eventually be home to the nation's first museum devoted exclusively to the arts of Asia.

In 1851, the San Francisco daily *Alta California* already envisioned a uniquely diverse future for the city, when it wrote of the Chinese population:

> They seem to live under our laws as if born and bred under them, and already have commenced an expression of their preference by applying for citizenship, by filing their intention in our courts. What will be the extent of the movement now going on in China and here is not easily foreseen. We shall undoubtedly have a very large addition to our population, and it may not be many years before the Halls of Congress are graced by the presence of a long queued Mandarin sitting, voting, and speaking, beside a Don from Santa Fe, and a Kanaker from Hawaii.

When Mark Twain visited the city during its Gold Rush heyday, he stayed at a hotel on the southwest corner of Sacramento and Leidesdorff streets (near Montgomery Street), called the What Cheer House. (Opened in 1852, it was destroyed in the fire of 1906.) Despite its carefree name, the building was owned by a teetotaler, Robert B. Woodward, who permitted no liquor or women on the premises—which may be why Twain left only a few dry remarks about the place.

Woodward was the operator of the city's main thoroughfare, the Mission Toll Road, a wide, wooden-plank carriage route crossing the western dunes and marshes to the mission; part of the road would evolve into today's Mission Street. The toll road passed

< Avery Brundage at the Asian Art Museum, about 1966.

13

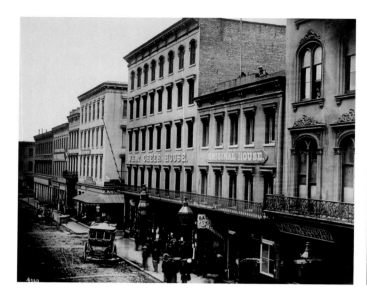

Left: The What Cheer House, home of San Francisco's first public museum, 1865.

Right: The original de Young Museum, 1894.

near the Yerba Buena Cemetery, which was filled with nameless bodies and dashed dreams of the Gold Rush, in which a few found fortune and most of the rest misfortune. That location would become the site of City Hall by the end of the nineteenth century, of the main branch of the San Francisco Public Library throughout most of the twentieth century, and of the Asian Art Museum in the twenty-first.

Many notable figures, including veterans of the U.S.–Mexican War such as Ulysses S. Grant, enjoyed the What Cheer's facilities, which included the only public bathtubs in the city (they were not in the rooms but in the basement). Besides the baths, the most cheering thing about the building was its public library and museum, the first in the city (some years later the *San Francisco Chronicle* would describe the contents of this ever-expanding museum as "walrus tusks, whalebone, wampum, corals and all sorts of large, medium-sized and small knickknacks"). Ever since, the histories of these two city institutions, one a home for a collection of books and the other for a collection of objects, have been intertwined in San Francisco, and it seems appropriate that in the twenty-first century the Asian Art Museum should find a new home in the building that had housed the main branch of the library.

Golden Gate Park and the de Young Museum

At first, San Francisco's exploding population huddled along a narrow, crescent-shaped bayside strip from North Beach (at that time actually a beach, before the city was built out into the bay) to Pleasant Valley (not far from the current site of the San Francisco Museum of Modern Art). But soon the steep hills to the west were leveled or climbed, and the swelling throngs spread west to the sandy expanse stretching seaward where, most thought, no trees could ever grow—Frederick Law Olmsted, the designer of New York's Central Park, visited the city and wrote that he didn't see how a shrub, much less a tree, could be made to grow on its dunes. Nonetheless, in 1870, the city set aside a large, featureless stretch of sand to be designated as parkland. In the 1980s, John McLaren, an energetic Scotsman who had left his dairy farm to study horticulture at the Royal Botanical Gardens near London and then had emigrated to San Francisco, was named Superintendent of Golden Gate Park, a post he held for decades. Under McLaren's supervision and diligent protection, a beautiful wooded park was conjured up from the dunes and protected from the ravenously expanding city. Golden Gate Park would provide a home for the Asian Art Museum through its first thirty-six years.

By the last quarter of the nineteenth century, the horrors of the Civil War and the

mismanaged Reconstruction were fading into the past. The country was experiencing tumultuous changes, including unchecked industrialization, new waves of immigration, political corruption, disputed social values, and economic volatility, but it was poised to move aggressively forward. In 1893 a world's fair was held in Chicago. Ostensibly a celebration of the quatercentenary of Columbus's arrival in the Americas (its official title was the Chicago World's Columbian Exposition), the fair actually was a celebration of the new American culture of the industrial age. It was an enormous success, drawing more than twenty-seven million visitors. The exposition showcased technological breakthroughs—its motto was "I Will"—and introduced new commercial products (among them Cream of Wheat, Pabst beer, Aunt Jemima syrup, and Juicy Fruit gum).

The fair also had a profound influence on the cultural life of the nation. It saw the proclamation of a new holiday, Columbus Day, and the introduction of the Pledge of Allegiance. Musicians such as Antonin Dvorak, John Philip Sousa, and Scott Joplin performed at or were influenced by the fair. The winner of a competition for commission of the main sculptures on display in the Women's Building, a nineteen-year-old from San Francisco named Alice Rideout, was one of the hits of the fair; Mary Cassatt contributed a mural to the Women's Building. Displays of "native villages" aroused an interest in tribal and foreign cultures, and the fair's emphasis on art and science exhibitions inspired the creation of several new museums around the country.

One of these was the de Young Museum in San Francisco. M.H. de Young, the publisher of the *San Francisco Chronicle,* had been appointed a National Commissioner at Large for the Chicago fair. On his return to San Francisco, de Young persuaded the Golden Gate Park Commission to host a West Coast version, called the California Midwinter International Exposition, in 1894.

To distinguish his fair from Chicago's, de Young asked exhibitors to emphasize Asian themes. One of the exhibits was a "Japanese Village." It became the Asian Art Museum's longtime neighbor, the Japanese Tea Garden, the oldest public Japanese-style garden in the United States. At the close of the fair, the proposal was made to create a permanent museum in Golden Gate Park as a memorial to the exposition. The fair's executive committee, led by de Young, decided to donate its Fine and Decorative Art Building (along with the adjacent Bavarian Pavilion) for this purpose. Consequently, the Memorial Museum's first home was an Egyptian Revival building, complete with images of Hathor, the cow goddess. The museum officially opened in March 1895.

In the following decades de Young filled the building with sculpture and painting,

arms and armor, porcelain ware, and native American artifacts. But the museum was not yet devoted entirely to art, and the spirit of the What Cheer Museum still echoed in those years—the Fine Arts Museums of San Francisco's website describes de Young's acquisition of "such diverse objects as sculptures, polished tree slabs, paintings, a door reputedly from Newgate Prison, birds' eggs [the *Chronicle* claimed the museum contained "eggs of every biped that ever had wings"], handcuffs and thumbscrews." Visitors could also view such wonders as snakes preserved in alcohol, a stuffed canary, "curios" from de Young's European travels, soil samples, a variety of cereals and nuts, and collections of coins, door knockers, and strongboxes.

When the museum outgrew its initial home, another exposition helped to provide it with a new one. Louis Christian Mulgardt, coordinator for architecture for the 1915 Panama-Pacific International Exposition, was hired to create a Spanish, plateresque–style building to replace the original building (which had been damaged in the great 1906 earthquake). It was completed in 1919; a central tower was added in 1921. By that year, the museum's attendance equaled that of the Metropolitan Museum in New York and surpassed that of the Smithsonian Institution. It was renamed the M.H. de Young Memorial Museum. Until 1949, when they were removed because their supports had rusted, elaborate cast-concrete ornaments embellished the facade of Mulgardt's new building. (The Pan-Pacific Exposition, as the 1915 fair was popularly called, was also the impetus behind the creation of a new city center, as discussed on p. 39.)

The most substantial subsequent addition to the building would occur in 1966, with the opening of a special wing of the de Young built to house the Avery Brundage Collection of Asian Art—the collection that would form the foundation of the Asian Art Museum.

Avery Brundage and the Founding of the Asian Art Museum

In 1893, as the Chicago World's Columbian Exposition held the nation in thrall, a six-year-old boy named Avery Brundage moved with his mother from Detroit to Chicago. The grand, exotic spectacle of the fair must have excited the young Brundage's imagination, and perhaps it influenced his lifelong fascination with foreign cultures.

Brundage's father had abandoned the family, and the boy was left to be raised by his mother and her relatives. He soon began to exhibit self-reliance, initiative, and a dedication to self-improvement. He trained seriously as an athlete in high school. Because his school had no physical education classes or instructor, no pool, and no gymnasium, he heaved rocks to develop his ability in shot putting, threw heavy washers to train for the discus, and used a sandpit for broad jumping. By the time Brundage left college he was discus champion of the Big Ten, and he was the U.S. winner of the "All-Around Championship" (similar to today's decathlon) in 1914, 1916, and 1918. Yet a competing sprinter recalls, "I remember very distinctly that he was not so much a born athlete as he was a great fighter."

Brundage was training for athletic competition by moonlight, after his daytime work was completed. After a few years as a construction superintendent with a leading architectural firm and then with a building company, he founded the Avery Brundage Construction Firm. Having resourcefully kept the company afloat during the Great Depression, Brundage was later able to expand his business into a building empire that would make his fortune and help to define the Chicago skyline.

In the early 1920s Brundage became president of the Amateur Athletic Union, and in 1929 he became president of the United States Olympic Committee, a post he would hold for decades. His tenure was marked by an inclusive internationalism—he sought to involve as many of the world's cultures as possible in the games—and an adamant opposition to professionalism in sports. For decades, Brundage successfully fought back efforts to allow professional athletes to compete in the games.

Young Avery Brundage.

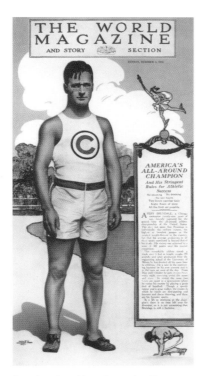

Brundage the athlete, featured in *The World Magazine* as U.S. All-Around Champion, 1916.

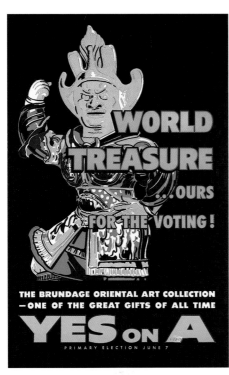

Poster produced to raise support for a 1960 bond measure to finance a home in San Francisco for the Avery Brundage Collection.

In 1936 Brundage traveled to Europe in connection with that year's winter Olympics in Berlin. His decision to allow the U.S. team to compete was controversial, but the four gold medals won by Jesse Owens exposed the folly of Hitler's racial theories. (In 1971, Brundage would make a similar decision, insisting the Munich Olympics continue after Palestinian guerrillas had murdered eleven Israeli athletes.)

During his trip, Brundage visited the exhibition of Chinese art sponsored by the Royal Academy at Burlington House in London. It was an unprecedented show—the Chinese government had sent 800 pieces from the imperial collection, and another 1,200 items from nearly every major Western collection were added. Brundage, who is said to have spent three full days viewing the exhibition, found it "overwhelming." Not long afterward, he began collecting in earnest, first favoring Chinese art and then expanding into Korean, Japanese, Indian, Southeast Asian, and West Asian art as well.

In 1939 Brundage and his wife, Elizabeth, traveled to Japan, which he praised for its "wholesome amateur outlook on life." After World War II, Brundage was instrumental in returning Japan to the Olympic community of nations and in staging the 1964 Olympics in that country. Japan showed its appreciation for Brundage's effort by "deregistering" some of its cultural properties in order to allow Brundage to remove them from the country.

Brundage attacked collecting ferociously. "Anything Brundage did, he did 110 percent," recalled Alexander D. Calhoun, a former commissioner of the Asian Art Museum and member of the Asian Art Museum Foundation. "He was a 110-percent athlete, a 110-percent chairman of the Olympic Committee and a 110-percent art collector." Before long Brundage's residence in Chicago, a hotel he owned there, and the new house he had built in Santa Barbara were all crammed with Asian art. Visitors have described invaluable ancient works spilling out of cabinets and closets and from underneath beds. There were bathtubs filled with netsuke and shoeboxes containing objects such as the Asian Art Museum's famous rhinoceros vessel. It was said that only Brundage could comfortably navigate through the cluttered passageways. To make matters worse, he had started collecting Indian and Southeast Asian sculptures after his initial concentration on Chinese and Japanese art, and many of the South and Southeast Asian sculptures were quite large. It was time for his collection to find a suitable home.

Brundage was a trustee of the Art Institute of Chicago, but when that institution hesitated to commit to such a large collection, Brundage began looking elsewhere. A determined and resourceful group of civic-minded individuals in San Francisco launched a campaign to obtain the collection. In 1957, they formed the Society for Asian Art, which through the decades would be the museum's most dedicated support group. Among the early organizers most active in helping to persuade Brundage to donate his collection were Elizabeth Hay Bechtel, Marjorie Bissinger, Jane Smyth Brown, Katherine Caldwell, Dorothy Erskine, Gwin Follis, Martha Gerbode, Edwin Grabhorn, Alice Kent, Kitty and Charles Page, Mrs. Ferdinand Smith, Dr. Wallace B. Smith, Marjorie Stern, and Joe Yuey. Brundage was sympathetic to their efforts because he saw San Francisco as a meeting point—a "bridge," as he said—between Asia and the United States.

George Christopher, mayor of San Francisco from 1956 through 1964, recalled, "We were competing with a number of other major cities for the collection, including Chicago, Mr. Brundage's hometown. At one point I said, 'Mr. Brundage, as International Olympic Committee President, you are a man of international stature. I want to remind you that San Francisco is the gateway to the Orient. In the future, every day dozens of planes from Asia will land here, bringing countless people who will see your collection. In Chicago, fine city that it is, a much more limited number will see it because Chicago is a midway city." Explained Christopher: "I very much wanted the Brundage collection for San Francisco because I believe in art; I believe in museums, symphonies, all the cultural things that make a big city. I thought it would be a tremendous asset to San Francisco. And it is."

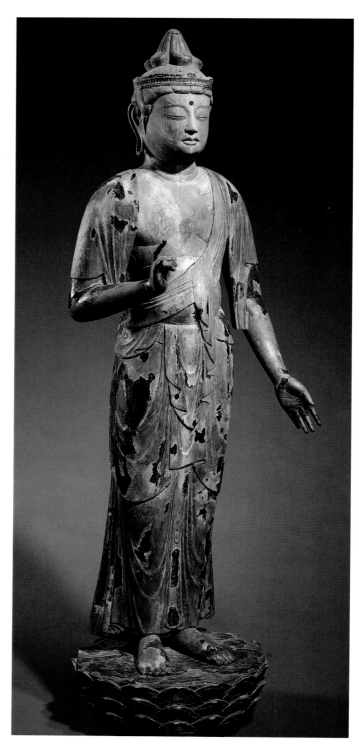

The Bodhisattva Avalokiteshvara (Japanese: Sho Kannon), approx. 1100–1185. Japan, Heian period (794–1185). Wood with traces of lacquer and gilt. The *Avery Brundage Collection*, B60S420. Once registered as an Important Cultural Property, a designation that restricted its exportation from Japan, this piece was deregistered by the Japanese government especially for Avery Brundage.

In 1959, after intensive efforts by the Society for Asian Art and city officials led by mayor Christopher, Brundage signed an agreement to donate the bulk of his collection to the city with the understanding that a suitable home be constructed for it. The following year, a selection of 137 items was exhibited at the de Young Museum to raise support for a bond measure financing a museum for the collection. In the foreword to the catalogue of the exhibition, Laurence Sickman, the director of the Nelson-Atkins Museum of Art, wrote: "There is good reason to believe that the objects of Asian art offered San Francisco by Avery Brundage comprise the last comprehensive collection in this field that can be assembled in our time."

The campaign for the bond measure was again led by the Society for Asian Art, with support from scholars and collectors such as Peter Boodberg, Otto Maenchen, Rudolph Schaeffer, and Joe Yuey. The measure passed overwhelmingly (one of several demonstrations of consistently strong community support for the museum over the years) on June 7, raising $2.75 million to add a special wing to the de Young; after the passage of the measure, Chinese restaurants in the city served thousands of fortune cookies containing the same fortune: "Thank you, Mr. Brundage."

Construction on the new wing of the de Young Museum, where the Brundage collection was to be housed, began in 1964, and the collection was officially opened to the public in 1966. Curator of Himalayan and Chinese Decorative Art Terese Tse Bartholomew—who has worked at the Asian Art Museum since 1968—recalls the opening: "The building for the Avery Brundage Collection was officially opened to the public on June eleventh in 1966. The designer, recommended by Dr. Laurence Sickman, was John Yeon of Portland. The galleries were painted a light blue-green. The cases were green, the blocks and risers were all the same color, and the pieces were sparsely displayed. Mr. Brundage was a great admirer of the 'breezy' and inspired approach initiated in the early 1950s by some of the best private museums in Japan. He was convinced that objects need a good deal of 'breathing space' around them to be fully appreciated. To him, a successful presentation was one conducive to an aesthetic and spiritual dialogue between the individual object and the viewer. He did not approve of lengthy labels, charts, maps and diagrams, believing that they might interfere with direct communication between the individual object and the viewer."

After donating his collection to the city of San Francisco, Avery Brundage had continued to amass a second collection, filling in gaps in the first and spending more than a million dollars a year on art purchases. By 1969, Brundage had become frustrated with the administration of his collection by the de Young Museum, and he opened up conversations with the city of Los Angeles to give it the second collection. Again the Society for Asian Art and San Francisco city leaders entered into negotiations with Brundage. One of his demands was for the creation of a commission to oversee the Asian Art Museum as an entity separate from the de Young.

Brundage signed an agreement granting San Francisco the second collection in 1969. The agreement included a legal obligation for the city to raise $1.5 million in eighteen months so Brundage could add to the collection and a "moral obligation" to raise another

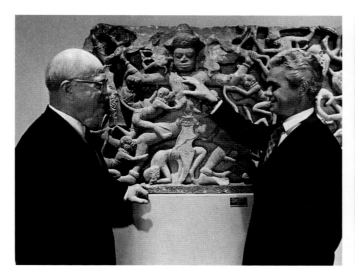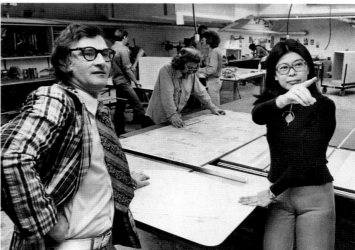

LEFT: Avery Brundage and René-Yvon Lefebvre d'Argencé admire a twelfth-century Cambodian door lintel.

RIGHT: Clarence Shangraw with Royoko Takaki, exhibition designer, planning the *Exhibition of Archaeological Finds of the People's Republic of China,* 1975.

$1.5 million within another eighteen months. After the agreement was signed, the Asian Art Museum and the de Young Museum continued to share a building, but their administrations were separate and distinct city agencies. On July 2, 1969, the nonprofit Asian Art Museum Foundation was created to assist in the museum's administration, and the Asian Art Commission was sworn in by Mayor Joseph L. Alioto on July 30. (At the time, the museum was known as the Center for Asian Art and Culture; it would be officially renamed the Asian Art Museum in 1973.)

Brundage's goal throughout his negotiations with San Francisco was to find the best possible home for his extraordinary collection, which still accounts for more than half of the museum's collections, including some of its most celebrated objects. With the opening of the new Asian Art Museum in Civic Center, Brundage's vision has finally been fulfilled.

After Brundage: Setting the Course

First Leaders: René-Yvon Lefebvre d'Argencé and Clarence Shangraw

Avery Brundage died in 1975 at the age of eighty-eight, when the museum was still in its infancy. The spirit that underlay his collecting continued, however, in the figures of René-Yvon Lefebvre d'Argencé, who was director and chief curator of the museum until his retirement in 1985, and of deputy director and senior curator Clarence F. Shangraw, who retired in 1992.

D'Argencé, whose education included work at the Sorbonne and at Cambridge, was a professor of art history at the University of California, Berkeley. His museum background included curating the Blanchard de la Brosse Museum in Saigon and the Louis Finot Museum in Hanoi during the 1950s, and he had served as Brundage's principal art advisor for years. Shangraw had worked with Brundage in 1964 to catalogue the Avery Brundage Collection.

D'Argencé and Shangraw were among the first to employ blockbuster exhibitions as a means of attracting visitors and promoting the institution. In 1975, *The Exhibition of Archaeological Finds of the People's Republic of China* attracted more than 800,000 visitors, the highest attendance for any museum exhibition held in San Francisco to that date. D'Argencé also traveled to Seoul and Shanghai to arrange the exhibitions *5,000 Years of Korean Art,* which opened in 1979, and *Treasures from the Shanghai Museum: 6,000 Years of Chinese Art,* which opened in 1983; the latter was the first exhibition ever organized in the United

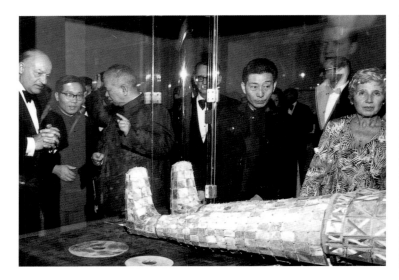

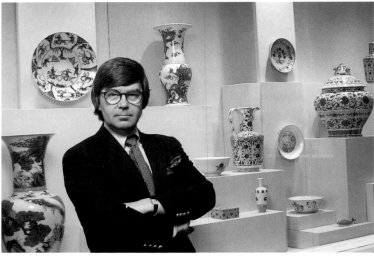

States in cooperation with a museum in China. These shows traveled from the Asian Art Museum to nine other museums in the United States.

In a museum publication entitled *A Decade of Collecting* (1976), D'Argencé recalled, "During the first ten years of its life the Asian Art Museum has accomplished twenty major rotations of its own collections, organized seven exhibitions that traveled to twenty-four museums in this country and abroad, housed fifteen special exhibitions, built practically from scratch a ten thousand–volume library, published eleven books and catalogues and received millions of visitors from all over the world."

Thanks in part to these efforts, the museum was attracting increasing national and world attention. In 1972, it received its first exhibition funding from the National Endowment for the Arts, for *Ancient Indonesian Art of the Central and Eastern Javanese Periods*. In 1976, the London review *Oriental Art* devoted its whole winter issue to the museum. In 1983, Queen Elizabeth II of England and President Ronald Reagan visited.

New Initiatives: Rand Castile

Despite these achievements, direction of the Asian Art Museum during these years reflected d'Argencé's quiet and scholarly persona. The museum was a place of scholarship and reflection but not yet fully the center for Asian art and culture invoked in its original name. In 1986 Rand Castile, previously the director of the Japan House Gallery in New York, was named director of the Asian Art Museum; he would serve until 1994. Under Castile's leadership, the museum began an effort to place its art in a context that would make it more understandable and accessible to the general visitor. Castile also took a more active role in the local community and sought a higher profile for the museum through publicity and promotion.

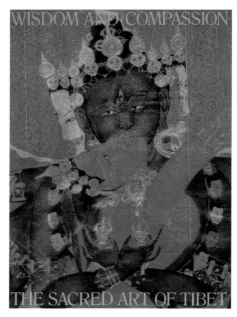

One of Castile's first projects as director was to double the number of works on display (despite this increase, the Golden Gate Park site remained too small to exhibit more than 15 percent of the museum's collection at a time.) Under Castile's tenure the museum emphasized thematic exhibitions based on objects from its own permanent collection, which ranged from *Ganesha: The Elephant-Headed God* to *Ancestral Dwellings: Furnishing the Han Tomb* to *Later Japanese Lacquers.* There were also some larger, traveling exhibitions during this period, among them *Essence of Indian Art; Traditional Chinese Flower Arranging; Views from the Jade Terrace: Chinese Women Artists, 1300–1912; Yani: The Brush of Innocence; Wisdom and Compassion: The Sacred Art of Tibet;* and *Sculpture of Indonesia.*

During the 1980s the museum became increasingly concerned with its obligation

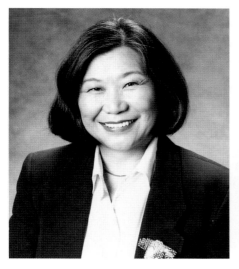

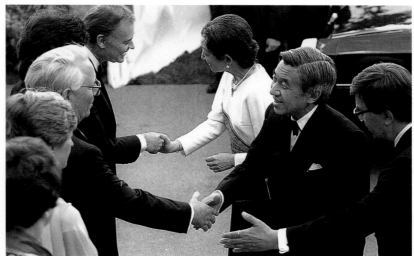

LEFT: Emily Sano, Director of the Asian Art Museum.

RIGHT: Among many distinguished visitors to the museum were their imperial majesties the emperor and empress of Japan, who visited on June 22, 1994. Shaking hands with the empress is Mayor Frank Jordan, and shaking hands with the emperor is Johnson S. Bogart, chair of the museum's boards.

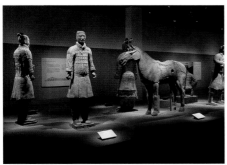

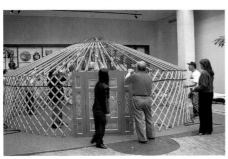

TOP: A completed gallery from the exhibition *Tomb Treasures from China: The Buried Art of Ancient Xian,* 1994.

BOTTOM: Installing a yurt for the exhibition *Mongolia: The Legacy of Chinggis Khan,* 1995.

to provide public education (this concern responded in part to the changing priorities of many sources for public funding). The museum's educational efforts were expanded, and videos on such subjects as *Mr. Oh: A Korean Calligrapher* and *Bone, Flesh, Skin: The Making of Japanese Lacquer* won widespread attention and several awards. The same decade, following a mandate from then-mayor Dianne Feinstein, the museum launched a community outreach program that brought more Asian audiences to the museum. As part of this initiative, the museum created an ambitious program of public events, including a variety of films, performances, and demonstrations.

Expanding the Vision: Emily Sano

Emily Sano joined the museum as chief curator, deputy director, and chief administrative officer in 1993. Her background included both scholarship and management. Prior to joining the Asian, she had served as deputy director of collections and exhibitions and senior curator for non-Western art at the Dallas Museum of Art, and had spent eleven years as assistant director for academic services and curator of Asian art at the Kimbell Art Museum in Fort Worth.

Sano was appointed director in 1995, working with Paul Slawson, who was museum president from 1995 to 1996. As director, Sano, working with board commissioners and trustees, addressed the needs of the museum as it looked forward to moving to a new location and taking on a new status as an independent cultural organization in San Francisco. These efforts included preparing a master plan, crafting a new mission statement (see p. 22), and initiating a capital campaign for the new building. Internally, Sano's focus was on increasing programming activities in all areas of the museum: exhibitions, education, public relations, marketing, retail activities, and publications. She also established a senior management team of division heads charged with planning and executing the work of the museum. In preparation for the move, the commissioners and trustees recognized the need to ramp up by increasing staff across the board from forty-nine in 1993 to one hundred seventy in 2003, when the new Asian Art Museum opened at Civic Center.

Sano greatly expanded the museum's exhibition schedule, which every year has witnessed major exhibitions. To name but some: *Tomb Treasures from China: The Buried Art of Ancient Xian* (1994); *Mongolia: The Legacy of Chinggis Khan* (1995); *Splendors of Imperial China: Treasures from the National Palace Museum, Taipei* (1996); *Four Centuries of Fashion: Classical Kimono from the Kyoto National Museum; The Art of Chao Shao-an; India: A Celebration;* and *Paintings by Masami Teraoka* (1997); *Essence of Style: Chinese Furniture; Hopes and Aspirations:*

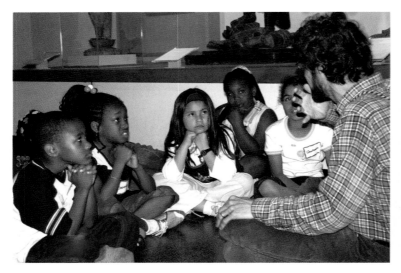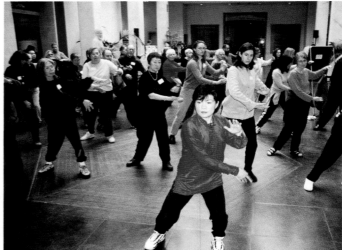

Decorative Painting of Korea; At Home and Abroad: 20 Contemporary Filipino Artists; and *Hokusai and Hiroshige: Great Japanese Prints from the James A. Michener Collection, Honolulu Academy of Arts* (1998*); Inside/Out: New Chinese Art; From the Rainbow's Varied Hue: Textiles of the Southern Philippines;* and *The Arts of the Sikh Kingdoms* (1999); *Alienation and Assimilation: Contemporary Images and Installations from the Republic of Korea; Bamboo Masterworks: Japanese Baskets from the Lloyd Cotsen Collection; The Golden Age of Chinese Archaeology: Celebrated Discoveries from the People's Republic of China;* and *Between the Thunder and the Rain: Chinese Painting from the Opium War through the Cultural Revolution, 1840–1979* (2000); and *Taoism and the Arts of China; Zen: Painting and Calligraphy, 17th–20th Centuries;* and *Empire of the Sultans: Ottoman Art from the Khalili Collection* (2001).

Sano also expanded the museum's educational and cultural outreach activities, and introduced a new emphasis on contemporary art, as described in the following sections.

Expanding the Vision: Educational Programming and Outreach

An Educational Mission

Education lies at the heart of the Asian Art Museum's mission. Its mission statement reads "The Asian Art Museum–Chong-Moon Lee Center for Asian Art and Culture is a public institution whose mission is to lead a diverse global audience in discovering the unique material, aesthetic, and intellectual achievements of Asian art and culture." This wording was forged in 1994 by a group led by Asian Art Commission President James Murad. It is interesting in several respects: First, it makes clear the educational role of the museum. Second, it goes beyond simply recording the material record to encompass the interpretation of Asian aesthetic and intellectual achievements. Finally, it expresses an interest not just in art but also in culture.

Traditionally, museums' educational activities have focused on school programs, tours, and lectures. But the role of art museum education is expanding and evolving. At the Asian Art Museum, a variety of materials is produced for every level of visitor, from the novice to the scholar, from the young child to the adult. Object labels and gallery wall panels are written in plain language that is geared to the general visitor; at the same time, the information reflects the latest scholarship.

Educating a Varied Audience

The museum provides graduated learning opportunities for a variety of audiences. Students in the second and third grades are introduced to Asian culture using art and tradi-

LEFT: Students participate in *Body Language,* an innovative program teaching the significance of traditional Asian gestures.

RIGHT: Photographer Oliver Laude on location in India shooting images for an Asian Art Museum video.

tional folktales. Fourth and fifth graders can take short gallery tours of Chinese landscapes and then return to the classroom to produce their own brush paintings. Sixth and seventh graders are offered interactive gallery tours that emphasize observational skills, critical thinking, group work, and peer presentations.

The museum's storytelling program was launched in 1993 in an effort to expand the museum's educational mission to better serve younger children. Commissioner Elaine Connell spearheaded the program. Volunteer storytellers not only lead groups through the museum but also travel to schools and other locations. Other docents travel to schools to teach brush painting, the meanings of traditional Asian gestures, the nuances of the Japanese tea ceremony, and many other subjects. For older students and adults the museum offers seminars, symposiums, lectures, and interactive demonstrations and programs.

Educational Resource Center

In the 1990s educators introduced special resource rooms to enhance the exhibition experience. These rooms provided hands-on materials to broaden visitors' understanding of the contexts and cultures behind the art on display. They provided reading corners, places to do art activities, and contextual information. Visitors were able to try everything from donning Japanese kimonos to sitting in Zen meditation to lounging on Turkish pillows. Full of objects, books, videos, and comfortable seating, resource rooms offered a respite from the traditional museum experience that prohibited interaction with the objects on display.

Building on this success, the new Asian Art Museum includes an educational Resource Center, which is located at the north end of the west wing. Here visitors can browse the docent library, view videotapes of lectures and programs presented at the museum, borrow or purchase slide packets, or consult the museum's online collection database.

Cultural Outreach

As part of its educational mission, the museum has sought to demonstrate connections between art objects and the living artistic traditions of Asia. Its impressive variety of Chinese programs have included New Year's celebrations, dance recitals, film presentations, poetry readings, performances of Kun Opera, hand puppet presentations by Yang Feng, and instrumental performances by Liu Weishan. Japanese events have ranged from *rakugo,* traditional comic storytelling from the Edo period by late Shijaku Katsura; to a *shamisen*

Brush painting in an educational resource room.

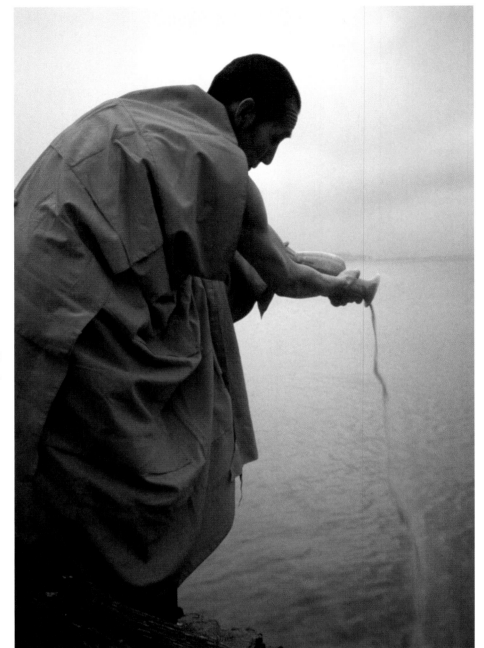

Tibetan monk Lama Tenzin releases sand into the waters below the Golden Gate Bridge. The sand came from a colored sand painting produced by a group of Tibetan monks in conjunction with the exhibition *Wisdom and Compassion: The Sacred Art of Tibet,* 1991.

Tuvan throat singer Kongar-ool Ondar.

(three-stringed lute) performance by Chikuzan; to a recent bamboo workshop by Jiro Yonezawa; to screenings of such films as *Sword of Doom* (1966), directed by Kikachi Okamoto and starring Tetsuya Nakadai; to multidisciplinary pieces such as *Dark Passages: Ruminations on Japanese American Internment Camp Survivors and on World War II.* Among the Korean programs were performances by a single singer accompanied by the *puk* (a barrel drum) of an ancient epic dramatic opera called Pansori and the presentation of a Korea Foundation program called *Korean Classical Music and Dance.* Rediscovering traditions helps to promote a sense of community, and the museum makes this possible through a variety of family days and events, including celebrations of the Korean lunar new year and Chuseok, the Korean harvest festival.

The museum has also presented performances, films, and artists from Burma, Cambodia, Indonesia, Laos, the Philippines, Thailand, and Vietnam. It has featured different types of Indonesian *wayang,* including the shadow theater, and rod puppetry. Some of

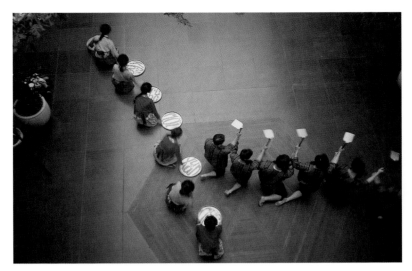

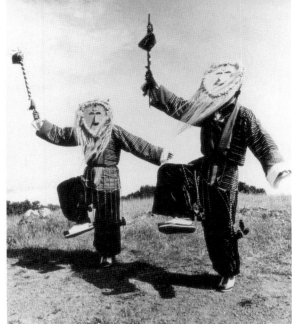

TOP LEFT: The Wings of the Hundred Viet, a Vietnamese dance company, performs during Tet, the Vietnamese lunar new year.

TOP RIGHT: Masked dancers from the Chaksam-Pa Tibetan Dance and Opera Company.

BOTTOM: A dramatic moment from a Korean mask dance.

Indonesia's best-known puppeteers have performed at the Asian Art Museum, including I. Wyan Wija, I. Nyomen Sumandi, and Asep Sunandar Surarya, as well as U.S.–based puppeteers Larry Reed, Kathy Foley, and Widiyanto S. Putro.

The Southern Philippine musical and dance company Palibuniyan Kulintang Ensemble's Danny Kalanduyan, who performed for *At Home & Abroad: 20 Contemporary Filipino Artists* helped to bring weaver Baingan Dawan from the Philippines to serve as artist-in-residence during the exhibition, demonstrating traditional techniques.

The San Francisco Bay Area is home to the third largest Indian community in the United States. Ali Akbar Khan and students from his College of Music in San Rafael have performed a number of sold-out shows at the Asian Art Museum over the years. In 1997, on the fifteenth anniversary of India's independence, students from the college performed during the three-month-long *India: A Celebration,* then returned for a *Spirit of India* concert series the following year. The vast diversity of Indian arts has been showcased through music, dance, literature, film, and craft demonstrations from Andhra Pradesh, Kerala, Madras, Rajasthan, and Uttar Pradesh, and other regions.

When singer Kongar-ool Ondar returned to perform at the Asian Art Museum during the exhibit *Mongolia: The Legacy of Chinggis Khan* in 1995, he met musician Paul Pena, who had learned throat singing on his own and later traveled to Tuva, a remote village on the Siberian/Mongolian border, to participate in their national throat-singing contest. In 1999, Kongar-ool Ondar and Pena became the focus of the documentary *Ghengis Blues,* which was nominated for an Academy Award.

Artistic performances and demonstrations cross cultures just as religious and artistic traditions have spread across Asia, each culture adding its special stamp. For example, the Asian American Orchestra—led by Anthony Brown and featuring a diverse orchestra of musicians from several Asian heritages playing alongside musicians from Western backgrounds—has appeared several times at the Asian Art Museum. Its performances combine Western instruments and Asian instruments. The group performed the San Francisco premiere of *Far East Suite* by Duke Ellington and Billy Strayhorn (a recording of the orchestra's interpretation of this work was nominated for a Grammy) and premiered a collaboration between pianist Jon Jang and the late Horace Papscott. When the second phase of the Asian Art Museum construction, which will add an auditorium, is completed, such performers will have a venue worthy of their accomplishments. The Asian American Orchestra is a visible expression of the way in which the living arts can bypass boundaries to enrich the lives of many people.

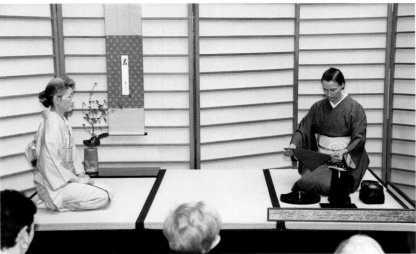

Interactive Programs and New Media

Demonstrations and interactive programs continue to be a museum priority. The core program for the general public is *AsiaAlive,* which operates daily in the Grand Hall. *AsiaAlive* features artist demonstrations, hands-on activities, video viewing, and reading and relaxation. A special area is devoted to each of these components. Each month a new theme is explored, reflecting the museum's focus on diverse educational offerings. On weekdays, docent lectures and gallery discussions are offered at lunchtime, and art classes are given later in the day. For families, an opportunity to explore the *AsiaAlive* theme in a more structured program in the Family Studio is presented on Saturday mornings. Short introductory art history classes are also offered for adults on the weekends. For those who are ready to invest more time in learning, docent lectures, education symposiums and workshops, and scholarly courses and workshops are offered by the museum and the Society for Asian Art.

Multimedia stations throughout the galleries present another learning opportunity. At each station, visitors are able to select from a number of videos showing environments, geographies, and artistic processes. In the south wing of the second floor, visitors can experience a functioning Japanese teahouse. Programs in this space bring to life the many arts and objects associated with the tea ceremony—among them calligraphy, ceramics, lacquer, and bamboo tea utensils. The art of serving tea the traditional Japanese way is presented at least once a month by local tea ceremony practitioners. With daily artist demonstrations, drop-in activities, a variety of art classes, lectures, and advanced workshops and symposia, the museum provides a variety of entry points for experiencing its educational and cultural activities.

Expanding the Vision: Contemporary Asian Art

As a collector, Avery Brundage, who assembled the core of the museum's collection, showed a preference for works from ancient Asian cultures, especially bronze and ceramic objects. In this he reflected the tastes of his generation, and those of the first leaders of the Asian Art Museum. As a result, contemporary and modern works were underrepresented in the collection.

Now, in the twenty-first century, the museum's leaders acknowledge that, in the Asian's new home at Civic Center, the artistic activities of the past century need to come to the forefront of its programs. Under the direction of Emily Sano, the museum has already taken steps to correct this imbalance. In 1997 it hosted a show devoted to the

Yook Taejin, *Patriot Game,* 1992. From the exhibition *Alienation and Assimilation: Contemporary Images and Installations from the Republic of Korea,* 2000.

Li Huayi, *Cloudy Peaks at Dawn in Spring,* 1999. Hanging scroll, ink and color on paper. *Gift of Susan and Ian Wilson,* 1999.10.

Japanese-born artist Masami Teraoka that had been organized by the Freer and Sackler galleries in Washington, D.C. The following year, the museum organized the group exhibition *At Home and Abroad,* which featured contemporary works by twenty Filipino artists. The San Francisco Bay Area is home to the largest community of Filipino Americans in the United States, and this exhibition was timed to recognize the centenary of Philippine independence.

But mounting contemporary art exhibitions has posed unique challenges for the museum, whose curatorial staff is trained in the traditional arts and is less familiar with the language of modern and contemporary art. To address this limitation, Sano, with support from the Society for Asian Art, engaged a consultant, Jeff Kelley, for advice. A widely published writer and former contemporary curator who teaches art criticism at the University of California, Berkeley, Kelley helped to plan a symposium to consider the special challenges presented by this new field of art—and how the Asian Art Museum might formulate a role and a presence in this field.

On October 2, 1998 the museum hosted the seminar, which brought to San Francisco a number of important professionals active in the field of Asian contemporary art. The keynote speaker was Dr. Vishaka Desai, director and vice president for programming of the Asia Society, New York; a few years before, Desai had led the field of Asian traditionalists by supporting a major group show of Asian and Asian American artists at the Asia Society. Other speakers included Alexandra Munroe, director of the Japan Society Gallery, New York; Dr. Apinan Poshyananda, curator of contemporary art at Chulalongkorn University, Bangkok; Elaine Kim, chair of the ethnic studies department, University of California, Berkeley; Mary-Ann Milford-Lutzker, Carver Professor of Asian Studies, Mills College; and the freelance curator Gary Garrels, then curator and custodian of painting and sculpture at the San Francisco Museum of Modern Art.

This group discussed the complexities of dealing with contemporary art when coming from a foundation of traditional art, and they called upon the Asian Art Museum to take up the challenge. This call increased the resolve and energy of the staff, and an ambitious program of contemporary art was planned. One component of this program is a series of small solo shows planned for the Civic Center location that will feature individual Asian and Asian American artists.

Meanwhile, the museum continued to mount shows of contemporary art. In 1999, together with the San Francisco Museum of Modern Art, the museum presented a huge show (organized by the Asia Society and P.S.1 in New York) called *Inside Out,* featuring

LEFT: Elmer Borlongan, *Gabay* (Guide), 1994. Oil on canvas. *Collection of Enrico Santos.* From the exhibition *At Home and Abroad: 20 Contemporary Filipino Artists,* 1998.

RIGHT: Xu Bing, *Book from the Sky,* 1987–1991. Hand-printed books, wooden boxes, and hand-painted scrolls. *Collection of the artist.* From the exhibition *Inside Out: New Chinese Art,* 1999.

avant-garde Chinese art from the mainland, Hong Kong, and Taiwan. This was a true eye-opener, encompassing a great diversity of styles in a range of mediums, including painting, sculpture, video, photography, and unusual installations. It was followed with *Alienation and Assimilation,* containing works from South Korea. Organized by the Museum of Contemporary Photography at Columbia College in Chicago, this edgy show expanded our understanding of what constitutes photography today.

The museum also took the lead in organizing exhibitions of modern art. Borrowing from an extensive local private collection, *Between the Thunder and the Rain: Chinese Paintings from the Opium War through the Cultural Revolution, 1840–1979* documented the development of modern Chinese painting in traditional styles. It traced the tumultuous changes during nearly a century and a half of China's recent past, and the responses of artists from this period to social change, war, and wide dispersal.

As of this writing the museum has plans for several contemporary art exhibitions, including a show in cooperation with the National Museum of Modern Art in Seoul that will feature contemporary Korean artists; an exhibition organized by the Asia Society in New York called *Temple of the Mind,* which will focus on the late Thai installation artist Montien Booma; a show by the San Francisco painter Li Huayi; a selection of the work of Beijing artists; an exhibition of prints by the noted Japanese artist Tetsuya Noda; and more. The museum is actively investigating contemporary art currents in such countries as Burma, Indonesia, Iran, Malaysia, Singapore, Turkey, and Vietnam.

The museum has also been more active than in the past in acquiring contemporary works. Recent gifts and acquisitions include a major canvas by Korean artist Se-duk Lee; a group of Chinese paintings by important artists from a collector in Hong Kong; and a large, lively work in mixed media on paper, *Personal Space* (2001) by Jayashree Chakravarty, an innovative Indian artist based in New Delhi. These works are part of expanded acquisitions activity that has recently seen a significant growth in the museum's collection, as described in the next section.

For the Asian Art Museum, attention to contemporary art is an adventure that is being embraced with enthusiasm. Through these programs the museum hopes to contribute to an international dialogue about art in our own age and to an understanding of what defines and distinguishes the art being produced by Asians and Asian Americans now.

Among the most recent contributions to the Asian Art Museum's collection are significant donations from the Doris Duke Charitable Foundation's Southeast Asian Art Collection and from the Lloyd Cotsen Japanese Bamboo Basket Collection.

TOP: Flower-arranging basket entitled *Steep Cliff*, 1980–1990, by Higashi Takesonosai (born 1915). Japan. Bamboo. *Lloyd Cotsen Japanese Bamboo Basket Collection*, F2002.40.3.

BOTTOM: Crowned and bejeweled Buddha image and throne, approx. 1850–1900. Burma (Myanmar). Lacquered and gilt wood and metal with mirror inlay. *Gift of the Doris Duke Charitable Foundation's Southeast Asian Art Collection*, R2002.27.1-.2.

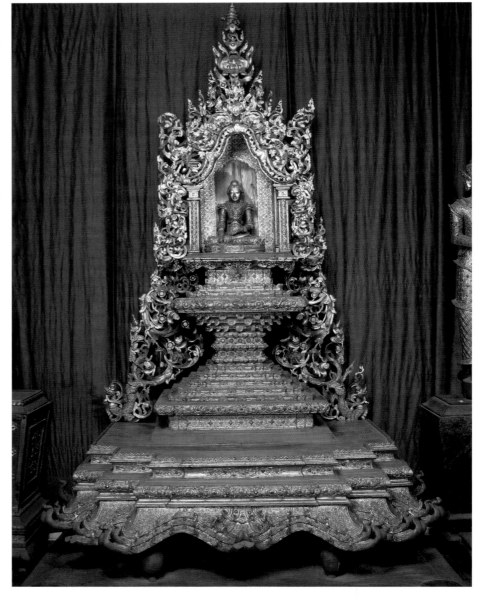

Building on Brundage: Donations and Acquisitions

"All the while he was acquiring art for the museum," noted Clarence Shangraw in 1991, "Mr. Brundage's intent was for his collection to serve as a catalyst for other collectors and donors." Today Brundage's gifts amount to a little more than half of the museum's total collection. Over the years, generous contributions of acquisitions funding and direct donations of art have supplemented (and significantly surpassed) the museum's outright art purchases. Between 1960 and 1975, contributions from Ransom Cook, Gwin Follis, James M. Gerstley, George F. Jewett, and Marjorie Bissinger were particularly significant.

Roy Leventritt donated more than 240 pieces of blue-and-white porcelain, George Hopper Fitch provided 80 Indian miniature paintings, and Ed Nagel contributed several dozen works, many of them Indian sculptures. Fifty Kosometsuke porcelains (Chinese blue-and-whites made for the Japanese market) were given by Effie B. Allison. Richard Gump provided Japanese prints and Chinese jades. James and Elaine Connell donated a collection of Thai ceramics.

To assist in the acquisition of new objects, the Connoisseurs' Council was founded as a support group for the museum in 1985 by Mrs. John Bunker. An organization of Asian art collectors and enthusiasts, the council has since its inception raised millions of dollars for acquisitions of art objects for the museum. In addition to participating in an active program of events, council members meet annually to vote on objects proposed by the museum's curators for acquisition. The Connoisseurs' Council has contributed toward the acquisition of a number of major works, such as a rare sixteenth-century Korean hanging scroll depicting bamboo by the artist Yun In-ham and a Muromachi period Japanese fan painting of two monkeys at play by Shikibu Terutada. The Connoisseurs' Council has also been the sole donor for some sixteen artworks that are on display in the Asian. Highlights of this group are an inscribed gold ritual bowl from the ancient kingdom of Angkor, a Chinese Han dynasty "money tree," a large Mughal marble architectural panel depicting lilies and irises, and a seventeenth-century Tibetan treasure chest.

Significant recent additions to the collection include a collection of Sikh art donated by Dr. Narinder and Mrs. Satinder Kaur Kapany, and a collection of Indonesian rod puppets contributed by Mimi Herbert. In August 2002 the museum announced important new gifts from the Lloyd Cotsen Japanese Bamboo Basket Collection, one of the most notable collections of its kind in the world, and the Doris Duke Charitable Foundation's Southeast Asian Art Collection. The Cotsen gift includes 832 objects, and the 173 objects in the Duke gift include rare sculptures, paintings, and decorative arts.

Together, the Cotsen and Duke donations represent the most significant gifts of art to the museum since Avery Brundage's initial founding gifts in the 1960s. Many of these objects are considered so exceptional that the museum will showcase a significant portion of each collection at all times in its galleries (see p. 214 for an example chosen by curator of Japanese art Yoko Woodson in her selection of highlights of the Japan galleries). With the addition of these gifts, the museum's overall collection now stands at more than fifteen thousand objects.

The Museum Leaves the Park

By the 1970s it had become obvious that the museum's facility in the park had become inadequate as a home for its collection and as a venue for temporary and traveling exhibitions and museum programs. Although the Asian was independently managed, it was perceived by many to be a part of the de Young, and it needed an opportunity to establish its own identity. In the park no more than 12 to 15 percent of the museum's collection could be exhibited at a time. Portions of the museum's permanent collection constantly had to be taken down and reinstalled in order to mount the impressive special shows for which the museum had become known. By the museum's final year of operation in the park, its Chinese collection (representing some 60 percent of the total collection, including a number of its most notable objects) was not on display at all because of the needs of

Chong-Moon Lee addresses the crowd at a ground-breaking ceremony on May 8, 1999. In the crowd, left to right: Supervisor Michael Yaki, Foundation President Maura Morey, an unidentified man, and Foundation and Commission Chair Johnson S. Bogart.

special shows. Space for educational activities was similarly limited, and some student groups had to be turned away. The museum staff had multiplied exponentially since the early years of the institution, and gallery space on both the east and west sides of the second floor had to be converted to offices, further reducing exhibition space.

Potential seismic dangers were another concern, especially after the Loma Prieta earthquake in 1989, which damaged the Asian's facility and objects in its collection. Even though the more recently constructed wing in which the Asian was housed escaped the more severe damage that the older parts of the de Young building suffered, initial repair and retrofitting estimates still ran to some $30 million.

Moving the museum would allow it to expand its educational programming and improve its ability to safely store, conserve, and display its valuable collection. A move to Civic Center would improve the museum's accessibility to visitors (with more than twenty Municipal Railway lines as well as direct transit service from the East Bay and San Mateo and Marin counties within three blocks of the site), at the same time helping to revitalize the former home of the main public library, one of San Francisco's most treasured historic buildings. Moving the Asian would also provide space for the expansion of the de Young Memorial Museum in the park. And it would serve as a reminder of the city's vital historic—and ongoing—role as a Pacific Rim city and a bridge between East and West.

The museum had outgrown its home—it was time to move.

Funding the Move
The New Asian Capital Campaign

Following the 1988 approval by the Board of Supervisors of Mayor Dianne Feinstein's Restoration Plan for Civic Center, voters also approved an amendment to the city's charter granting the Asian Art Commission, the museum's governing board, control over any properties set aside for an Asian art museum. In 1989, shortly after the Loma Prieta earthquake, San Francisco voters approved a bond to finance seismic retrofitting of city properties, and the Asian's share from that bond was about $9 million. A similar measure in 1993 attempting to increase the seismic funding failed. In 1994 the Asian launched its own bond initiative, which the voters of San Francisco overwhelmingly endorsed, bringing the Asian's total bond amount to $52 million. These funds were the building blocks for establishing the Campaign for the New Asian, a public and private partnership.

Since that time, a large and dedicated corps of volunteers has helped shape the vision for the new Asian Art Museum. Three individuals who have played a key role in the museum's fundraising success are Johnson S. Bogart, chairman of the Asian Art Museum Foundation and Commission and chairman of the Campaign for the New Asian; Judith F. Wilbur, who served as chair of the 1994 "Yes on B" Asian Art Museum Bond Campaign, as well as chair of the New Asian Project Committee since 1994 and vice chair of the Campaign for the New Asian since 1996; and Maura B. Morey, president of the Asian Art Museum Foundation.

Financial support for the new Asian Art Museums was received on local, national, and international levels, with more than 30 percent of the funds coming from board members of the Asian Art Museum Foundation and Commission. The largest private gift, $15 million, was provided by Korean-born Silicon Valley entrepreneur Chong-Moon Lee. Thirty-two donors contributed $1 million or more (for a list of donors, see p. 221). Government funding was significant, with grants totaling more than $7 million from the State of California. Local foundation support included grants from the Bernard Osher Foundation, Koret Foundation, the William G. Irwin Charity Foundation, and the David and Lucille Packard Foundation. Nationally the campaign enjoyed support from such foundations as the Starr Foundation and the Henry Luce Foundation in New York; international support was generous as well, with contributions from the Korea-based company Samsung Semiconductor, Inc., and the Korea Foundation of Seoul, Korea.

LEFT: Judith F. Wilbur leads Connie Lurie on a tour of the building, May 21, 2002.

RIGHT: Left to right: Judith F. Wilbur, Johnson S. Bogart, and Maura Morey at the Asian Art Museum annual meeting, September 17, 2002.

"The response to the New Asian campaign has been phenomenally supportive, not only in San Francisco but throughout the Pacific Rim," said Johnson S. Bogart. "That reflects the respect and esteem in which the museum and its collection are held internationally. It's also indicative of the importance people at home and abroad place on the concept of an outstanding museum of Asian art and culture in San Francisco. The community's support has been critical to our ultimate success."

Giving Back: Chong-Moon Lee

With one gift from one individual, the campaign for the new Asian Art Museum got moving in earnest. In 1995 Korean American businessman Chong-Moon Lee gave $15 million to the museum and the New Asian Project. Without the support of Chong-Moon Lee the Asian Art Museum's dream of relocating from its old home in Golden Gate Park to the city's former main public library building would not have been possible. His gift was not only an extraordinary sum of money but also a clear call to other philanthropists to follow his lead in lending serious support to the project. It was a genuinely inspirational act that had a profound effect on everyone involved with the museum.

Lee was appointed to the Asian Art Commission in 1994 and has also served as a member of the Asian Art Museum Foundation since 1995. His commitment to the museum was reflected not only in his 1995 gift but also in a generous 1994 gift to the museum's Korean art department.

What lay behind Lee's extraordinary generosity? When his gift was announced at the museum, he explained: "It is a way of paying back to this community, this country. . . . This country gave me an education, a job, an opportunity to work with great engineers." The United States, he explained, helped with the modernization of Korea. The United States liberated Korea after World War II and provided aid that helped rebuild the war-torn country. American support provided the funding that enabled Lee himself to attend Vanderbilt University, where he received his postgraduate education.

Yet Chong-Moon Lee came late to the outstanding achievements that would enable such generosity and far-sighted commitment to the community—in fact, most of his wealth was made when he was already in his sixties. Though Lee was the descendent of a royal family, he was not a person of privilege in Korea. His father sold herbal medicine. Lee's two older brothers turned their father's herbal supply store into a small pharmaceutical business, but Lee became not a businessman but a school teacher and librarian. He remains an avid reader and a firm advocate of the written word. It is appropriate that his

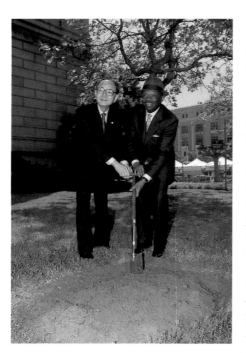

At the 1999 ground-breaking ceremony, Chong-Moon Lee and Mayor Willie Brown demonstrate the teamwork between the private and public sectors that brought the new Asian Art Museum to downtown San Francisco.

commitment helped to save the former main library building from disuse and deterioration.

When he was in his thirties his oldest brother died, and Lee joined the family business. His dedication, hard work, and resourcefulness caused the business to grow dramatically—but it also caught the attention of Korea's military junta, who tried to co-opt his skills. Lee refused to collaborate, and in 1970 he fled to the United States, where he experienced a mix of successes and setbacks. He began exporting American-made sports equipment to Japan, and the success of this venture bankrolled a move into rental properties and investments.

Then personal computers—still in their infancy—caught his eye, resonating with his background as an educator. He bought an Apple II for his daughter in 1980 and an IBM PC for his son in 1981. That started him on a mission to develop a computer plug-in that would combine the power of the PC with the ease of use of the Apple. It was a good idea but it was costly and time-consuming to bring to fruition. By the time Lee had a product ready for the market in the late 1980s, his venture, Diamond Computer Systems, showed a loss of $2.7 million, and life became difficult indeed.

"How can I describe to you how low I had sunk?" he says, recalling those dark days. "I got a notice from the post office that there was an important letter to be picked up. I was hoping it was a loan from a friend but—can you believe it?—I didn't have money to buy gas. I didn't even have money to ride the bus. So I went down to the local used car dealer and pretended I was interested in buying a car. I took it for a test drive, and the salesman was a little surprised when I asked him if we could stop by the post office. But the joke was on me. Instead of the loan, it was a notice from the IRS. I had not been able to pay payroll taxes for my employees for a year and a half, and I now owed $480,000 in taxes."

Lee dealt with the IRS in a straightforward fashion, admitting without hesitation that he owed the money. "If you are honest, if you open yourself to people," he says, "you will find many who will help you—even tax collectors." Today Lee is philosophical about the bad times. "If the weather continues to be fine 365 days a year, then the earth becomes a desert," he says. "Grass grows, trees bear fruit, flowers blossom because of wind and rain. All the rain, wind, and snow makes the earth lively."

Lee persevered. He turned his computer company around by focusing on multimedia and graphics. Renamed Diamond Multimedia Systems, it became one of the fastest growing companies in the country. After it went public in 1993, Lee sold three-quarters of his stock for $92 million. That is the fund from which most of his philanthropy has come, and the donation to the Asian represents an impressive portion of it.

Chairman of the boards of CM Lee & Company, LLC, and Diamond Multimedia, Lee has served as an officer and board member of Korean UNESCO and the Olympic Committee, as well as president of the Cycling Federation. In 1995 he established the Educational Technology Scholarship Program to bring Asian educators to the International Conference on Technology and Education. Currently, Lee serves as a board member of the American Red Cross, Santa Clara, and is a founding member and the board director of the Tech Museum of Innovation, San Jose.

Lee holds a Master of Business Administration equivalent from Korea University, a Master of Science in Library Science and Data Management from the George Peabody College at Vanderbilt University, and an LL.B. degree from the law school of Chung Ang University. He has received a number of accolades for outstanding leadership in business and civic areas, including the Key to the City of San Francisco; the Cyril Business Leadership Award from the San Francisco Chamber of Commerce; and the Excellence 2000 Award (as Asian American Man of the Year 1995) from the Asian American Chamber of Commerce, Washington, D.C. In 1993 and 1994 Lee was recognized as a finalist for *Inc.* magazine's Entrepreneur of the Year, Northern California region.

In making his remarkable gift to the museum, Lee sought to transform the institution and help it realize its full potential. The new museum at Civic Center will be a lasting testament to his generosity and foresight.

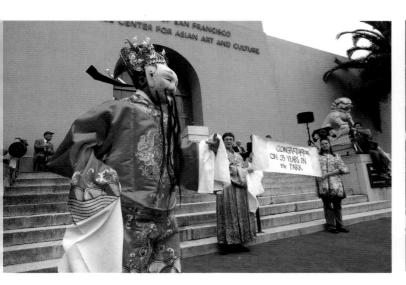

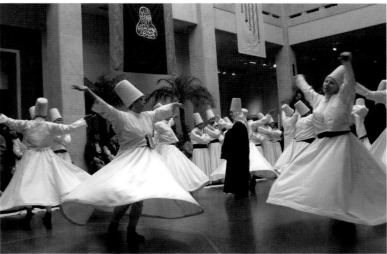

Final Days in Golden Gate Park

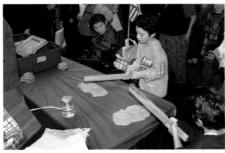

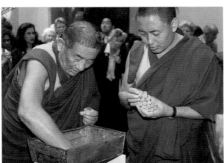

Five Final Days of Fun

Finally, in the fall of 2001, the Asian Art Museum closed to the public at its Golden Gate Park location in preparation for its move to Civic Center. From Wednesday, October 3, through Sunday, October 7, 2001, in recognition of this momentous transition, the museum held a celebration called Five Final Days of Fun, presenting examples of all the things it had become known for: great art, music and dance performances, hands-on activities, and demonstrations. Admission to the museum and its programs was free, and record crowds filled the building throughout the week. "Five Final Days" presented an opportunity for the museum to reach out to and thank its constituent communities from China, India, Japan, Korea, South Asia, Southeast Asia, the Himalayas, and West Asia. By sharing traditions and exploring new artistic directions, the museum continues to help bridge borders and promote understanding.

Moving and Storing the Collection

The museum has increasingly taken a leadership role in the field of preserving and conserving Asian art. The museum's move to Civic Center presented an opportunity to upgrade its storage conditions. With funding assistance from the National Endowment for the Humanities and the Institute of Museum and Library Services, the museum was able to develop a state-of-the-art storage environment that is well matched to the quality and importance of the collection it houses. Storage areas for textiles (which require low-light conditions) and metal objects (which require a low-humidity environment) were laid out separately from the main art storage area. A new system was developed that enables large, heavy sculptures to be stored upright. Specialized cabinets were manufactured for storing East Asian scroll paintings and Tibetan *thangkas* (sacred paintings on cloth). Many textiles previously stored flat in crowded drawers were rolled and suspended from conduits on cantilever textile racks.

Moving even one object as large as the museum's fifteenth-century Southern Indian granite sculpture of the bull Nandi, which weighs more than two tons, is a sizable undertaking. Moving fifteen thousand artworks ranging from tiny netsuke to massive stone statues, along with the offices of more than a hundred persons, a scientifically equipped conservation laboratory, decades of photographic and registration materials, a one-of-a-kind research library, and all of the other aspects of a museum as important and distinctive as the Asian—and then quickly reinstalling them in a new site—was a daunting task. Tracking, packing, crating, and moving the museum's collection was complicated by the closure of the de Young Museum at the end of 2001 and its ongoing demolition.

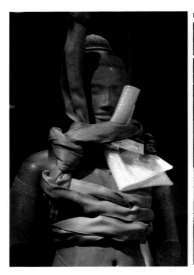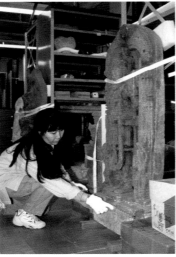

LEFT: An eleventh-century Cambodian sandstone sculpture of the Hindu god Shiva is prepared for moving.

CENTER: Registrar Sukie Lee measures an object as part of a thorough inventory and status assessment prior to moving the collection.

Demolition of the de Young Museum

In January 2002 internal demolition work began on the neighboring de Young Museum, which had been severely damaged in the 1989 Loma Prieta earthquake and was seismically unsafe. This condition had limited the museum's availability as a venue for touring exhibitions because of the loss of Federal indemnification. The closing and demolition of the de Young required many changes at the Asian, which had shared an entrance and infrastructure with its sister institution. A new entrance and shipping area had to be prepared, and heating, cooling, ventilation, telephone, and security system controls had to be shifted to the Asian Art Museum wing.

Around the beginning of April, demolition workers began removing sections of the de Young building, beginning at the north end and working toward the Asian. Palm trees in front of the two buildings were removed by the city's Parks department to a holding area for replanting when the de Young reopens. At the end of May, the de Young tower was taken down with a crane and wrecking ball, and later in the summer excavation for a new building, designed by architects Herzog & de Meuron, began. In the final months of 2002, Asian Art Museum staff left the park.

The Asian had moved on.

ABOVE RIGHT: Demolition of the de Young Museum began with the north wing. The central section of the building, containing the tower, was the last portion to be removed.

RIGHT: City workers removed palm trees from the de Young site for later replanting.

A New Home for Asian Art

WHEN PLANS FOR A NEW CITY CENTER were drawn up in the years following the great 1906 earthquake, a library building was considered a fundamental element. Opened to the public in 1917, the main San Francisco Public Library building—now transformed into the Asian Art Museum—was the first major project completed after the construction of a new city hall. It has been designated a contributory building to the historic Civic Center Landmark District, which like the Federal Triangle area in Washington, D.C., is regarded as one of the foremost beaux arts architectural districts in the United States. Allan Temko, the former architecture critic of the *San Francisco Chronicle,* called San Francisco Civic Center "the finest group of classical 'City Beautiful' monuments in the country."

City Hall and the New City Center

San Francisco's City Hall has resided in five different locations since the first English-speaking mayors took over from Hispanic *alcades* and governed from a rented building at Montgomery and Merchant streets (near the site of the present Transamerica Pyramid). From there City Hall soon moved to a couple of locations on Kearny Street, first at Pacific Street and next at Washington Street, where it occupied a converted theater and later expanded into a nearby gambling house. Many of its offices remained there through much of the rest of the century (the building at that site was replaced by a Hall of Justice).

In the 1870s, work on a new city hall building was begun at the current site of the Asian Art Museum. Although less than three decades had passed since the Gold Rush, the site was already considered historic, for it had been the location of a pioneer burial ground known as the Yerba Buena Cemetery, conveniently located near the old Mission Toll Road. The cemetery was inaugurated in February 1850,

> ... when the triangular plot of ground bounded by Market, McAllister, and Larkin streets, embracing thirteen acres, was procured. During the sickly season which followed, this new City of the Dead almost kept pace in population with the then distant city of the living. From the time that the Yerba Buena Cemetery was consecrated until the opening of the Lone Mountain cemetery, the number of burials amounted to seven thousand. Here lie, side by side, the rich and the poor—no stately obelisk marking the resting-place of the former, but to the living world, reposing as obscure as the latter. This grave-yard is a most forbidding spot to all who take a melancholy pleasure in seeing the homes of the departed, beautiful by reason of natural scenery, and beautified by the hands of the faithful mourner. The cemetery

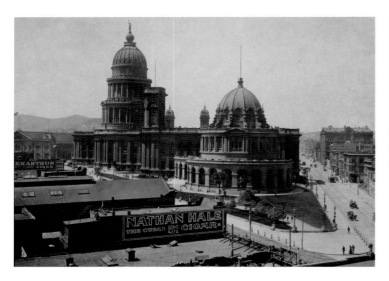
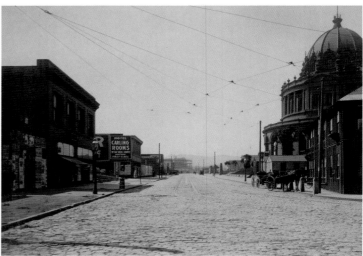

LEFT: City Hall in 1906, before the Great Earthquake.

RIGHT: Civic Center area, 1913.

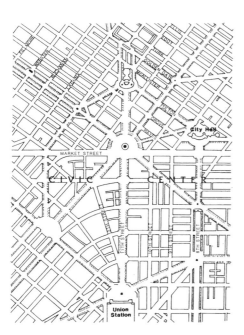

Daniel Burnham's plan for a new San Francisco Civic Center, 1905.

is situated in the midst of sand-hills, and surrounded by sand-hills, through the ravines of which the bleak western winds sweep terrifically during a great part of the year; the only vegetation, the stunted oak or dwarfish chaparral, scarcely less repugnant than the sand itself [from the *Alta California,* June 25, 1861].

Before construction on the new City Hall began in this unlikely spot, the cemetery's contents were removed, probably to the new City Cemetery (also known as Potter's Field), in use from 1868 to 1909 and extending north and west to the beach from 33rd Avenue and Clement. From there most of the anonymous remains would be moved again to various cemeteries in San Mateo County as the land-greedy city continued to grow. Some, however, were left behind, to be discovered during the retrofit excavation at the Palace of the Legion of Honor (the de Young Museum's sister institution under the umbrella of the Fine Arts Museums of San Francisco).

Removal of the dead had been no more thorough at Yerba Buena Cemetery than at City Cemetery. Bodies continued to be uncovered during the excavation for the new City Hall in the 1870s; as late as 2001, human remains were still being encountered, this time during seismic retrofitting of the former main library building for its transformation into the new Asian Art Museum—their discovery delayed construction as a forensic anthropologist analyzed them before they were turned over to the city coroner. Along with the bodies a single crude headstone was discovered; etched on the stone were the words "Sacred to the memory of . . ." The rest was lost.

The cornerstone of City Hall was inscribed with the date 1872, but the building was not fully occupied by the intended municipal offices until 1889, and it was still incomplete at the time of the 1906 earthquake. The gaudy, poorly constructed building failed to withstand the earthquake, and indeed much of the surrounding area needed to be reconstructed, as almost the entire area of the city east of Van Ness Avenue went up in flames.

Prior to the earthquake, former mayor James Duval Phelan, the spokesperson for a group called the Association for the Improvement and Adornment of San Francisco, had enlisted the influential urban planner Daniel Burnham to propose a new plan for the city that, it was hoped, would stimulate an urban renaissance and symbolize San Francisco's envisioned role as "the capital of an empire." Phelan's and Burnham's plan reflected the City Beautiful movement, which promoted beaux arts principles of design around the turn of the century. Responding to an ugly industrial urban landscape, the movement's proponents argued that such principles would elevate American cities to the level of their

European rivals and inspire civil loyalty and moral rectitude (ironically, much of the civic beautification was financed by industrial profits). City Beautiful activists espoused the virtues of urban parks such as New York's Central Park and San Francisco's Golden Gate Park (as mayor, Phelan had unsuccessfully sought to extend the Golden Gate Panhandle to Van Ness Avenue or beyond, which would, in effect, have connected Civic Center with Golden Gate Park).

The proponents planted trees and flower beds, and preached "the gospel of Beauty and the cult of the god Sanitation"; Burnham himself argued that "a lesson of order and system, and its uplifting influence on the masses, cannot be overestimated." They also encouraged cooperation between architects and artists in a variety of mediums, leaving a mark not only on architecture but also in the form of public sculpture, murals, and stained glass used in building facades and interiors.

Burnham had overseen the influential 1893 World's Columbian Exhibition, and he was also known as a leader in the design of skyscrapers (especially in Chicago). Influenced by Baron George-Eugène Haussmann's redesign of Paris and also by Pierre Charles L'Enfant's original design for Washington, D.C., Burnham proposed a city plan based on a radial design of boulevards and monuments emanating from a new urban center housing the city government buildings. "Make no little plans; they have no magic to stir man's blood and probably themselves will not be realized," urged Burnham. "Make big plans; aim high in hope and work, remembering that a noble, logical diagram once recorded will never die, but long after we are all gone will be a living thing asserting itself with ever-growing insistency."

Burnham's plan was announced in 1905. In April 1906, copies were printed and bound for distribution to the Board of Supervisors when, at 5:13 AM on the 18th, the city was shaken by the massive earthquake (estimated at 8.25 on the Richter scale) and then consumed by the even more damaging holocaust that followed (the earthquake broke gas lines, which led to fires being started; and water lines, which prevented the fires from being put out). Burnham's vision for the city remained a motivating ideal but one that went largely unrealized in the rebuilding that followed the earthquake (even the plan's most fervent supporters were reluctant to exercise the control over private property that the plan demanded)—with one exception. A new Civic Center would be constructed on City Beautiful principles. With the addition of an exhibition hall, library, and opera house, the area would be not just a government center but also a cultural one.

Yet a decade after the earthquake Civic Center was still a ruins. Suspicious of the city's notoriously corrupt government of that period, which had been rocked by revelations of graft, voters rejected construction bonds in 1906 and 1909; the failure of the latter marked the end of the Burnham plan for Civic Center. Not until the election of Mayor James Rolph, Jr.—better known as Sunny Jim—did the plans move ahead. Rolph served as mayor from 1911 to 1932, and his accomplishments included the Panama-Pacific International Exposition, the construction of Civic Center, the beginnings of Municipal Railway (MUNI) service, and an improved city water supply (at the cost of Hetch Hetchy Valley in the Sierra Nevada, which was dammed). In 1912, shortly after his election, Rolph adroitly convinced voters that a new Civic Center was essential for the success of the Panama-Pacific International Exposition that was planned for 1915. Rolph commissioned a panel of three architects, John Galen Howard, Frederick W. Meyer, and John Reid, Jr., to rework the plans and oversee the construction projects. The architects scaled down Burnham's "big plan," relying mainly on an 1899 plan by B.J.S. Cahill, a local architect. Cahill's plan had retained City Hall in its previous location, but the committee moved it to its present location at the west side of Civic Center to allow for a longer and grander approach from Market Street.

The new City Hall opened in 1915. It remains the foremost example of San Francisco beaux arts architecture. The architect was Arthur Brown, Jr., who also designed San

A Japanese wrestler and other members of the Japan delegation to the Panama-Pacific International Exposition, 1915. Intended to show that San Francisco was back on its feet after the 1906 earthquake, the Exposition gave a boost to Mayor Rolph's plans for a new Civic Center.

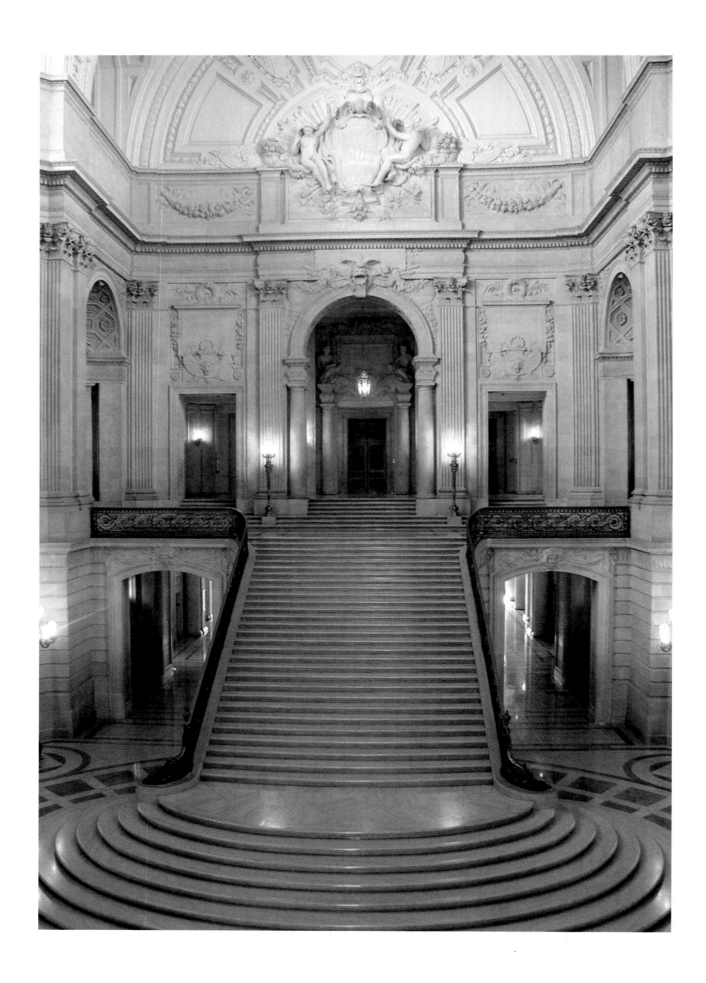

The spectrum of modern architecture. From left to right: Jean Louis Charles Garnier's beaux arts Paris Opéra (Palais Garnier), 1862–1875; Le Corbusier's modernist Villa Savoye, Poissy, France, 1928–1931; and one attempt at synthesizing classical and modernist elements, Ricardo Bofill's Espaces d'Abraxas housing complex (below), Marne-la-Vallée, France, 1978–1983.

< Restored City Hall interior featuring its monumental staircase.

Francisco's original Opera House, Veterans Building, Temple Emanuel, Coit Tower, and 50 United Nations Plaza. It was the pet project of Mayor Rolph, who liked to boast that its rotunda was "16 feet, 2 5/8 inches higher than that of the national capital." Today the height of City Hall—which has been designated a National Historic Monument—seems less impressive than the building's having taken only three years to complete, come in below budget, and returned some of the allocated funds to the city treasury.

In 1995, financed by a bond approved by city voters, a large project of base isolation seismic retrofitting—similar to the work done on the former main library building during construction of the new Asian Art Museum—was begun on City Hall, along with extensive historic restoration and the installation of new telecommunications and safety systems. Although not a major part of then mayor Dianne Feinstein's visionary 1987 plan for Civic Center, the renovation of City Hall was a dramatic expression of a new, comprehensive effort by the city to restore, improve, and revitalize the district.

Beaux Arts Architecture

The Beaux Arts Context

The end of the nineteenth century was an era of imperial aspirations. The United States had grown to be a force on both oceans, and some San Francisco leaders envisioned the city as the capital of its own West Coast empire. The 1906 earthquake created a blank slate for their ambitions. Big plans called for grand buildings, and beaux arts architecture expressed civic pride and prestige.

The beaux arts style in architecture, which flourished between about 1885 and 1930, takes its name from the École des Beaux-Arts (School of Fine Arts) in Paris. The school had been founded in 1648 to promote studies not just in architecture but also in drawing, painting, sculpture, engraving, modeling, and gem cutting. Committed to a classical approach to the arts based on the study of Greek and Roman masters, the school was a vigorous force in architecture throughout the nineteenth century. Its unique instructional regimen for the design of grand public buildings included study at the French Academy in Rome, where handsome examples of classical architecture were readily available. Inspired beaux arts architects created buildings that were both beautiful and functional, but in pedestrian hands the style could be lifeless. By the late nineteenth century, some innovative artists regarded the school's rigorous formal approach as stiff, stale, and outmoded. Nonetheless, it continued to represent "official" achievement in the arts, and it dominated the arena of large-scale public architecture.

Architectural details from San Francisco's historic Civic Center, showing the continuity of beaux arts elements in the architecture of several buildings. From left to right: City Hall, the new Asian Art Museum, Bill Graham Civic Auditorium, the Earl Warren California State Building, the Opera House, and the War Memorial Building (in the Opera House and War Memorial buildings, City Hall appears as a reflection).

The World's Columbian Exposition of 1893 in Chicago was a pivotal event in the promotion of the beaux arts style in the United States. It was a major influence on M.H. de Young and the museum he founded, and it gave life to the City Beautiful movement that inspired advocates for a new San Francisco civic center. Beaux arts architecture was made to order for the City Beautiful movement, for both represented a reaction against the grim late-nineteenth-century industrial landscape. Conservative beaux arts architect Jean Louis Charles Garnier, who designed the Paris Opéra, expressed such an attitude in 1886 when he complained about plans for the art nouveau–influenced Paris metro entrances, "The underground, in the eyes of the majority of Parisians, will be inexcusable unless it totally rejects any industrial characteristics and becomes a true work of art. Paris must not turn into a factory; she must remain a museum. Do not therefore be afraid to cast aside latticed beams and steel frames; recall stone and marble, bronze, sculpture, and triumphal columns." Similarly, a committee of beaux arts architects complained in 1889 about plans for the Eiffel Tower: "Is then the City of Paris to associate herself with the eccentric and mercantile ideas of a machine manufacturer, to dishonor herself and irreparably spoil her beauty? For the Eiffel Tower, which even commercial America would not want, is, make no mistake about it, a dishonor to Paris."

Not all beaux arts architects were so conservative. The essence of classical design is harmony, balance, and proportion, and these elements can be expressed in a variety of forms and materials. At the turn of the century, for example, French architect Victor Laloux combined modern metallic structures with beaux arts elements in his design for the Orsay train station—which architect Gae Aulenti would later transform into the Musée d'Orsay, just as she would transform San Francisco's former main public library building into the new Asian Art Museum.

Nonetheless, modernist architects after World War I—rallying against the restraints of tradition and reacting in part to the imperial undertones of beaux arts architecture—turned against the style. Frank Lloyd Wright, for example, dismissed beaux arts architecture as "Frenchite pastry." For half a century the modern style would dominate modern architecture, but gradually some postmodernist architects began to mix classical and modernist elements. Ricardo Bofill's Espaces d'Abraxas housing complex (1978–1983) near Paris, for example, combined classical form and structure with modernist materials and distortions. Other architects have varied the mix, some tending more to the classical and others to the modernist.

Characteristics of the Beaux Arts Style

Like the classical architectural styles that preceded it, beaux arts architecture was formal in presentation. But it was much more eclectic, and even baroque, than its predecessors in its mixing of forms from ancient Greece and Rome with those of the Renaissance. It favored stone and masonry buildings with varied finishes, which were highly ornamented with such flourishes as garlands, floral motifs, shields, and shells, reflecting a late-nineteenth-century taste. Windows and bays on massive symmetrical facades were defined by a profusion of oversized columns, piers, pavilions, and balustrades, often grouped in pairs. Expressive cornices and entablatures often underscored the formal elements of the architect's design. Monumental staircases were a common feature (both the Asian Art Museum and City Hall boast fine examples).

Because beaux arts buildings tended to be stately, expressive, and grand in scale, they were favored for train stations, such as Grand Central Terminal and Pennsylvania Station in New York City, and Union (North) and South Stations in Boston; performing arts centers, such as New York's Carnegie Hall and the San Francisco Opera House; museums, such as the Museum of Science and Industry and the Art Institute in Chicago, and the Metropolitan Museum in New York; libraries, such as the New York, Boston, and San Francisco public libraries; and government buildings—the clusters of beaux arts government and cultural buildings in Washington, D.C., and San Francisco's Civic Center are among this country's foremost examples.

The formality, precision, and symmetry of beaux arts architecture extended to gardens, parks, and city planning. Wide boulevards and green spaces were common features. This influence is visible in San Francisco's Civic Center Plaza, a central green space surrounded by five beaux arts or beaux arts–influenced buildings (City Hall, Bill Graham Civic Auditorium, the new main San Francisco Public Library, the new Asian Art Museum, and the California State Building). The original plaza was divided into quadrants bisected by an east-west walkway from Market Street with a pair of circular fountains on either side. Unfortunately, the plaza was reconstructed when the Civic Center Parking Garage was built underneath it in the 1960s (Allan Temko called the result a "concrete garage lid"). The paired circular fountains were replaced with a rectangular pool in the center of the square, obstructing the clear visual line that was fundamental to the Civic Center architects' original vision (and making the staging of events in the plaza difficult). The pool has been removed and new plans for Civic Center that will restore the harmony of the original conception are now being discussed.

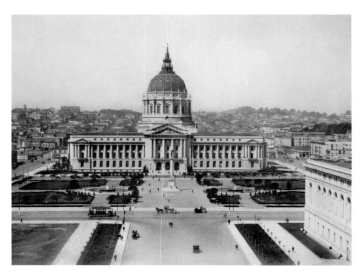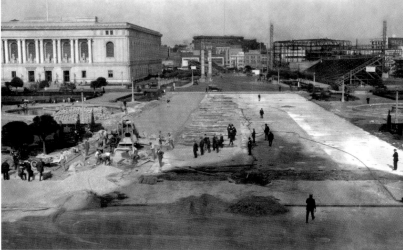

LEFT: Civic Center in the 1920s, looking west toward City Hall from Market Street. The former main public library building is on the right; the empty lot to the left is Marshall Square. The original division of Civic Center Plaza into four quadrants is visible in this photo.

RIGHT: Construction on and around Civic Center Plaza, 1920s. The only completed building visible in this view is the former main library building (now the Asian Art Museum).

Around Civic Center

Bill Graham Civic Auditorium

Exposition Auditorium (later Civic Auditorium and now Bill Graham Civic Auditorium), designed by a committee of architects led by Arthur Brown, Jr., was built for the Panama-Pacific International Exposition of 1915. Although City Hall was the first building to be designed for the new Civic Center, the auditorium was the first to be built because its construction was rushed to ensure completion in time for the fair. The auditorium occupies the south side of Civic Center Plaza on land formerly devoted to the Mechanics Institute Pavilion. The last use of the pavilion was as a hospital for those injured in the 1906 earthquake, but this use was short-lived, as the building was quickly consumed by fire in the aftermath of the quake. (The Mechanics Institute now is located at 57 Post Street, where it houses a comfortable library and a master-class chess facility.) Exposition Auditorium was a large building for its day, and it was the site of the Democratic National Convention in 1920.

The San Francisco Public Library

The former main library building followed in 1916 (the dedication ceremonies were held on February 15, 1917). A new main library building, designed by Pei, Cobb, Freed, would be erected on the south side of Fulton Street, opening in 1996. The library is discussed in subsequent sections.

The Earl Warren California State Building

On the north side of Civic Center Plaza, the Earl Warren California State Building, designed by Bliss & Faville, was completed in 1922; its construction was delayed by the World War I. It has been the home of the California Supreme Court and other state offices.

The Opera House and War Memorial Buildings

Near Civic Center, on Van Ness Avenue—the widest street in San Francisco because a broad swath was cleared there to stop the spread of the 1906 fire—is the site of several cultural and government buildings, including the Opera House (1931), the Veterans War Memorial Building (1931), and Louise M. Davies Symphony Hall (1980) and a new State of California Building (1986), both designed by Skidmore Owings & Merrill. The Opera House was once planned as a twin to the former main library building, to be located across from it in Marshall Square—the location now occupied by the new main library—

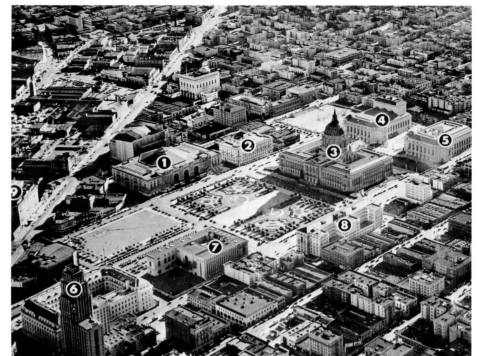

This photo of Civic Center in the 1940s was keyed to show significant buildings: Civic Auditorium (1); Health Center Building (2); City Hall (3); Opera House (4); War Memorial Building (5); Federal Building—the rectangular building behind McAllister Towers, now a student residence owned by Hastings School of Law (6); the former main San Francisco Public Library, now the Asian Art Museum (7); California State Building (8); and the Whitcomb Hotel (9). The empty lot to the left of the old main library is Marshall Square, now the home of the new library. The empty lot to the left of the Opera House is now the location of Louise M. Davies Symphony Hall.

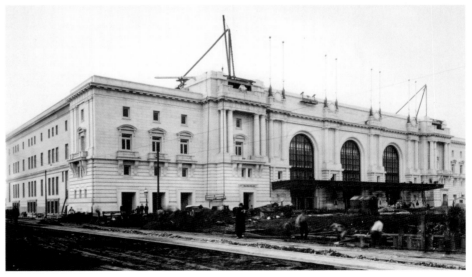

Construction of Exposition Auditorium (now Bill Graham Civic Auditorium), 1914.

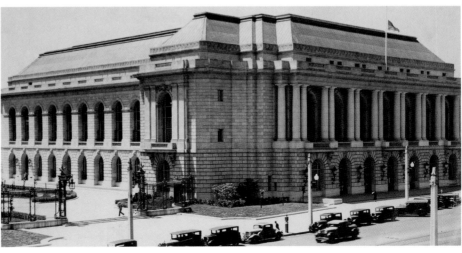

The Veterans War Memorial Building in 1936.

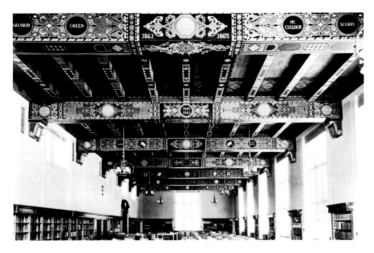

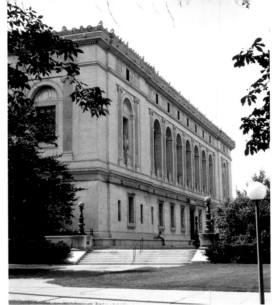

LEFT: Paul P. Cret, Library, now Main Building, University of Texas at Austin. Cret was one of the judges for the competition to select an architect for the San Francisco Public Library. Compare this library room with its decorative ceilings to the San Francisco library's reading room, p. 53, bottom right.

RIGHT: The Detroit Public Library, designed by Cass Gilbert in 1913. Gilbert was a judge in the competition to select an architect for the San Francisco Public Library, and the two buildings share many features.

but that plan was vetoed by Mayor Rolph as promoting "aristocratic pretensions." So the Opera House project was relocated to Van Ness Avenue, where construction was delayed for years by city politics and disputes about financing. The building was finally completed as part of a war memorial that included the companion Veterans War Memorial Building, where the San Francisco Museum of Art would open on the fourth floor in 1935. (The museum was renamed the San Francisco Museum of Modern Art in 1975 and moved to a new building on Third Street designed by Swiss architect Mario Botta in 1995.)

Following World War II, Civic Center was proposed as the site for the headquarters of the United Nations, which was signed into existence at the Opera House in 1945. San Francisco's role in the birth of that organization is commemorated today in United Nations Plaza, which extends east from the Asian Art Museum along Fulton Street.

The San Francisco Main Public Library

History of the Library

Thanks to a campaign launched by Andrew Hallidie, inventor of the cable car grip, the first San Francisco Free Public Library opened in 1879 in Pacific Hall on Bush Street between Kearny and Dupont (now Grant) streets. About a decade later it moved to the ill-fated City Hall building, where it filled the top floor of the McAllister Street wing. In the 1906 earthquake and fire, the building was destroyed, along with most of the library's collection. Assistant Librarian Joy Lichtenstein described visiting the ruins to determine whether anything could be salvaged: "We noticed first that the window weights had melted and were all running down the sides of the casements…. In the huge open stack room there was only a thin white ash where a hundred and sixty thousand books had been." Losses included a complete collection of the *Alta California* newspaper, old maps and other pioneer documents, and an original 1486 binding for a Bible printed by Paulus Florentius.

Some years before, the Andrew Carnegie Foundation had pledged $750,000 to help fund a new main library and several branches, but delivery of the funds had been delayed by city politics; the library now called on that pledge. While the library resided in a temporary home and worked on rebuilding its collection, plans were begun for a new civic center, and they moved forward in earnest after the election of major James Rolph, Jr., in 1911. Voters approved an $8.8 million bond measure for a new Civic Center in 1912. In 1913 a competition was announced to select an architect for a new library, to be located on the site of the old City Hall. Judges were former mayor James Duval Phelan, who had commissioned Daniel Burnham's ambitious plan for the district; Cass Gilbert,

an architect whose designs included New York's Custom House and Woolworth Building; and Paul Philippe Cret, a professor of architecture and graduate of the École des Beaux-Arts. Phelan, a leader of the City Beautiful movement in San Francisco, had seen in the earthquake an opportunity to improve the city: "Come at once!" he had telegraphed Burnham immediately after the earthquake. "This is a magnificent opportunity for beautifying San Francisco.... I am sure that the city will rise from its ashes, better, and more beautiful."

Six local architects entered the competition, and George W. Kelham was selected. Kelham had studied at the École des Beaux-Arts in Paris and then joined the firm of Trowbridge and Livingston in New York. After the 1906 earthquake he came to San Francisco to rebuild the Palace Hotel as part of the city's reconstruction program. Kelham would remain in the city until his death in 1936. His many commissions included the Standard Oil Building (1924), the Russ Building (1926), the Shell Building (1929), the Mother's Building at the San Francisco Zoo (1925), and the International House in Berkeley (1930). Kelham served as chief of architecture for the Panama-Pacific Exposition, and at the time of his death he was chair of the commission planning the layout for the 1939 Golden Gate International Exposition.

The selection of Kelham occasioned controversy. His design was quite similar to that of the Detroit Public Library, which was the work of Cass Gilbert (the facade of the Detroit library had itself been copied from that of the Boston Public Library). Paul Cret had been a judge for the competition that awarded Gilbert the Detroit commission. Furthermore, Kelham had employed one of Gilbert's draftsmen who had worked on the Detroit plans. The competition had the appearance of a set-up, and one of the losing candidates, Edgar Mathews (who was president of the State Board of Architectural Examiners from 1915 through 1918), sued the Board of Library Trustees for breach of contract and reimbursement of his expenses. But Mathews's complaint fell on deaf ears. The *San Francisco Chronicle* wrote in an editorial: "We must admit that the art of the architect is the art of plagiarism. There has been little new in architecture in the last hundred years—that is, [in] monumental architecture."

Ground was broken for the new library in 1915, and the cornerstone was laid in 1916. Library materials were moved by horse and wagon to the new building. In 1917 the library opened to the public with fanfare, and it was celebrated as one of the city's gems—but its luster quickly faded because of lack of support from the city. In her florid *History of the San Francisco Public Library* (1985), Jane Ferguson said that over the years the library was "the least burnished jewel in the City's proud cultural tiara." In 1926 a national survey found that San Francisco ranked last among major cities in library expenditure per capita, and things only got worse during the Depression and World War II. In the 1940s Moore S. Achenbach offered the library his extensive collection of prints—now at the Palace of the Legion of Honor—but in 1951, when the library proved unable to provide adequate care and presentation of the collection, he withdrew the offer. Similarly, the important Sutro Library collection was removed from the main library and relocated to the campus of the University of San Francisco in 1959. The library was understaffed and underfunded for book purchases, and the building itself was not adequately kept up. Even so, the collection had grown enough to create problems of storage and shelving. Nonetheless, efforts by Laurence J. Clarke, city librarian from 1945 to 1960, to increase the library's funding and to obtain additional space were repeatedly rebuffed.

There was little serious talk of expanding Civic Center until the election of Mayor George Christopher in 1955. The original vision for Civic Center had never been completed, and Marshall Square, the lot across Fulton Street from the library, was still unassigned to any major structure—it contained F.H. Happersberger's Pioneer Monument, which had been given to the city in 1894. (In July 1993 the monument was moved to Fulton Street over the protests of historic preservationists, who wanted it retained at its

LEFT: Workers removing books from the library's temporary quarters at Hayes and Franklin streets to be transferred by horse-drawn wagons to the new main library, 1917.

RIGHT: Laying the cornerstone of the library, April 15, 1916. Left to right: Library Trustee Joseph O'Conner, Mayor James Rolph, former Mayor and Hastings School of Law Dean Edward Robson Taylor, and John McGilvray, a stone expert who provided the granite for the cornerstone.

original site—and of indigenous people, who wanted it removed entirely.) One plan for Marshall Square proposed placing a courthouse there. Clarke, frustrated by the library's space limitations, was desperate to move. "I learned long ago," he told a *Chronicle* reporter, "that what was grandeur in 1917 is just so much waste space today." He made a counterproposal that called for converting the existing library building into a courthouse and building a new library in Marshall Square. But this effort, like his requests for increased funding, also failed. Once again, no action was taken. Marshall Square continued virtually unused, and the library continued its long decline and neglect—William R. Holman, city librarian from 1960 to 1967, called it "the most miserable library building in America," and his successor, John Anderson, agreed that it was "the worst metropolitan library in the country."

Civic leaders now halfheartedly pondered two proposals for improvement. One involved expanding the library at its Hyde and McAllister corner. The north wing of the building had essentially been left half-finished in the original construction because at that time the small library collection required only a portion of the building's available space. The back of the building had been finished with brick rather the granite used elsewhere. As early as 1917, a publication commemorating the opening had noted: "The main stack room has a capacity of 500,000 volumes when completely filled, and future additions may be made for a like number of volumes." The library leadership, however, had little faith in expansion, feeling that too much of the space in the building's central spine was unusable, and they clung to the hope of constructing a new, larger building at Marshall Square.

In the 1970s Major Joseph Alioto was persuaded to help secure a Housing and Urban Development grant for library planning and development. A feasibility study conducted by Arthur D. Little, Inc., recommended constructing a new main library building. But when faced with a competing proposal to put a new symphony building in Marshall Square, Mayor Alioto softened his support. Backers of the library then worked behind the scenes to secure the donation of a School Board property at Van Ness and Grove streets for the symphony—an opportune site opposite the opera house. As a result, Marshall Square remained available, but plans for a new library still dragged on. Staff morale was low. Street people had taken over the stairs and restrooms. In 1974 the *San Francisco Examiner* called the library "a public urinal with reading rooms attached."

As Mayor Dianne Feinstein was nearing the end of her term of office (1978–1988), she turned her attention to new proposals to expand and revitalize Civic Center. Feinstein cautiously encouraged a proposal from the Friends of the Library to construct a new

library building at Marshall Square and to move the Museum of Modern Art into the former main library building; Recent success in public fundraising for the new symphony building (Davies Symphony Hall opened in September 1980) raised hopes that private donations could help to fund the new library, and the Friends of the Library launched a successful campaign that relied on support from a broad cross section of library users. The Friends also commissioned several usage studies, including a 1987 study by Skidmore Owings & Merrill that concluded that the former main library building would be best suited for a museum; this study proved to be influential in deciding the agenda for Civic Center.

Meanwhile, the San Francisco Redevelopment Agency had developed a plan for the Yerba Buena district south of Market Street. As part of that plan the Museum of Modern Art committed to relocate to a space at 151 Third Street, where it would open in 1995 in a new building designed by Mario Botta—it was no longer a candidate for the library building. Aware of the Asian Art Museum's space limitations in Golden Gate Park, the mayor's office called Judith F. Wilbur, chair of the Asian Art Commission, to discuss the possibility of the Asian's relocating, which would require raising funds for renovation and adaptation of the building. Within weeks the museum had made a preliminary commitment to fundraising and moving. In 1987 the mayor submitted a comprehensive Restoration Plan for Civic Center—including the move of the Asian to the library building—to the Board of Supervisors. The supervisors approved the plan, and the Asian Art Commission accepted the city's proposal to move the museum to the Civic Center. The plan to move became official in May 1988.

"The Asian Art Museum is truly one of the world's greatest treasures and one of San Francisco's premier attractions," said Feinstein. "The magnificence of its collection is an unparalleled glory, and, in my mind, there is no more ideal location for its display than Civic Center." Mayor Feinstein's support for the Asian Art Museum as a cornerstone of Civic Center is consistent with Avery Brundage's original vision of the museum as a "bridge to understanding" between East and West. "As mayor," she said, "I proposed locating the Asian Art Museum in Civic Center as testimony of San Francisco's lasting connection to the rich artistic heritage of Asia. By locating there, the museum will lock in forever the historic relationship of San Francisco as a gateway to the Pacific Rim."

Historic Features

The library building is shaped like an **E** with a long base stroke and a short cap stroke. The vertical mainline of the **E** represents the west wing, which faces Civic Center Plaza across Larkin Street. The base stroke of the **E** is the longest side of the building, which runs along Fulton Street; the central spine of the building, containing the most elaborate elements, is the midstroke; and the north wing, which housed the library stacks, is the cap stroke, equal in length to the midstroke.

Exterior Facades

The Larkin and Fulton Street facades constitute the public face of the building, while the McAllister Street facade is the working face. The rear of the building, facing Hyde Street, was left relatively unfinished to allow for future expansion. The beaux arts exterior echoes that of City Hall, but it is more restrained, in deference to that structure. Like other Civic Center buildings, the library respects the cornice height of City Hall, giving the district a unified appearance.

The exterior design emphasizes the highly formal Larkin Street facade, which includes the main entrance. The facade is divided into seven regular sections, or bays. The outer two of these project to form pavilions, framing the composition. Each of the three horizontal layers has a distinct appearance, and the divisions between them are marked by floral ornamentation and cornicing. The lower portion serves as a base, while the second

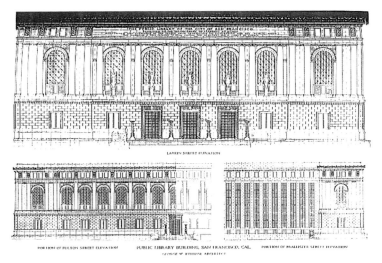

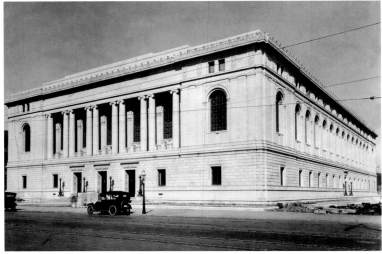

story features dramatically recessed arched windows flanked by Ionic columns and fronted with balustrades. Not long after the opening of the library, classical statues by Leo Lentelli (1879–1962) were added to the middle-layer windows. The statues represented Art, Literature, Philosophy, Science, and Law. They were originally conceived as temporary embellishments and have been removed. The third story, which is much lower in height than the other two, contains a frieze where an incised inscription read:

> The Public Library of San Francisco
> Founded AD MDCCCLXXVII Erected AD MDCCCCXVI
>
> May This Structure Throned on Imperishable Book Be Maintained and
> Cherished from Generation
> To Generation for the Improvement and Delight of Mankind

A panel overlaying the original inscription reads: "Asian Art Museum / Chong-Moon Lee Center for Asian Art and Culture."

The long Fulton Street facade emphasizes the east-west axis of Civic Center. The central Fulton Street axis divides the district into northern and southern halves, and points directly toward City Hall from Market Street. This facade is divided into fifteen bays and, like the Larkin Street facade, it is framed at either end with projecting pavilions. At the center was an entrance decorated with figures from Greek mythology. This now serves as an element in the museum cafe's outdoor dining area.

A pavilion on the west end of the simpler McAllister Street facade provides a transition to the Larkin Street front and leads to seventeen narrow bays eight levels in height, the levels corresponding to the original library stacks. Small windows on this facade lighted the stacks. The small Hyde Street facade (only a single bay in width), which is similar to that of the Larkin and Fulton Street pavilions, marks the limit of the original granite facing.

Entryway, Vestibule, and Lobby

The Larkin Street entryway is signaled by granite steps leading up to a broad plaza. From the plaza, more granite steps lead up to the main entrance. Upon entering, the visitor arrives at the historic vestibule and lobby. The two spaces, which form a unit, are separated by arched openings. Their floors are made up of square travertine pavers along with rose marble bands. These rooms are inevitably high-usage areas, and the floors suffered considerable abuse during the building's decades as a library. They were worn, stained, and cracked. Holes had been drilled in many locations. Here and there bolts protruded.

The Asian Art Museum invested considerable effort to restore the travertine floors, which once again form the appealing entryway of the original construction. Niched walls and vaulted ceilings decorated with floral ornaments were composed of a combination of travertine and faux travertine (plaster). The original surfaces have been extensively repaired and restored.

Monumental Staircase and Loggia

The monumental staircase was the central focus of the Kelham design. The staircase lies on the building's central axis, leading east from the main entrance on Larkin Street up to the grand hall. It is composed of three segments: a mere five steps to a first landing and then two long flights of steps separated by a second landing with built-in benches on either side. The benches, landings, treads, and risers are all made of Italian travertine stone.

A second-floor corridor surrounded the staircase. Crowned by a long, barrel-vaulted faux-travertine ceiling punctuated by small rectangular skylights, the corridor formed a spatial unit with the staircase; it was used mainly to travel between the grand hall, where the library kept its card catalogues, and the reference room (now the Korean art gallery). The corridor floor was made of rose marble slabs with travertine borders. The outside walls contain monumental travertine pilasters that divide the north and south walls into ten-foot bays. The bays once housed inspirational inscriptions. In 1936 they were filled with paintings on canvas by Gottardo Piazzoni. The Piazzoni paintings were removed for conservation and are being relocated (see p. 61).

In Kelham's original design for the main library building, long, irregularly shaped, and rather grim brick-walled light wells separated the building's central spine from the north and south wings. The cavernous light wells were needed to allow light and air into the building, which was underserved by mechanical systems.

Samsung Hall

The monumental staircase leads to the grand hall (called the "delivery room" by the library staff) on the second floor. Here, library patrons in the building's early years would submit requests for books to be retrieved from the stacks. Later, the room housed the library's card catalogues. It is, in the context of the overall architectural plan, a large room, measuring about sixty feet square with forty-foot ceilings. Like that of the lobby, the floor was covered with travertine pavers, and like that one it required extensive restoration—there were nine large cracks from three to eight feet in length, not to mention

LEFT: Ascending the staircase, December 1960.

RIGHT: Looking east across the monumental staircase to the entrance to Samsung Hall.

numerous smaller ones. The floor was discolored and mutilated with electrical boxes and holes for wiring. The grand hall is now known as Samsung Hall.

Reading Rooms

The second-floor rooms along the Larkin and Fulton wings were a focus of the architect's attention. They are distinguished by decorative ceilings divided by heavy plastered beams painted with polychrome floral and geometric patterns; these divide the ceilings into bays corresponding to large, arched windows. Both the ceiling and the windows were retained in the design of the new museum and extensively restored during the process of construction.

Seventy-foot-long, twelve-foot-high murals by Frank Vincent DuMond (1865–1951), originally painted for the Panama-Pacific International Exposition, were installed in the south wing Reading Room and the west wing Reference Room. The murals, entitled *Leaving the East* and *Arrival in the West,* depicted the journeys of the pioneers. They have been removed and restored.

Library Inscriptions

Incised inscriptions decorate many of the library's surfaces. Interior inscriptions tend toward moralistic and inspirational epigrams, while exterior inscriptions consist of lists of authors' names. The inscriptions are thought to have been chosen mainly by Edward Robeson Taylor, former mayor of San Francisco, dean of Hastings School of Law, and a library trustee; a bust of Taylor was placed at the entrance to the library. The inscriptions have been retained in the new building.

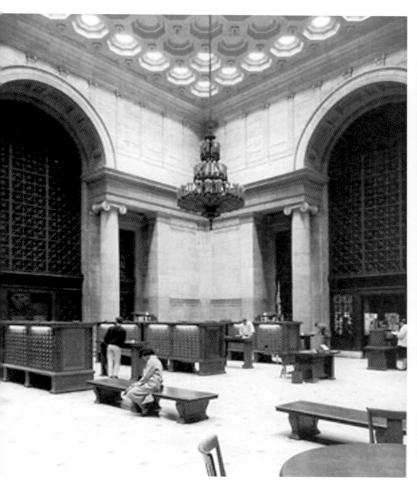

TOP LEFT: Samsung Hall as the library's "delivery room." To the right of the card catalogues is the entrance to the reading room on the south wing. The historic features of the room, including the ornate chandelier, have been restored.

TOP RIGHT: The south light well. Despite their name, the light wells were inefficient sources of illumination—because of their narrow, irregular shapes, they actually contained some rather dark and gloomy areas.

RIGHT: The reading room of the library in the 1960s

BELOW: One of the library's many inscriptions.

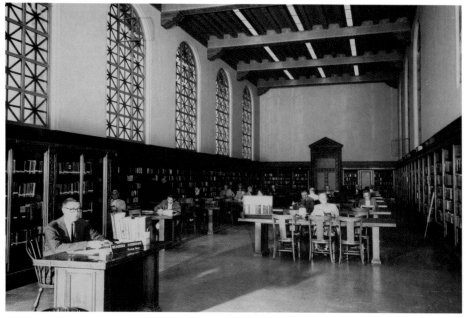

Selecting an Architect

Selecting an architect to address the formidable challenge of converting the 1917 beaux arts library building into a modern museum was a long and complicated process, subject to the constraints and regulations of the City and County of San Francisco. Avery Brundage's original gift of art that established the museum was made directly to the city, and the Asian Art Commission is a governmental body. As a result, the selection process was exceptionally rigorous. It was, for example, subject to review by the Human Rights Commission, which required that the review of candidates "include among consultant selection panelists individuals who are women and minorities." By the same token, each applicant was required to submit detailed forms attesting to compliance with city requirements, which include regulations regarding nondiscrimination, domestic partner benefits, and such legislation as the Sunshine (requiring public disclosure) and Burma (prohibiting contracts with Burma's State Law and Order Restoration Committee) ordinances.

On August 9, 1996, the museum formally announced the building project. Requests for proposals were made available to more than two hundred interested parties. On September 26, a two-part presubmittal orientation meeting, attended by nearly two hundred people, was held at the museum and the construction site to brief applicants on the museum's collections and programs, along with architectural and construction issues involved in the adaptation of the library building. Fourteen teams submitted outstanding proposals, which by October 15 were winnowed to a short list of six candidates by a technical committee composed of architects, engineers, preservationists, landscape architects, and others. Members of the selection committee then traveled to seven cities—Los Angeles, Saint Louis, Chicago, New York, Paris, Barcelona, and Londons—visiting up to four museums a day to evaluate the work of the finalists; at least two or three examples of each candidate's work were visited by the committee. Extensive reference checks complemented the on-site visits, and interviews with each candidate were held in November.

Candidates were ranked according to eleven key criteria, including: experience with exhibition facilities with a particular emphasis on museums; experience renovating and rehabilitating significant historic structures; experience with major seismic renovation projects, preferably involving base isolation; experience with major capital projects, applicable codes, and City and County of San Francisco review and permit processes; experience demonstrating interior design creativity within relatively severe architectural constraints; formulation of an appropriate and diverse team bringing together the appropriate set of specialties, expertise, and experience; the qualifications and commitment of staff who would be performing design and contract administration; design and engineering excellence; financial solvency and stability; experience with integrating building systems within a historic structure; quality of construction contract documents; and demonstrated ability to perform on budget and on schedule.

Though each of the finalists was highly qualified, the team of HOK/LDA/RWA was the consensus choice. The joint venture included as architects Hellmuth, Obata + Kassabaum, Inc.; LDA Architects, Inc.; Robert B. Wong; and Dott. Arch. Gae Aulenti. Forell/Elsesser Engineers, Inc., were charged with the building's seismic retrofitting. On December 3, the choice was approved by the Asian Art Commission.

"The selection process was thorough and rigorous," said Judith Wilbur, head of the New Asian Project Committee. "All of the finalists were extremely qualified—there wasn't a candidate who was less than first-rate. All had the technical acumen and ability to handle the project. The selection was made on the basis of a winning combination of a proven track record in renovating historic buildings, experience with major seismic projects, and exceptional skills in converting interior spaces." "All of the finalists were excellent," agreed Johnson S. (Jack) Bogart, chair of both the Asian Art Commission and the Asian Art Mu-

Left to right: Mark Otsea, Senior Vice President,
HOK; Gae Aulenti, design architect; Mark Paia, HOK.

seum Foundation, "but there was never any real doubt about the architect. We were unanimously in favor of Gae Aulenti."

"We face the challenge of creating an inspirational showplace for an unparalleled collection of precious art, while protecting and preserving the integrity of a historic design," declared museum Director Emily Sano when the selection was announced. "The architectural team we have selected represents the finest international experience in both the design of exhibition facilities and the rehabilitation of historic structures."

HOK, LDA, and Wong

Hellmuth, Obata + Kassabaum (HOK), an international design firm with twenty-three offices worldwide—including its San Francisco office, which was established in 1966—brought substantial experience in historic renovation and restoration to the New Asian project, as well as museum experience and an exceptionally innovative and creative approach to design. HOK orchestrated the largest preservation project in the history of Saint Louis, converting its 1894 Union Station into a mixed-use development. HOK also provided master planning services for the "adaptive reuse" of the Tacoma (Washington) Union Station, a beaux arts building listed in the National Register of Historic Places. Other HOK projects include the National Air and Space Museum in Washington, D.C., and the San Francisco Museum of Modern Art, with Mario Botta as the principal design architect.

Local architects included LDA Architects, Inc., and Robert B. Wong AIA Architects/Planners (RWA). LDA is a San Francisco firm with significant experience in the downtown area, including the programming and design of the Yerba Buena Gardens Children's Center and the rehabilitation and seismic retrofitting of the YWCA Clay Street Center, a historic structure designed by Julia Morgan. RWA is also a San Francisco firm with substantial; ackground in the design of public facilities; its projects have included the addition and alterations to the Presidio Officers' Club.

Forell/Elsesser Engineers, Inc., brought state-of-the-art expertise to the seismic retrofit and design of the base isolation system. Forell/Elsesser's extensive experience in historic renovation included work on the San Francisco and Oakland city halls, among other significant projects.

Gae Aulenti

There is much more to Gaetana Aulenti than the conversion of a Parisian train station into the Musée d'Orsay (1980–1986), the project that her name evokes for many people. True, that was—like the Asian Art Museum project—a stunning conversion of a declining beaux arts building into a modern museum. In fact, it was nominated as one of the most important works in the previous three years by the International Union of Architects, and for it Aulenti was named Chevalier de la Légion d'Honneur by the French government. But Aulenti's distinguished career in design (Herbert Muschamp, architecture critic of the *New York Times,* called her "the most important female architect since the beginning of time") includes not only a long list of impressive architectural projects but also significant achievements in industrial, furniture, lighting, interior, exhibition, graphic, and stage set design.

Built for the 1900 Paris World's Fair on the site of the early-nineteenth-century Palais d'Orsay, the Gare d'Orsay was the headquarters of the Orleans Railroad Company. By 1939 the station had become obsolete—its tracks and platforms were too short for modern trains. It became a mail center, a site for special events, and a stage set (most famously in Orson Welles's film adaptation of Kafka's The Trial). It was not until the 1970s that long-held plans for transforming the building into a national art museum moved forward in earnest with the decision to focus on Western art from 1848 to 1914. The museum's collections were drawn mainly from the impressionist collections of the

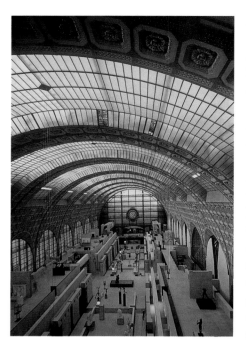

The Musée d'Orsay in Paris, formerly a beaux arts train station, was transformed into a museum by architect Gae Aulenti.

Musée Galerie Nationale du Jeu de Paume, along with works from the Louvre and the National Museum of Modern Art. Perhaps the biggest challenge faced by Aulenti was to create a unified presentation within such a large building (more than two hundred yards long and eighty yards wide). To solve this problem, she chose a homogeneous stone covering for both floors and walls. She also created a multiplicity of galleries in different styles and shapes, so that the visitor is not forced to pass through a succession of cookie cutter exhibition spaces. Through means such as these, she brought the large space of the former station down to size.

Finding an innovative solution to an architectural problem was nothing new for Aulenti. Born in Palazzolo dello Stello, Italy, in 1927, she graduated from the Milan Polytechnic School of Architecture in 1954 and established a private practice in Milan, which has remained her principal base. She was one of a group of young people influenced by the postwar Italian architect Ernesto Rogers, with whom she worked on the magazine *Casabella Continuita* from 1955 to 1965, handling graphic design and page makeup. She also taught with Rogers at the Milan School of Architecture from 1964 to 1967. Rogers was one of the first to explore in depth the question of contemporary architecture's relationship to urban traditions and contexts. Aulenti has continued to explore this theme, designing buildings that reflect the complexity and density of distinctive elements within an urban setting.

In 1964 Aulenti won first prize at the Milan Triennial for her work in the Italian Pavilion. Her *Arrivo al Mare* featured mirrored walls decorated with cutout silhouettes of women, an element inspired by Picasso's figures. She would serve on the executive board of the Triennial from 1977 to 1980. In 1972 she participated in the show *Italy: The New Domestic Landscape* at the Museum of Modern Art, New York, contributing a divided room punctuated by pyramidal shapes at the corners. In an accompanying essay she explained that her object was to explore the interaction between objects and architectural space. She sought to "achieve forms that could create experiences, and that could at the same time welcome everyone's experiences with the serenity of an effortless development."

Aulenti began working on theater set designs around this time, often collaborating with the director Luca Ronconi at the Prato Theater Design Workshop. In 1979 the Padiglione di Arte Contemporanea in Milan staged a show devoted to her.

Aulenti's work in the 1980s included several large-scale museum projects, most of which, like the new Asian Art Museum project, involved the adaptive reuse of historic structures. In addition to the Musée d'Orsay, she designed the Contemporary Art Gallery at Centre Pompidou (1982–1985) in Paris, renovated the Palazzo Grassi from an eighteenth-century Venetian palace (1985–1986), and created the Museu Nacional d'Art de Catalunya from the former National Palace, which had been built for the 1929 Barcelona International Exposition (1985).

Aulenti has taught and lectured throughout Europe. Her awards and honors include the Grand International Prize for Italian Pavilion XIII Triennale (1964), the Ubu Prize for the Best Italian Stage Design (1978), the Medaille d'Architecture from the Academy of Architecture (1983), the Josef Hoffmann Prize from the Hochschule for Angewandte Kunst (1983), the title of Chevalier de la Légion d'Honneur conferred by the President of the French Republic (1987), the title of Commandeur dans l'Ordre des Arts et Lettres conferred by the Minister of Culture of French Republic (1987), citation of "the re-function of Gare d'Orsay" as among the ten most important works in the past three years by the XVI Congreso de la Union Internacional de Arquitecto (1987), the title of Dean of Architecture from the Merchandise Mart of Chicago (1988), and the Special Prize for the Culture conferred by the president of the Consiglio dei Ministri of the Italian Republic (1989).

Gae Aulenti always observes and examines the location of her assignment before beginning work. "The main problem," she has said, "lies in the interpretation of the

confines of a project." She has described her working process as consisting of three distinct stages, First, she performs an analysis of the project's contexts and foundations. Second, she synthesizes the various elements, discarding or disregarding what is arbitrary in a project and unifying the essential elements. According to Aulenti, "there is always an interaction between objects of design and architectural space." The final step she calls the *prophetic function*. In this phase she envisions and actuates the work as a personal and contemporary expression of a shared cultural tradition.

Gae Aulenti on the Asian Art Museum

In October, 2001 Tim Hallman of the Asian Art Museum engaged in an illuminating discussion with Gae Aulenti about her approach to transforming the former main San Francisco Public Library building into the new Asian Art Museum:

Gae Aulenti.

Can you describe the most intriguing aspects of designing a new home for the Asian Art Museum?

The conversion of the former main library into the new Asian Art Museum has been one of the most challenging projects of my career. To design a museum in an existing building means dealing with many constraints—on the one hand, I had to consider the rules set by the existing structure; on the other hand, I had to meet the requirements of the new, completely different function. But first of all it was important to have a new vision for the new museum. Because the needs were so complex, it was necessary to keep a strong vision of the project. We could not design this renovation in pieces, by meeting single detailed requests, because in this way it would have been impossible to achieve a good architectural result and satisfy the program.

When did you first conceive of your design for the building?

When I visited the old main library for the first time in 1996, I thought that the building was very closed and gloomy, while a museum had to be a place full of light and air and be"transparent" to help orient the visitors. It was very clear that we had to maintain some historical parts, the lobby, the central stair, the Loggia and the grand hall. This was the central core of the old building and it had to remain the core of the museum—but with the aim of integrating the old architecture with the new one.

How was your vision for the building formed?

I have taken into account all the requests of the Asian Art Museum. The museum asked for open public space, education space, 45,000 square feet for special exhibitions and for permanent collection galleries, and then a cafeteria and museum store. They also wanted easy circulation, natural light, and friendly and elegant interiors. The first step has been to extend the two courts along the whole building to bring in a lot of natural light. In this way, we have created a large, single piazza. In the next phase of the project, in agreement with the director of the museum, Emily Sano, and with all the curators, our concept for transforming the former library into the new Asian Art Museum was aimed at finding the best possible synthesis and integration of three main points: the building, the museum programs, and the collection.

When directing the adaptive reuse of a structure, does the building inform the design or does the design inform the building?

When designing an adaptive reuse, the existing building is the foundation ground, together with the context—the place where the building is. So I start from the observation of the building; of course I mean the structure and not the appearance of the building. The other focal points in a project of adaptive reuse are the new function of the building, the new content, and who will be using all this.

Are there certain philosophies or principles that guide you?

There are three important principles that have guided my work, three basic skills from which architecture derives. The first is *analytic ability*, in the sense that we must know how to

study and recognize every different kind of architecture, to create unique, specific solutions with respect to their context, their foundation place. The second is *synthetic ability*, knowing how to make the necessary synthesis to give priority to the major architectural principles, to disregard what is only arbitrary in a project. The third is a *prophetic capacity*, that of artists, poets, and inventors. And, if cultural tradition is not something that can be passively inherited but something created day by day—as Eliot says—this third capacity can only be an aspiration. An ambition to create a continuity in culture, to build its forms, in a personal but always contemporary way.

The building was once the city's main public library and now will be a museum of Asian art. Please tell us how your design addresses the building's new purpose.

The starting point was based on the concept that converting a library into a museum means radically changing the attitude of the users of the place. People go to a library to find books and documents and then quietly sit down at a table in the most concentrated way possible. Their attitude is therefore completely *static*. On the contrary, people visiting a museum go to see and enjoy a collection, something unique that they will discover during a tour. This attitude is absolutely *dynamic*. In our building it was necessary first of all to create open spaces with natural daylight to help visitors' orientation and their best perception of the works of art.

The new Asian Art Museum is your first project in the United States. Have you discovered any major differences between working in Europe and in the United States?

A major difference between working in Italy and abroad, for example, here in the United States, is the possibility to build after winning a competition, as happened with the Asian Art Museum. Another difference is the tendency—very strong here in America—towards detailed specialization. In Europe it is different, and I have personally always tried not to fall into specialization, but rather to face all the different aspects of architecture: industrial design, interior design, exhibition design, and stage design.

San Franciscans are proud of their history and institutions. What have you learned about this city from working on this project?

This project is part of an ambitious program to upgrade the Civic Center area, the "historical" part of San Francisco, where the main political and cultural institutions are located. I had to relate a beaux arts building from the European tradition with an Asian art collection—one of the most important in the world. And this has been an occasion for me to learn how this city is an important cultural crossroads, a melting pot of different cultures living together while keeping their own identity, and also how crucial the role of private citizens is for artistic patronage and the support of public works.

There are numerous museum construction projects currently underway throughout the world, including several here in San Francisco. What separates the new Asian Art Museum from other projects in the city?

I think I have described how the new Asian Art Museum project is a special and complex one. Just think of the high technological level of the seismic strengthening system we have adopted. But more than that, I think that this project is special because it is part of another important plan—a fascinating cultural concept, the extraordinary American idea of creating a unifying history for a "young" nation while enhancing the heritage of each culture that has contributed in building this common history. And I am deeply honored to take part and play such an important role.

Making It Real: The Building of the Museum

The museum's design and construction teams were challenged to modernize the beaux arts building while respecting its essential historic form. The design had to account not just for the display of thousands of unique artworks but also for the many additional functions required of a museum today. Classrooms, studios, and modern electronics systems, along with increased space for gatherings, performances, and festivals, reflect the museum's educational mission. Visitor amenities such as shopping and food services were

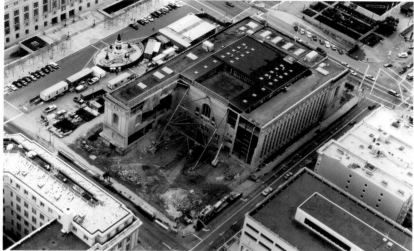

LEFT: Construction begins on the new third floor.

RIGHT: The museum in April 2000, showing temporary bracing and the removal of old, seismically unsound brick walls.

also required, as were facilities for a significant library of materials on Asian art and culture, a photographic studio, and an expanded and upgraded conservation facility. All of these features and more were needed to make the new Asian Art Museum a true center for the study of Asian art and culture.

The New Asian Project Office

To oversee the work of converting the library building, the museum established a separate project office, headed by Langston Trigg in the initial phases. Trigg's first steps included reviewing previous seismic and architectural studies, completing a physical inventory of the site, and helping to develop the Request for Proposals to launch the architectural selection process. In February 1998 James C. Killoran was hired as project director. His experience as executive director of the Committee to Restore the Opera House was invaluable, but the museum project proved more complex, time-consuming, and expensive than the Opera House renovation. "That project was to restore, seismically strengthen, and technically update an opera house, which remained an opera house," Killoran explained. "With the former main library, the function has changed. We've gone from a library to a museum, and the criteria for success were entirely different."

The Construction Team

In 1999 the joint venture of Lem Construction, Inc. (LCI) and DPR Construction was appointed construction manager for the New Asian Project. LCI, which held the majority interest in the joint venture, was known for the quality and reliability of its work in the San Francisco Bay Area, while DPR, one of the largest contractors in the United States, brought expertise and experience in constructing large, complex projects. Mayor Willie Brown hailed the selection as "an unprecedented joint venture by two renowned construction firms that will culminate in the rebirth of San Francisco's Civic Center Plaza," adding that "the fact that one of them is an Asian company represents the city's commitment to seeking diversified talents for important projects." The selection of LCI/DPR was consistent with the museum's commitment to engage a maximum of local small businesses throughout the project. Altogether, more than fifty trades were involved in the construction of the new Asian Art Museum. The principal contractors included the following:

> Architects: A joint venture of Hellmuth, Obata + Kassabaum, Inc., with Lem Design Associates and Robert B. Wong, Associates; the joint venture in association with Dott. Arch. Gae Aulenti, FAIA

Left: A partially completed base isolator, with steel deck, framing and connection to an existing building column. Each of the 204 base isolators contains 48 alternating layers of steel and rubber disks sandwiched between top and bottom steel plates.

Right: Preparing the foundation slab for the installation of base isolators. After the base isolators were installed, a new concrete floor was installed about five feet above the foundation site.

Historical Architect: Page & Turnbull
Structural Engineering: Forell/Elsesser Engineers, Inc.
Subconsultants: OLMM Structural Design
Engineers: Tennenbaum-Manheim Engineers
Mechanical Design: Mazzetti Associates
Electrical Design: Pete O. Lapid & Associates
Geotechnical Engineering: Treadwell & Rollo
Soils Engineering: Olivia Chen Consultants
Plumbing and Fire Protection: Mechanical Design Studio
Design Engineering: Avery Miller
Construction Management: LEM/DPR a joint venture
Structural Steel: Bostrom Bergen
Structural Concrete: SJ Amoroso
Mechanical and Plumbing: Marelich Mechanical
Electrical: E. J. Scott
Demolition: Aman Environmental
Isolator Manufacturer: Dynamic Isolation Systems
Roofing: Lawson Roofing
Sitework: Malcolm Drilling

Seismic Retrofitting

The library building was founded on concrete footings bearing on dense sand dunes. It was supported by a riveted steel frame encased in brick masonry in-fill or unreinforced concrete fireproofing. The infill acted as sheer walls, providing limited resistance to lateral movement. In 1992 Rutherford and Chekene, consulting engineers, completed a seismic upgrading study of the main public library building. As a result of that study, it was apparent that the building would require substantial earthquake retrofitting for any public use. The north wing of the building, which had housed the library stacks, was seismically the most vulnerable. Its independent steel frame was simply bolted to the envelope of the building, and this section experienced the worst damage in the Loma Prieta earthquake of 1989.

For the Asian Art Museum, earthquake standards would have to be much higher than for most buildings. Its unique and often fragile artworks—not just an irreplaceable cultural resource but also the city's most valuable asset, apart from its real estate—de-

manded a structure that could withstand earthquakes as strong as that of 1906 with less than one percent damage. That meant seismic isolation at the foundation along with sheer wall strengthening.

Seismic isolation involves the placement of base isolators—essentially specialized shock absorbers, each weighing more than five thousand pounds—under bearing walls and columns. The isolators absorb energy and equalize its effects so that the building responds to impact as a single unit. In order to install the isolators and give them room for movement in the event of a stress to the building, a moat—one thousand feet long, ten feet deep, and five feet wide—was dug around the perimeter of the building. Two hundred four 3-foot-tall isolators were installed in place of the old, inadequate supports. The load was transferred to the spool-like, rubber-centered, and metal-based isolators by releasing six bolts each from 510 locking plates. The base isolation and seismic retrofitting of the building was the most time-consuming and expensive part of the renovation. It took three years from start to finish and cost more than $50 million.

Mural Restoration

A major feature of the historic spine of the building was a set of murals painted by Gottardo Piazzoni (1872–1945) to decorate the second-floor Loggia that surrounds the central staircase. When the Asian Art Museum began its building program, the restoration and relocation of the Piazzoni mural cycle became a contentious issue.

Piazzoni was an influential early-twentieth-century California painter of romantic figures and landscapes. Born in Switzerland, he emigrated to California with his family in 1887, and grew up on the Monterey Peninsula south of San Francisco. Piazzoni studied art at the San Francisco School of Design, and returned to Paris to continue his study of painting at the École des Beaux-Arts in 1895.

When the main San Francisco Public Library building was completed in 1917, the Loggia was enclosed on its north and south sides by walls punctuated with niches measuring eleven feet high by seven feet wide. The niches were filled in with thin plaster walls attached to an exterior brick wall by metal rods. In the 1930s the Library Commission raised funds to fill the Loggia niches with paintings, and they chose Gottardo Piazzoni, the most highly regarded local painter of the day, for this commission.

The murals Piazzoni completed for this commission were not frescos (painted directly on the plaster of the niches), but rather works on canvas that were pasted onto the plaster walls. Piazzoni designed the murals as two landscape series, each consisting of five panels, entitled *The Land,* a representation of the California hills around Monterey, and *The Sea,* a view of a stretch of ocean along the same coast. As pure, nondidactic landscape murals, they are rare among the works of their time. Piazzoni was proud of this commission and endeavored to completely fill the Loggia spaces with painted canvases. In 1945 he completed four additional canvases intended for the northeast and southeast corners of the Loggia. Although these paintings, called *The Mountain, The Forest, Night,* and *Dawn,* were not installed in the library during Piazzoni's lifetime, they were finally installed by members of the Piazzoni family in 1975.

In 1987, when the Asian Art Museum was offered the main library building as a future home, concern for the murals was voiced from many quarters. As a result of a city bond issue passed in 1988 to build a new facility to house the library across Fulton Street in Marshall Square, that building was already under construction, and the library chose to leave the murals behind when it moved to its new location. In 1991 Kathy Page, chief of facilities development for the library, stated that the library had "seriously considered moving them to the new Main." But, she said, "we just don't have a lot of room for that in the new building."

The paintings had suffered noticeable abuse over the years, including scratches, tears, graffiti, and layers of dirt and grime. Many historic preservationists, art historians,

61

and conservators preferred to see the paintings restored and kept in their original place. Those who were concerned with construction, however, argued that the paintings had to be removed for their own safety. The 1992 study undertaken by Rutherford and Chekene, Consulting Engineers, emphasized that, no matter what the final design of the building, the in-fill brick walls of the light courts—to which the Piazzoni paintings were attached—had to be removed. The unreinforced walls presented a falling hazard in the event of an earthquake, and they had to be demolished and replaced. Since the paintings would not survive the demolition, the report recommended that "the murals be dismounted and safely stored for the duration of the construction work."

Transparency of the interior of the building, site lines for orientation, and free flow of light were fundamental to Gae Aulenti's concept for the transforming the dark, passive library building into a bright, dynamic museum. Asian Art Museum leaders supported the architect in her vision of opening up the Loggia niches like windows onto the light courts and establishing a visual and conceptual relation between the Loggia and the central piazza she created below on the first floor around the base of the monumental staircase. The museum staff saw in the niches the potential for much-needed additional display space for its collections. Therefore, the museum committed to safely removing and restoring the paintings, and finding an appropriate new home for them.

Removal of the murals was an important piece of the total plan for the building the museum presented to the San Francisco Planning Commission in 1997 and 1998. On December 10, 1998, the Planning Commission approved that plan by a 6-to-1 vote. The commission also approved the project's Supplemental Environmental Impact Report (SEIR) and granted a Certificate of Appropriateness. On January 25, 1999, the Board of Supervisors approved the Planning Commission's recommendations, representing the final step in the city's approval process.

The museum now had the necessary permits to continue with the rehabilitation and adaptive reuse of the library building but the San Francisco Architectural Heritage Foundation filed a lawsuit in February 1999 to bar removal of the murals from the building. On May 27, 1999, San Francisco Superior Court Judge David Garcia ruled that the museum's plan complied with local historic preservation laws and state environmental protection statutes. Finally, the museum could proceed with its ground-breaking ceremony and the initiation of its construction process.

Besides the Piazzoni landscapes, the library reading rooms were home to two huge murals (forty-seven feet long by twelve-feet high), also painted on canvas, by Frank

DuMond. The DuMonds were produced for the Panama-Pacific Exposition of 1915 and later given to the library. These compositions of families moving across a western landscape with wagons, horses, and cows, were meant to commemorate the pioneer spirit and the movement west.

Both the Piazzoni and the DuMond murals were safely removed following strict professional standards by a team of experienced conservators, all of whom were American Institute for Conservation fellows. The team was advised throughout the process by a second team of senior conservators including Perry Huston, an independent conservator from Fort Worth; Albert A. Albano, executive director for the Intermuseum Conservation Association, Oberlin, Ohio; and Andrea Rothe, senior conservator for special projects at the J. Paul Getty Museum in Los Angeles. The Piazzoni paintings underwent restoration in the conservation studios of the three-person team that removed them: the Scott Haskin studio in Santa Barbara; the Jim Alkons studio in Sacramento; and the Susan Blakely studio in Skaneateles, New York.

As the paintings were being removed, the Asian Art Museum formed a panel, composed of two commissioners, a representative of the San Francisco Art Commission, and three community representatives to consider proposals for relocating the murals. Suggestions included the lobby of the Earl Warren California State Building on McAllister Street, which housed the California Supreme Court, and the soon-to-be-renovated San Francisco Ferry Terminal Building on the Embarcadero, among others. Finally, the panel accepted a proposal from the Fine Arts Museums of San Francisco to take custody of the Piazzoni murals for the new de Young Museum, which was being designed by the Swiss architects Herzog & de Meuron. It was recommended that the two primary landscape cycles be placed in a large room on the ground floor of the new de Young building. This space would be freely available to the public and it would not require the use of space designated for the de Young galleries. This plan won the support of the Asian Art Museum's panel and satisfied those who wished to see the murals installed in a museum for the enjoyment of the public.

New Functionality: A Working Museum

The new building's dramatic architectural features and finishes and its exhibition and programming spaces strike the eye and capture the imagination. But behind the scenes an enormous amount of work has gone into making the former library building function as a modern art museum.

The building houses not only the galleries and collection storage but also the museum's administrative offices, a library, a conservation laboratory, a preparators' shop, a photography studio, three multipurpose classrooms, an educational Resource Center, a store, and a restaurant, as well as such features as a Japanese teahouse, an outdoor space reserved for a garden, and a Himalayan *mani* wall. Samsung Hall, located at the center of the building, showcases live demonstrations, hands-on art activities, and self-paced learning activities, as part of a comprehensive program called *AsiaAlive*, which helps visitors gain a greater appreciation of Asian art and culture.

All of the library's systems were below the current standards for a public building, and had to be brought up to code during the renovation. With seven different levels on the first floor, for example, it fell far short of disabled access standards. It had no air conditioning system, yet climate (temperature and humidity) control is essential for protecting objects with strict parameters of atmospheric tolerance. None of the building's mechanical and electrical systems were salvageable. New electrical, plumbing, telephone, computer, heating, ventilation, and air conditioning systems had to be run through the framework of the existing structure as well as through the new building features designed by Gae Aulenti, which was a major challenge. For example, the new third floor in Aulenti's design is set off from the outside wall, which makes running systems through the walls in

the traditional vertical manner impossible, and a horizontal delivery system through the flooring had to be adopted.

The Ground Floor

The first floor of the museum has been converted by Gae Aulenti into a public *piazza,* a space where people can gather, orient themselves, plan their visit, and enjoy the museum's amenities. In addition to exhibition and programming spaces, the first floor houses a 1,700-square-foot museum store, a cafe featuring an outdoor dining terrace overlooking the Fulton Street mall, an outdoor space reserved for a garden, and a Himalayan mani wall donated by Richard C. Blum and the American Himalayan Foundation. *Mani* is short for "Om ma-ni pad-me hum," the six-syllable prayer to Avalokiteshvara, the bodhisattva of compassion. Mani walls consist of piled-up boulders and slate pieces carved with prayers or images of Buddhist deities. They are usually found on mountain passes, often at sacred spots or in dangerous locales. The slate mani stones in the museum's wall are the work of the stone carvers of Nupri, a region in Nepal near the Tibetan border. These stones were specially commissioned for the museum by the donors.

The Upper and Lower Levels

The upper and lower levels of the museum, which are closed to the public, contain the behind-the-scenes elements needed to bring exhibitions, programs, and amenities to visitors in the museum's public spaces. The lower level includes a modern conservation laboratory for protecting and conserving the collection. The lab has common areas for the three main specialties: textiles, paintings and works on paper, and other objects. A skylight and other light sources allow conservators to check repairs under a variety of lights, which is an aid in color matching. The conservation area also includes a fumigation chamber and an analytical lab, including an X-ray room, for characterizing the materials and the fabrication methods of objects.

Art storage facilities on the lower level have been designed to meet the highest conservation standards, providing climate control and protection from earthquake damage, as well as ease of access. Separate rooms have been allocated for exhibition storage, for loans and pending acquisitions, and for metals, textiles, and other materials; there is also a supervised examination room for the benefit of visiting scholars. Design of the storage spaces was constrained by low ceilings, shear walls, pillars, piping, and floor hatches allowing access to the base isolators. To maximize the use of space, modular high-density mobile storage cabinetry was installed. Storage cabinets were manufactured by Delta Designs Ltd. of Topeka, Kansas, and affixed to mobile carriages produced by Spacesaver Storage Systems, Inc., of Fort Atkinson, Wisconsin. The storage fixtures were manufactured from chemically inert, noncorrosive materials and custom designed to house such Asian art objects as handscrolls and hanging scrolls, *thangkas* (sacred paintings on cloth), garments and textiles, folding screens, and stone sculptures. Stationary cabinets were specified for objects unsuited for movable storage because of their fragility. Archival storage boxes were custom-made to house newly acquired collections of Indonesian rod puppets and Japanese bamboo baskets (see p. 30) along with prints and other works on paper already in the collection.

The lower level also includes a variety of workshops, security features, a modern photographic studio, an expanded preparators' shop for building display fixtures for exhibitions and creating seismic mounts for artworks, and the kitchen and staging areas for the restaurant and store. Shipping and receiving are facilitated through new lower-level access on the Hyde Street side of the building.

The museum's top floor includes its administrative and curatorial offices, as well as the museum's library, which contains thirty thousand specialized titles. The library is not open to the public, but it is available to visiting scholars upon advance request.

Construction on the north court.

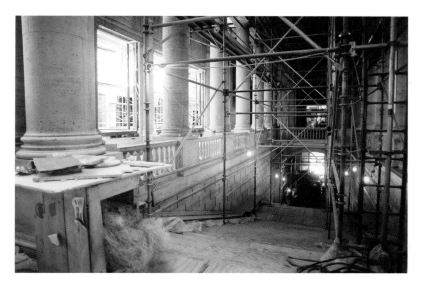

The library under construction. The Loggia and monumental staircase as seen from Samsung Hall.

New Architectural Highlights

"We're preserving the building but giving it a new heart. Now there will be an explosion of light."

—Gae Aulenti

Gae Aulenti's design for the Asian Art Museum has revitalized the structure by creating a new heart for the building while respecting its historic elements and framework. "Our concept for transforming the library into the new Asian Art Museum," she explained, "aims to find the perfect synthesis and integration of three main points: the collection, the program, and the building. The design recognizes the fundamental difference in the uses and expectations of libraries and museums. The library served the focused and concentrated interaction between the individual and the written word, while the museum now serves the energetic interaction between the individual and the panorama of art and culture represented in the collection, which requires space, light, and the best possible perception and orientation for museum visitors."

An indoor sky-lit court, incorporating the prominent entrance and grand staircase, provides a dramatic focus for the new museum's central space. Reworked interior walls allow views into galleries, creating a sense of openness and orientation as visitors circulate through, above and around the court. The rehabilitation leaves the beaux arts exterior essentially unchanged (though cleaned and restored), while the conceptual design retains the historically significant architectural spaces and details of the interior, including the entrance, grand staircase, Loggia and Samsung Hall, vaulted ceilings, skylights, inscriptions, molded plasters, light fixtures, stone floors, and other elements.

First-Floor Piazza

The key elements of Gae Aulenti's conception come into full view on the building's ground floor. The historic entrance opens onto a newly created interior court—an expansive public space brightened by natural light from two banks of skylights—which serves as the museum's lobby and primary gathering spot for tours, school groups, and other visitors. Open sight lines through the museum store visually connect the north and south courts. The aim, according to Aulenti, has been to create "a large, single piazza" on the model of Italian village design; at the center of the piazza is the historic staircase, with the museum store underneath and Samsung Hall overhead. The creation of a unified ground floor substantially helped to achieve her goals of opening up the building and creating focal points and vistas. The old library first floor was a hodgepodge of seven different levels and

a variety of narrow corridors and small rooms that were not coordinated to work with one other as a unit.

The first floor now houses eighty-five-hundred square feet of special exhibition galleries, three multipurpose classrooms, and a drop-in educational Resource Center to support the museum's highly regarded public programs. The ground floor also incorporates visitor amenities such as the 1,700-square-foot museum store and a cafe featuring an outdoor dining terrace overlooking the Fulton Street mall.

Skylights

The skylights are not only one of the most striking features to greet the visitor upon entering the building, but they are also one of the fundamental building blocks of Gae Aulenti's overall plan for integrating the building's elements. In place of the bleak, irregularly shaped, brick-walled light wells of the library, she has created new open spaces between the central spine and the north and south wings. The massive skylights that top off the new open areas are designed in a V shape so that they reach into the interior of the building and open it up to a flood of light. This allows the light to penetrate throughout the building, eliminating the "tunnel" effect that would have resulted from conventional skylights at the roof level. The skylights are hinged for movement in case of seismic activity. A unique moveable carriage device provides access for cleaning the glass, and a drainage system has been installed at the base of the V.

One of the most remarkable experiences in the new building is simply to stand on the stainless steel bridges with the sky appearing overhead through the skylights, with views into the galleries and down into the main court, and with the activity of the city visible through the glass curtain at the east of the building.

Escalator

A striking two-story interior-exterior escalator—which extends 115 feet from the rear of the central court on the first floor through a glass-enclosed curtain along the outside of the building—acts as a dramatic means of escorting visitors to the galleries on the second and third levels. The fifty-foot-high glass curtain continues the architect's twin emphases on light and orientation; a similar glass wall in the north court unifies the conception and reinforces these goals. The escalator offers views of the city and, back through the glass curtain, the second-floor galleries.

The escalator's steel framing is painted a blue-green color inspired by Gae Aulenti's fascination with the unique qualities of the sunlit San Francisco sky. The escalator carries visitors to a platform where, after passing through a small orientation space that explains the gallery layout and the major culture areas, they can enter the South Asian suite to begin the recommended tour of the galleries.

Third Floor

Gae Aulenti's innovative design for the museum creates a new third level by splitting the library's former 31-foot-tall reading rooms and stacks into two separate floors that serve as gallery space for the museum's collection.

The galleries display more than twenty-five hundred works from the museum's collection—more than double the number of objects that were on view at the Golden Gate Park facility. Spread over twenty-nine thousand square feet in thirty-three separate galleries, the treasures on view—colorful paintings, ancient stone and bronze sculptures, intricately carved jades, delicate ceramics, embroidered textiles, and much more—are complemented by state-of-the-art interpretive displays and programs, offering visitors a comprehensive introduction to all the major cultures of Asia.

The new third floor, like the second floor below it, is shaped like a squared-off U—three sides of a rectangle that opens to the east. To best follow the recommended

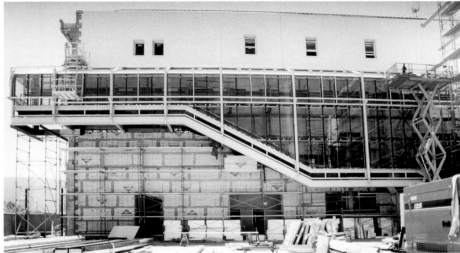

visitors ride the glass-enclosed escalator directly to an orientation space located at the east end of the south arm of the U on the third level. Visitors travel clockwise through this U, then, at the far end of its other arm, descend to the second floor and move through the galleries in the opposite direction.

The third level contains the galleries displaying works from India, Southeast Asia, Persia and West Asia, the Himalayas, and China; the Chinese galleries continue on the second level. On the south and west wings, the third level is recessed from the exterior walls, allowing unique views of the second level below (and enabling glimpses of the upper level's historic ceiling from below).

Second Floor

The second floor houses part of the museum's Chinese art collection, as well as galleries dedicated to the collections of Korean and Japanese art. The second level is also home to the 1,200 square-foot Atsuhiko Tateuchi and Ina Tateuchi Foundation Gallery. Located in the southwest corner, Tateuchi Gallery is a special exhibition space that provides the museum's curators an opportunity to examine common themes among objects within the museum's collection. The artworks on view in the Tateuchi Gallery will change on a regular basis—approximately every six months—allowing the curators to explore various themes and create interesting juxtapositions.

The unique angles of the gallery ceilings echo the lines of the V-shaped skylights above the courtyards. (In the north wing angled ceilings also have been created on the third floor.) Through means such as this the architect has unified the interior space of the building.

The central focus of the second floor is Samsung Hall. With its generous dimensions, high ceilings, and rich architectural detail, the hall serves as the locale for exciting public presentations such as *AsiaAlive*—an ambitious new program of live performances, artist demonstrations, and hands-on, interactive activities structured to engage visitors of all ages. After hours, Samsung Hall serves as the primary rental space.

After experiencing the galleries and Samsung Hall, visitors may return to the first-floor central court via the monumental staircase. Through openings onto the former interior light wells, the Loggia surrounding the upper end of the staircase is visually tied to the court, as well as to the second-and third-floor galleries, contributing to the museum's sense of openness and integration. The Loggia serves as an exhibition space addressing issues of Asian trade and exchange.

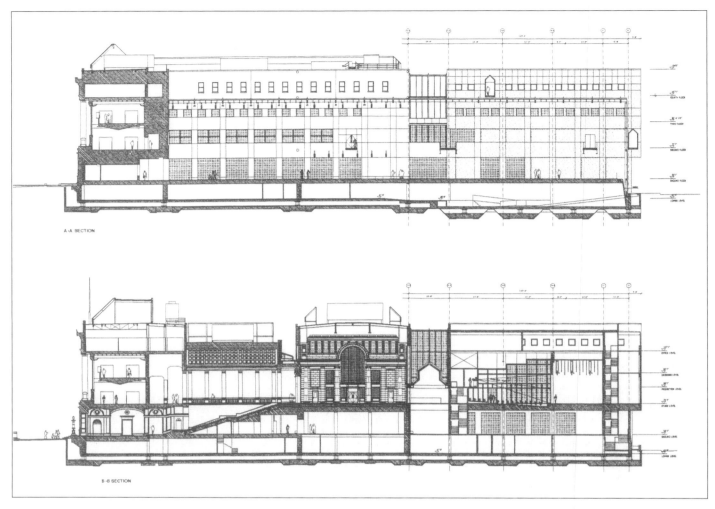

A-A SECTION

B-B SECTION

Top: Preliminary architectural cross-sections prepared in 1999.

Bottom left: City Hall viewed across Civic Center Plaza.

Bottom right: An open-air market adds a festive tone to Civic Center.

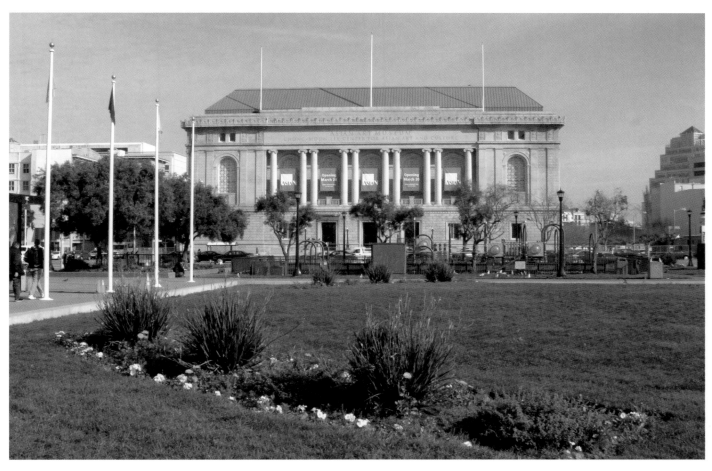

The Asian Art Museum today, as viewed from Civic Center Plaza.

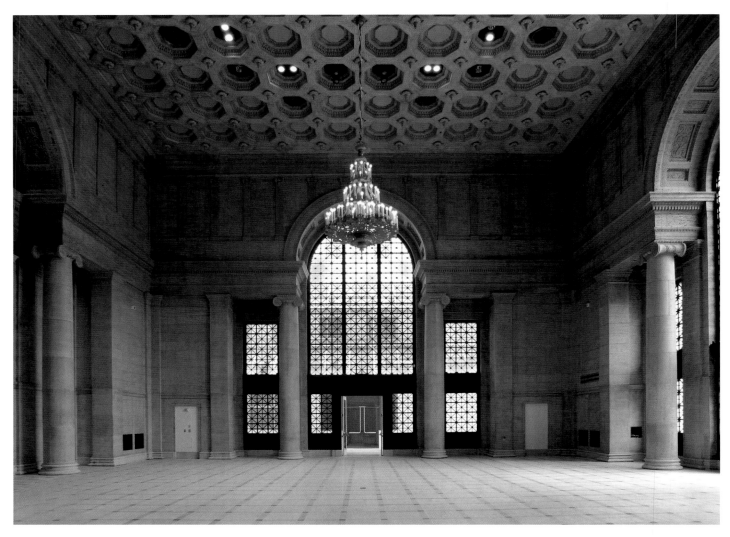

Samsung Hall. The hall has been restored and now serves as
the home of a series of live performances, artist
demonstrations, and interactive activities called *AsiaAlive*.

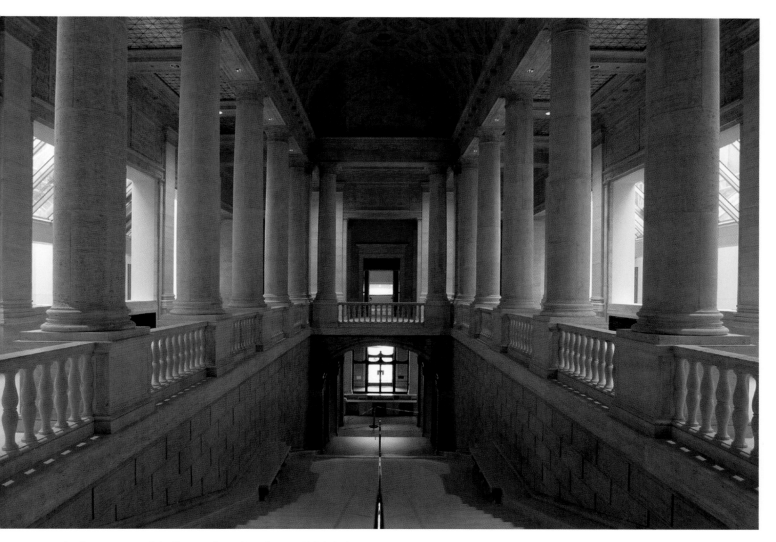

Looking west toward the Korean galleries from Samsung Hall. Light from the skylights fills the north and south courts on either side of the Loggia.

A detail from a restored historic ceiling, which can be viewed
from the South Asia galleries on the third floor.

This view of South Court from the Loggia shows >
the infusion of light provided by the skylights.

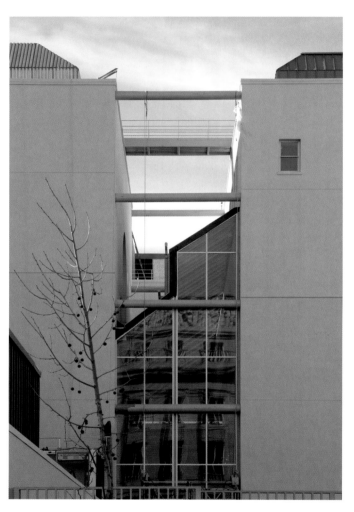

North Court viewed from Hyde Street.

Samsung Hall viewed from Hyde Street.

The massive skylight is the most >
dramatic feature of North Court.

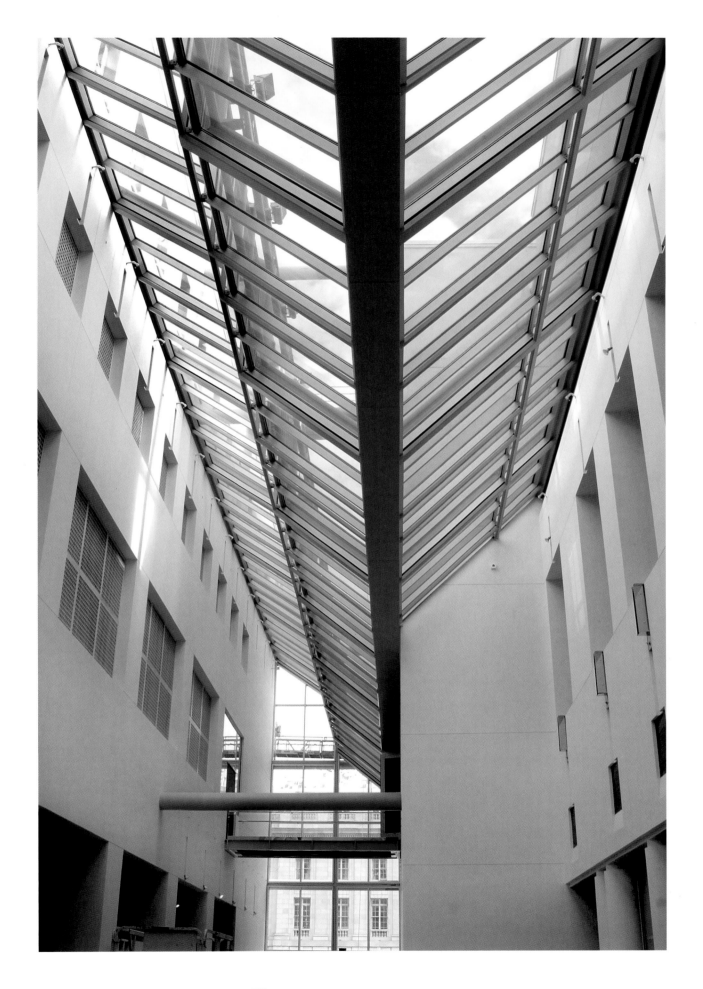

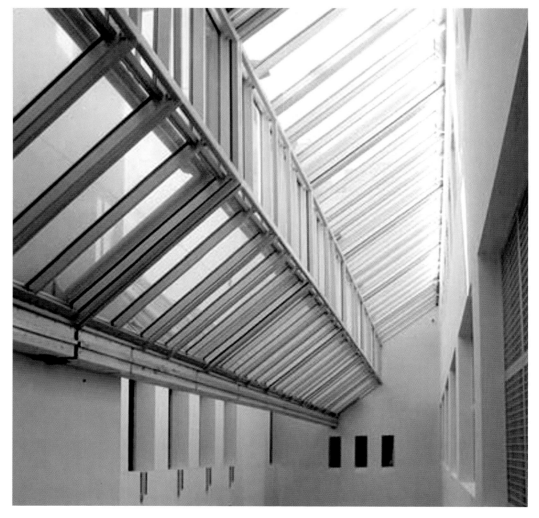

The shape of this skylight detail is echoed in
some of the gallery ceilings.

From the escalator visitors can look back into >
South Court or out to the surrounding area.

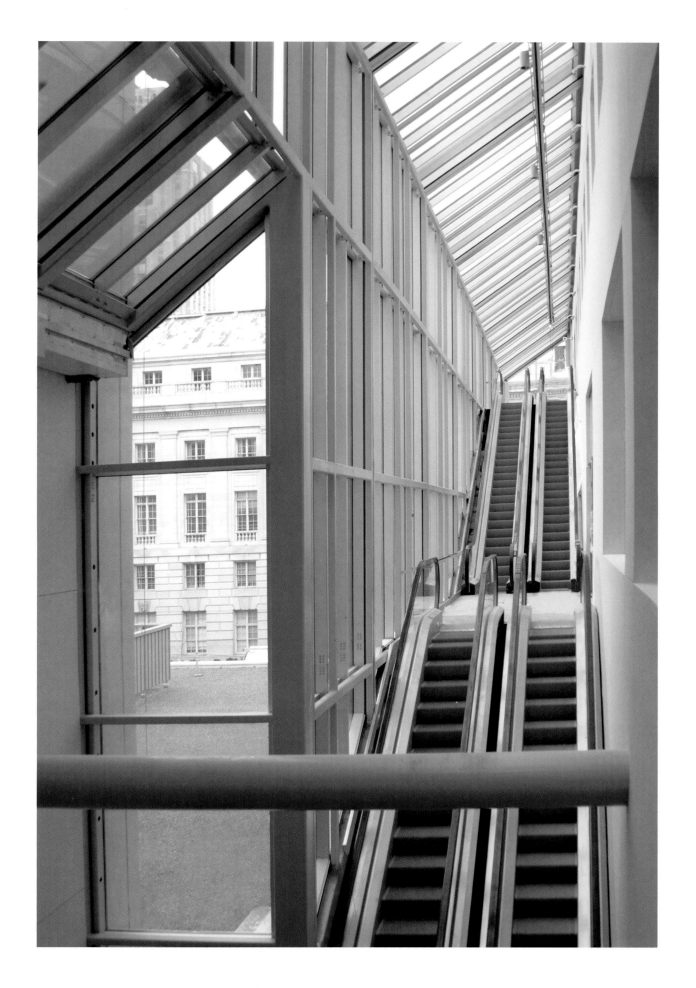

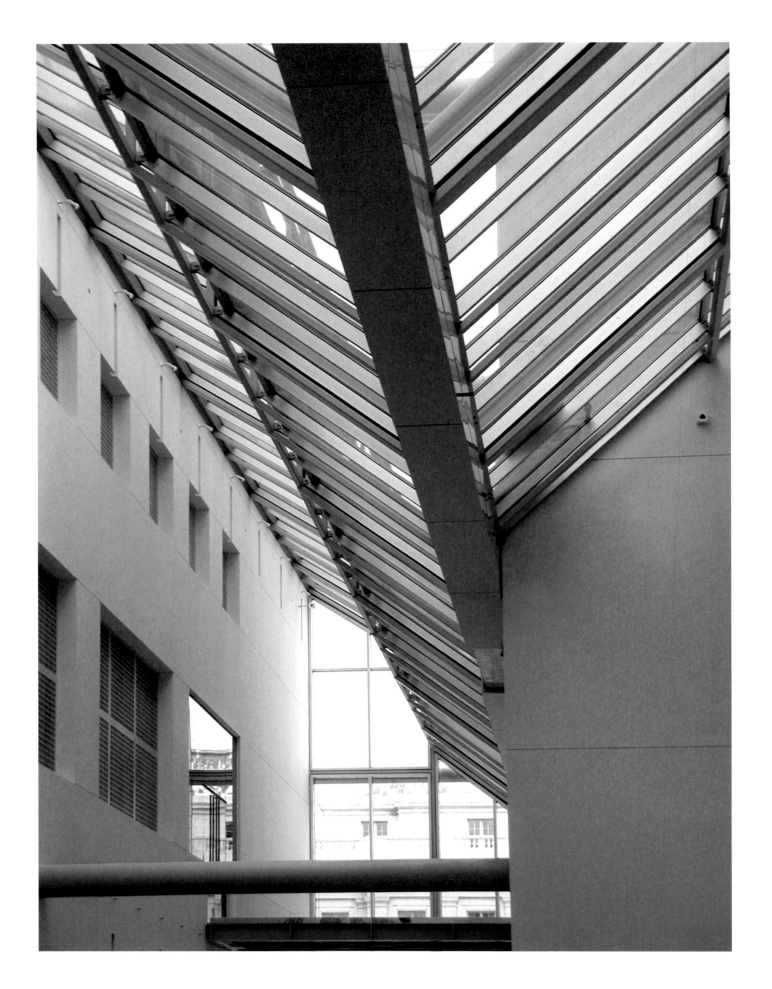

Into the Galleries

Designing the Galleries

George Sexton Associates

I N THE SPRING OF 2000, the museum engaged the services of George Sexton Associates of Washington, D.C., to design and coordinate the development of casework and lighting for the museum's galleries. George Sexton Associates was chosen for its experience in museum planning, exhibition design, and lighting design. Its previous clients included the Art Institute of Chicago, the Museum of Fine Arts, Boston; the Denver Art Museum; the Henry R. Luce Center for the Study of American Art; the Honolulu Academy of Arts; the Library of Congress; the Metropolitan Museum of Art; and the Museum of Modern Art, New York. The company has won many awards; one of the most recent was the prestigious GE Edison Award (2000) for the lighting design, for the Herz Jesu Kirche (Heart of Jesus Church) in Munich, Germany.

George Sexton first became fascinated with lighting design while studying architecture in the 1970s. After receiving his architecture degree from Virginia Polytechnic and State University, Blacksburg, Virginia, he spent nearly a decade in exhibition design and lighting in museum contexts. He was a member of the design team at the National Gallery of Art from 1973 through 1977, and he cites Gil Ravenel, chief of design and installation at the National Gallery of Art, as a formative influence. From the National Gallery Sexton went on to work at the Sainsbury Centre for Visual Arts at the University of East Anglia in England and the Fine Arts Museums of San Francisco (the M.H. de Young Memorial Museum and the California Palace of the Legion of Honor). In 1980 he established George Sexton Associates as an independent company.

Explaining his approach to gallery design, Sexton emphasizes that "nothing should get in the way of the experience between the visitor and the object." For his work at the Asian Art Museum he sought an organic approach to object presentation. He was guided by a desire to simplify the design of the galleries, to clarify the relations between objects, to clearly orient and guide the visitor, and as much as possible, to enable the objects to speak for themselves. Rather than imposing a rigid framework upon the presentation, he concentrated on the visitor's movement through space and tried to create a coherent flow among the objects on display. He worked to simplify and unify the casework, applying a uniform color scheme and consistent size standards for the cases. He established an "art wall" ten and a half feet high as a basic design element—this creates a conceptual distinction between the art space and the architectural space.

Design and Production, Inc., of Lorton, Virginia, was contracted by the Asian to assist in engineering exhibit structures, preparing shop detail drawings, and fabricating

Designer George Sexton, museum director Emily Sano, and curator of Korean art Kumja Paik Kim review gallery plans.

and installing approximately three hundred custom built, in-wall, glass-faced display cases and free-standing display cases. Each display case was specially engineered with unique dimensions to fit the gallery space and the contents. Nonglare glass was employed to further reduce the viewer's separation from the objects.

The Design Process

Early in the design process a forty-foot scale model of the building (one inch in the model being roughly equivalent to one foot in the actual building) was constructed. Small representations of objects from the museum's collection were arranged in various ways inside the model, as the designers and curators worked together to determine the most effective arrangement of objects. After determining the size constraints of the gallery spaces, museum curators and registrars assembled detailed binders of objects to be displayed, including photographs, dimensions, materials of construction, and other pertinent information. George Sexton Associates prepared AutoCAD plans of the galleries, showing the exact layout and dimensions of the cases; they also prepared another level of AutoCAD diagrams detailing the content and layout of each case.

Wall and case texts had to be related to the gallery design. As a first step, museum educators and curators consulted with a panel of leading scholars; then they worked with an outside consultant, Hal Fischer, to refine, interconnect, and unify their messages. The design process was a continuous back and forth, as inevitable difficulties and evolving concerns were addressed. In this way, the museum developed like an anthology of Asian art—not only does a continuous storyline connect the various galleries but each gallery and each case also offers its own interpolated storyline within the larger context.

Highlights: A Virtual Tour

After extensive discussion of various ways to divide and organize the collection in the galleries, such as thematically or strictly chronologically irrespective of country, museum curators decided on a mixed plan that is primarily chronological within major cultures, but with certain themes running throughout. They reasoned that Buddhism should be emphasized as a theme, because it is one of the few cultural elements present almost everywhere in Asia, and the museum's Buddhist collections are uniformly strong. They agreed that another major theme should be trade and interchange. This theme, important in itself, could also be related to the spread of Buddhism, and again the museum's collections could support it effectively. A third theme, linked to the first two, would be the

development of local beliefs and practices. This theme provides opportunities to contrast international phenomena, such as aspects of Buddhism or the popularity of blue-and-white ceramics, with such local phenomena as the worship of indigenous spirits or the customs of daily life.

Although the galleries can be entered at any of several points, to take full advantage of their contents and arrangement, visitors should follow the tour recommended by the museum's curators. This begins on the southeast corner of the third floor with India, the homeland of Buddhism, and continues in a clockwise direction through Southeast Asia and the Himalayas to ancient China and Buddhist China. Then visitors go down a floor to continue in a counterclockwise direction through later China, Korea, and Japan.

The Varieties of Museum Experience

Just as there are many paths to enlightenment, so there are many ways to enjoy a museum experience. Some people come to the museum mainly to appreciate the rarity and beauty of the objects on display. Others come for ideas—to learn about different subjects and themes. Still others come for the social experience of an outing shared with family or friends. Finally, some people come to the museum for a reflective personal experience: for contemplation or to stimulate their imaginations or their memories.

The attitudes that visitors bring to museums depend in part on the nature of the exhibits there. In a study of visitors to the Arthur M. Sackler Gallery, the Freer Gallery of Art, and the National Museum of American History, a 1999 Smithsonian Institution survey found that 36 percent of visitors came mainly for rare object experiences, another 36 percent for cognitive experiences, 20 percent for introspective experiences, and (8 percent primarily for social experiences. The Asian Art Museum hopes to accommodate all of these approaches. That means designing a museum with different types of information and activities for different people—or for the same people on different visits. Visitors will therefore find a variety of different galleries, displays and activities on their journeys through the museum.

There are many paths. The monumental staircase connects the ground floor with Samsung Hall. From Samsung Hall one can proceed to the second-floor Chinese or Japanese galleries via stainless-steel bridges, or to the galleries of Korean art by walking through the Logia to the west wing of the building. Samsung Hall can also be reached using a glass elevator located on the south side of the central first-floor court; from this elevator one can also enter the Japanese galleries on the second floor or the Southeast Asian galleries

on the third floor. Another elevator on the north wing leads to Chinese galleries on the second and third floors. Stairs can be used to travel between the levels on both the north and south wings.

The most rewarding path for many visitors is followed by ascending the escalator past the second-floor landing to the third floor. On arriving at the orientation area on the third floor, visitors proceed into the galleries of Indian and South Asian art to begin the recommended tour.

First Floor

Education Resource Center

Museum Store

Special Exhibition Space

Cafe Asia

Classrooms

North and South Court

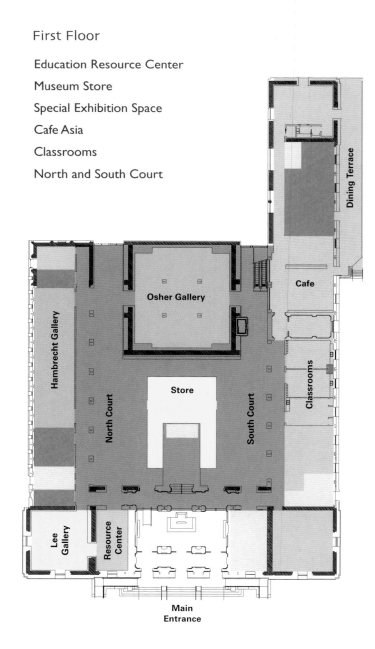

Second Floor

China
17 China 960–1911
18 Chinese Painting
19 Chinese Imperial Arts 1644–1911
20 Chao Shao-an and Chinese Painting Since 1900

Korea
21 Korea through 1392
22 Korea 1392–1910
23 Korea 1392 to the present

Thematic Exhibition Gallery
24 Thematic Exhibition Gallery

Japan
25 Early Japan
26 Japanese Buddhist Art
27 Japanese Arts of Daily Life
28 Japanese Paintings and Screens
29 Japanese Porcelain and Prints
30 Japanese Tea-Related Arts
31 Betty Bogart Contemplative Alcove

Loggia
Asian Ceramics: Trade and Exchange

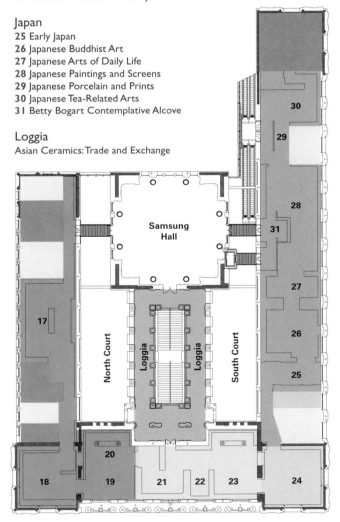

Third Floor

South Asia
1 South Asia to 600
2 Eastern India 600–1600
3 Central and Western India 600–1600
4 Southern India 600–1600
5 South Asia after 1600
6 The Sikh Kingdoms

The Persian World and West Asia
7 The Persian World and West Asia

Southeast Asia
8 Early Southeast Asia
9 Southeast Asia 600–1300
10 Southeast Asia 1300–1800
11 Southeast Asia after 1800

The Himalayas and the Tibetan Buddhist World
12 The Himalayas and the Tibetan Buddhist World

China
13 Chinese Jade Treasury
14 China through 221 BCE
15 China 206 BCE–906 CE
16 Chinese Buddhist Art

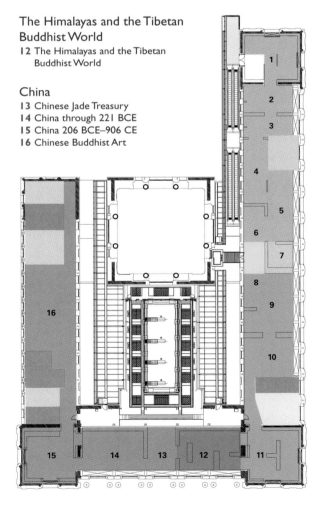

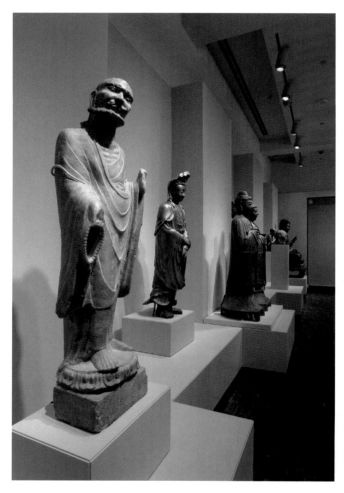

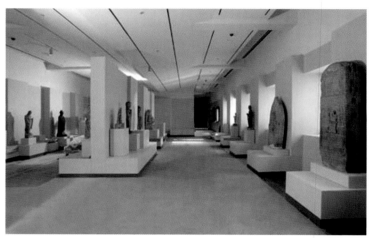

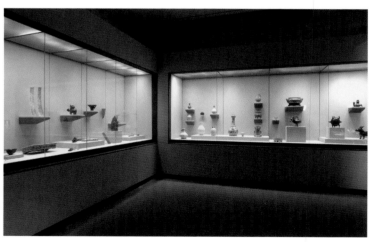

LEFT AND TOP RIGHT: The Arhat (a being of intense spiritual concentration who has reached a stage of perfection through study and meditation) at the left is one of a number of large, dramatic sculptures in Gallery 16 (Chinese Buddhist Art).

BELOW RIGHT: This detail from Gallery 17 (China 960–1911, which features objects from the Song through Qing dynasties, shows the custom casework created by Design and Production, Inc.

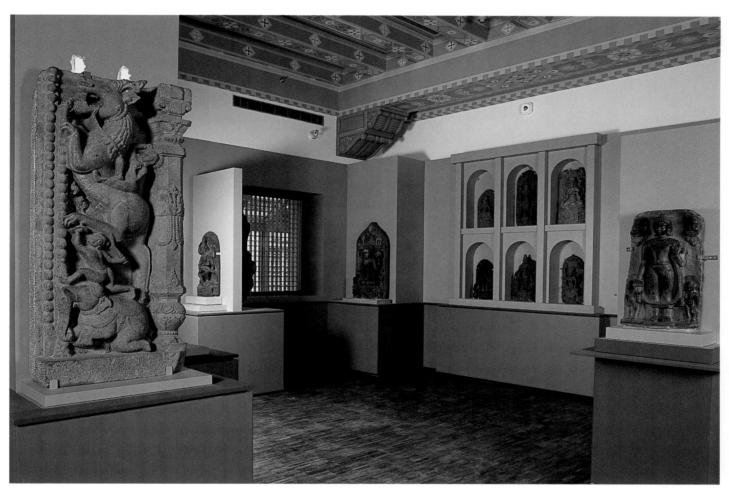

A view of Gallery 2 (Eastern India 600–1600). The stone object at the left, which depicts elephants, warriors, and a rearing lion-like creature, is a section from the back of a throne for what must have been an enormous Hindu or Buddhist figure.

Third Floor
South Asia

Gallery 1
South Asia to 600

The Isha and Asim Abdullah Gallery

Ganesha, remover of obstacles and ensurer of auspicious beginnings, receives visitors preparing to enter the Indian galleries in the new museum. With his elephant's head above a pudgy human body, he would be freakish in European art, but in this Indian sculpture he is as natural, as confident, as amiable as can be. In the Indian galleries—Ganesha's territory—visitors will find a world of challenged perceptions and unexpected beauties.

Leaving the orientation space to enter the Indian galleries, visitors come face to face with a large, early stone image of a serpent king, a personification of the power of water in nature. This work, and a group of others surrounding it, establish the importance of natural forces, especially those related to fertility, in ancient India.

Next one proceeds to early images of the Buddha and bodhisattvas, and reliefs of the life of the Buddha. Text panels with photos, maps, and diagrams introduce fundamental concepts and symbols of Buddhism, addressing such questions as "How do you recognize an image of the Buddha?" Finally, in this first gallery, one finds early images of Vishnu and Shiva, and of other Hindu themes, a reminder that multiple religious traditions existed side by side.

This first Indian gallery also features Gandharan sculptures and discussions of why they look Greek or Roman; early gold coins with portraits of mighty kings (and sometimes both representations of Hindu deities and inscriptions in Greek); and a group of ancient and modern miniature stupas, with explanations of what stupas are and why they are so important throughout the Buddhist world.

A number of artworks shown in this gallery, as in the other galleries, have never been exhibited before. Displaying the artworks to best advantage and creating a sense of visual drama were guiding principles of the new designs. The Indian galleries make use of filtered natural light falling across sculptures from the side, together with the most sensitive artificial lighting. The height and positioning of each sculpture is calculated to evoke its placement in its original architectural context. Also, great attention has been paid to long vistas, so that imposing works can entice the visitor to further exploration.

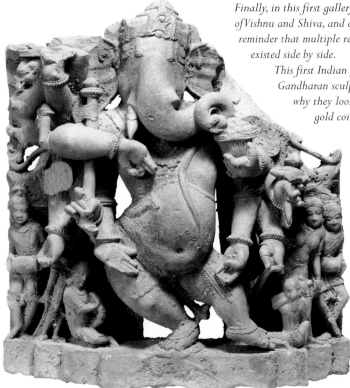

DANCING GANESHA, 900–1000. India; Madhya Pradesh State. Sandstone. *The Avery Brundage Collection*, B66S8.

Coin of the emperor Huvishka, approx. 126–163. India or Pakistan; ancient region of Ganhara, Kushan dynasty (approx. 35 BCE—300 CE). Golda. *Museum purchase with funds from the Society for Asian Art* .F1999.38.2. (below)

Fertility goddess, approx. 100 BCE. India; Chandraketugarh, West Bengal state. Terracotta. *Gift of Gursharan and Elvira Sidhu, 1991.256* (p. 89).

Standing Buddha with devotee, 500–700. India; Sultanganj, Bhagalpur district, Bihar state. Stone. *The Avery Brundage Collection,* B60S571 (p. 90).

With its classical figure and use of Greek script, this gold coin documents the enduring legacy of Alexander the Great's military campaigns, which took him as far east as the Indus Valley before his death in 323 BCE. The Greek settlements that unfailingly followed Alexander's war machine ensured the absorption of Mediterranean elements into a complex cultural sphere that also absorbed Central Asian, Indic, and Iranian influences. Nearly four centuries after Alexander's reign, the Kushan dynasty incorporated into a new empire the Indo-Greek kingdoms that had arisen in Central Asia and Pakistan. The Kushans, whose nomadic origins can be traced to northwestern China, were politically astute in their use of Greek religion, figural types, and alphabet. The reverse side of this coin, for example, depicts a classically draped goddess, cornucopia in hand, who would have been familiar to the Kushans' Indo-Greek subjects. The accompanying Greek inscription identifies her as Ardoxsho, the Iranian embodiment of abundance and prosperity. That this goddess had close parallels in the Greek, Buddhist, and Hindu pantheons made her an ideal unifying image in a vast and diverse empire. The coin enlists her image in support of the Kushan emperor whose portrait appears on the obverse.

This nearly nude terracotta figurine, with her prominent breasts and wide hips, is related to earlier female fertility figures, some of which date to the third millennium BCE. In contrast to those images, many of which were crudely fashioned, this one reveals a more naturalistic form, greater in its elaboration and complex symbolism. The bejewelled goddess, standing with arms akimbo and wearing an elaborate headdress, was a popular iconographic type in eastern India. The artist's adherence to general conventions for depicting fertility goddesses makes the exact identification difficult. Comparison with more complete images, however, suggests that her headdress was decorated with five weapon-shaped pins emblematic of female deities of nature (*yakshis*), heavenly nymphs (*apsarases*), and the goddess of prosperity (*Lakshmi*). As both this terracotta figure and the nearby gold coin illustrate, female embodiments of fertility and abundance have long been venerated in South Asia, though their forms may have varied greatly.

In 1982, the museum acquired startling information about this lovely Buddha image, which was part of the original Avery Brundage collection. An 1864 pamphlet, printed in London, had recently come to the attention of scholars who recognized in its pages a photograph of this stele. The forgotten publication documented excavations that, from 1861 to 1862, halted construction of the East Indian Railway at Sultanganj, Bihar. There the image was unearthed, along with another of similar appearance acquired by the British Museum. Both were buried above the famous over-seven-foot-tall bronze Buddha now in the Birmingham City Museum and Art Gallery. The pamphlet confirmed the Asian Art Museum's long held belief in the importance of this image, one of few sculptures known to have been carved in eastern India prior to the rise of the Pala dynasty (700–1200). All three pieces, dated through stylistic analysis and testing between the sixth and seventh centuries, share a history that is extraordinary in the annals of collecting. The museum's example is placed between the first and second galleries, providing superb visual evidence of stylistic developments that led to the emergence of the Pala and other regional styles in the following centuries.

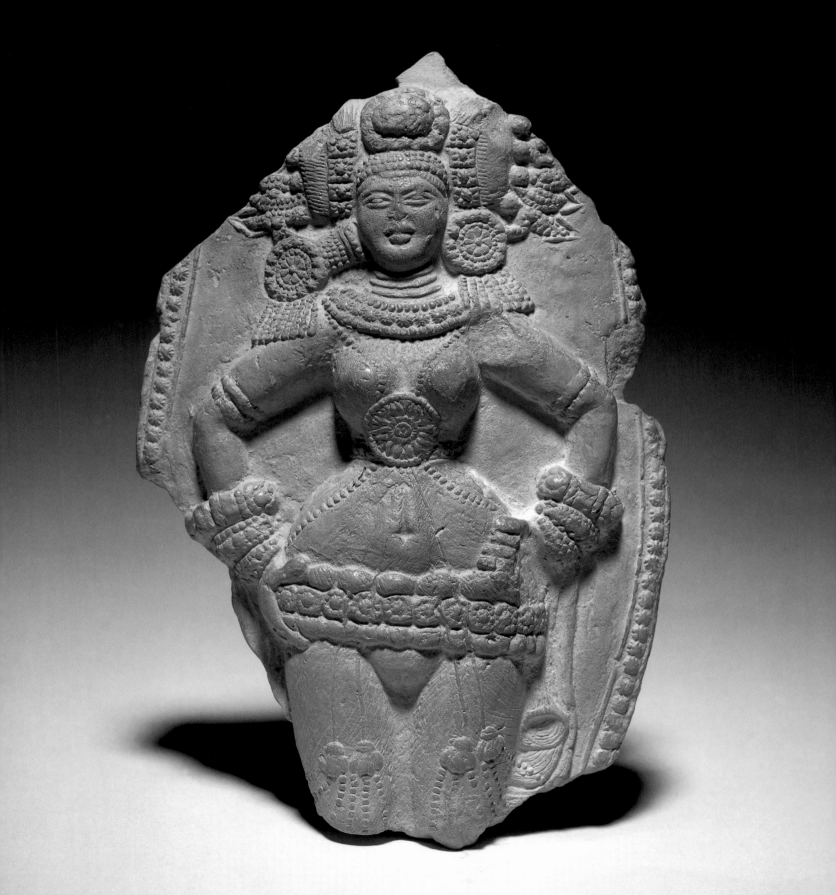

FERTILITY GODDESS, approx. 100 BCE. India.

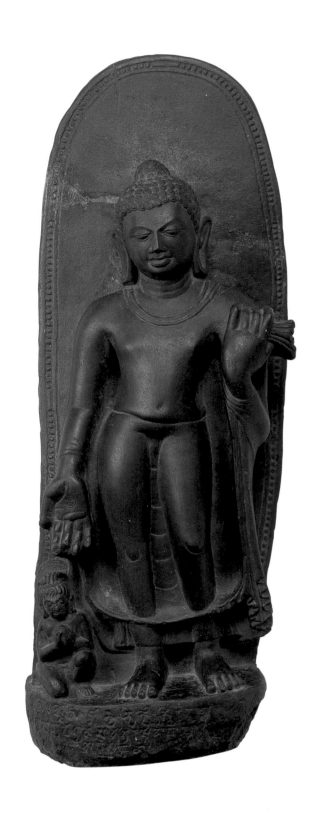

STANDING BUDDHA WITH DEVOTEE, 500–700. India.

Gallery 2
Eastern India 600–1600

The Rajnikant and Helen Desai Gallery

Highlights of this gallery include three sculptures of Vishnu, side by side, of the same general period, type, and material, but from different regions. A text panel explains that through much of its history India was divided into competing regional kingdoms, which usually had distinct art styles. The three Vishnus exemplify how strongly geography can affect style. This gallery, and the next two, display artworks from the eastern region, the center, and the south of India.

The gallery also contains a superb seated Buddha image made in the area where the Buddha's enlightenment occurred and a wall of tiered niches with Pala dynasty sculptures arranged as they might have been on a temple.

THE HINDU DEITIES SHIVA AND PARVATI, 600–700. India; probably Bihar state. Stone, *The Avery Brundage Collection*, B62S9+ (p. 92).

Tender caresses and attendant signs of erotic longing are captured in this picture of intimacy between a husband and wife who are none other than the Hindu deiities Shiva and Parvati. Beneath them, Shiva's bull settles cozily into a rocky crevice. An eternity may pass before his master's return, for Shiva and Parvati have been known to engage in lovemaking that, at times, has lasted a thousand years. Their intensely sensual relationship has a flip side, however, that is fiercely ascetic and withdrawn from the world. Shiva's erect phallus is a mark of his ascetic discipline, and other aspects of his iconography, such as his matted hair, tend to emphasize the ascetic aspect of his nature. The goddess, also a practiced ascetic, is said to have won Shiva's affections through the devoted performance of austerities. The interrelationship between sensuality and asceticism is a pervasive feature of Indic art and reflects attempts to reconcile the realities of worldly existence with the ultimate goals of escaping that existence entirely. Complex iconographical elements that would allow fuller expression of such ideas had not yet been established at the time of this early image. Shiva and Parvati, two-armed, appear rather human, although Shiva is given his traditional attributes of cobra, trident, and third eye.

THE BUDDHIST DEITY VAJRA TARA, 1075–1200. India; perhaps Nalanda, Magadha region, Bihar state. Stone. *The Avery Brundage Collection*, B63S20+ (p. 93).

Bejewelled and wielding various implements, this is the Buddhist deity Vajra Tara (Diamond or Thunderbolt Tara), known as a provider of magical protection. Her devotees were adherents of an esoteric branch of Buddhism that believed Enlightenment could be achieved in just one lifetime. To that end, they made use of various spiritual tools including mandalas, special diagrams for meditational purposes. This Vajra Tara is, in fact, a sculptural mandala, the organization of its figures adhering to Buddhist texts that speak of her being seated amidst a group of ten goddesses. Here, they are arranged along the upper edge of the stele and at the sides of the lotus pedestal, while a presiding Buddha appears at the sculpture's apex. The eight arms of this goddess, indicators of her divine nature, carry attributes—such as noose, elephant goad, and lotus—that are also prescribed in Buddhist literature. While the dark stone and crisp carving link this image with earlier sculpture from eastern India, its visual complexity reflects the developments in religious thought and the establishment of defined iconographic formulas that had occurred by the twelfth century.

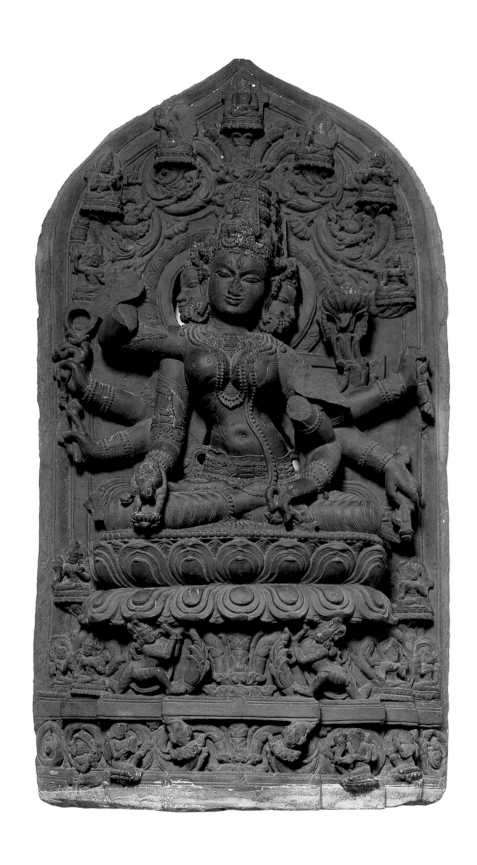

THE HINDU DEITIES SHIVA AND PARVATI, 600–700. India.

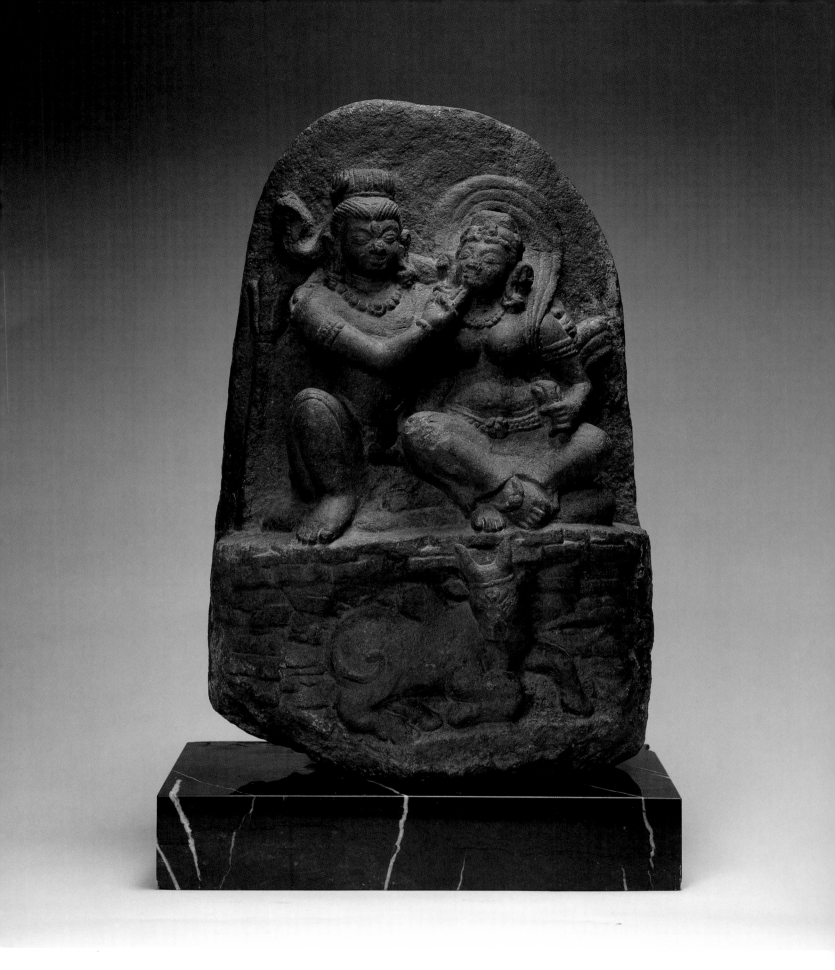

The Buddhist deity Vajra Tara, 1075–1200. India.

The Herbst Foundation, Inc. Gallery

In this gallery the visitor will find a grouping of images of the Hindu deity Shiva in various forms, with explanations of his powers and symbolism. There are also an elaborately carved stone ceiling and roof decorations installed high enough to suggest their original placement. Visitors will also find paintings and sculptures of deities of Jainism, with descriptions of this important religion, which has thrived in parts of India for 2600 years..

THE BUDDHIST DEITY JAMBHALA, approx. 1000–1100. India; perhaps Sarnath area, Uttar Pradesh state; or Bodhgaya area, Bihar state. Sandstone. *The Avery Brundage Collection,* B63S8+ (p. 95).

Overturned treasure vases and a mongoose spitting forth strands of jewels indicate the ability of the portly Jambhala, pictured here, to grant wealth. It literally tumbles, in fact, towards those who honor him, hoping also to gain tremendous spiritual and temporal powers and freedom from sickness. Jambhala is chief among a group of popular deities, known as *yakshas,* who are closely associated with nature and the riches of the earth. Powerful figures who could unleash malevolent forces as well as bestow unlimited prosperity, they were the focus of countless local cults before Hinduism, Buddhism, and Jainism emerged as major religious forces by the end of the first millennium BCE. Each faith incorporated yakshas and other local deities into a vast pantheon, creating dramatic narratives accounting for their inclusion. Many of these tales are stories of conversion and thus are not subtle in asserting the supremacy of one path over another. Although it shares stylistic features with eastern Indian images, this sculpture, with its light decorative treatment and buff sandstone medium, is a beautifully preserved example of late Buddhist art from central India.

SHRINE WITH TWENTY-FOUR JINAS, 1493. India; Gujarat state. Bronze. *Gift of the Asian Art Museum Foundation,* B69B11 (p. 96).

The nudity of this bronze shrine's numerous figures indicates the strict disavowal of material possessions as practiced by an ascetic Jain sect. Like Buddhism and Hinduism, Jainism seeks to curb the effects of karma, aiming for ultimate release from the cycle of rebirth. Although it did not spread outside India, unlike Buddhism it still commands a large following in the land of its birth. The twenty-four figures shown here represent the faith's revered teachers and namesakes. Known as *jinas,* or victors, they long ago conquered the bonds that condemn one to repeated lives of suffering. This bronze was made for a wealthy patron—perhaps one of the many merchants who supported Jainism—and would have been placed in a domestic shrine.

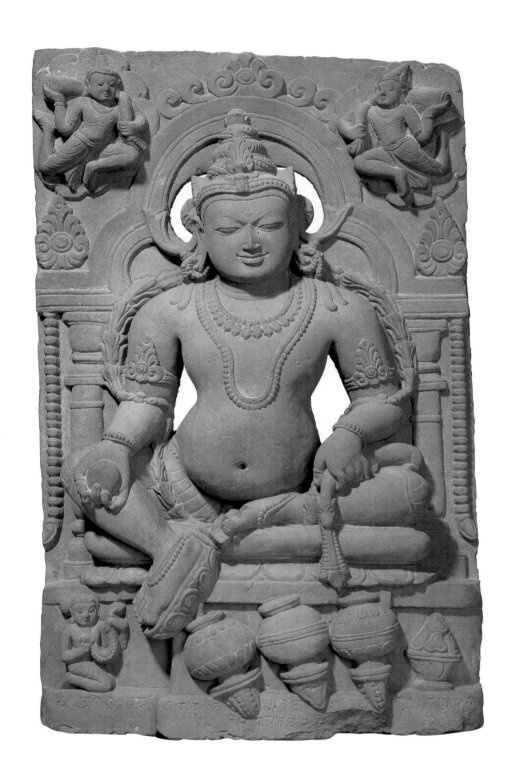

THE BUDDHIST DEITY JAMBHALA, approx. 1000–1100. India.

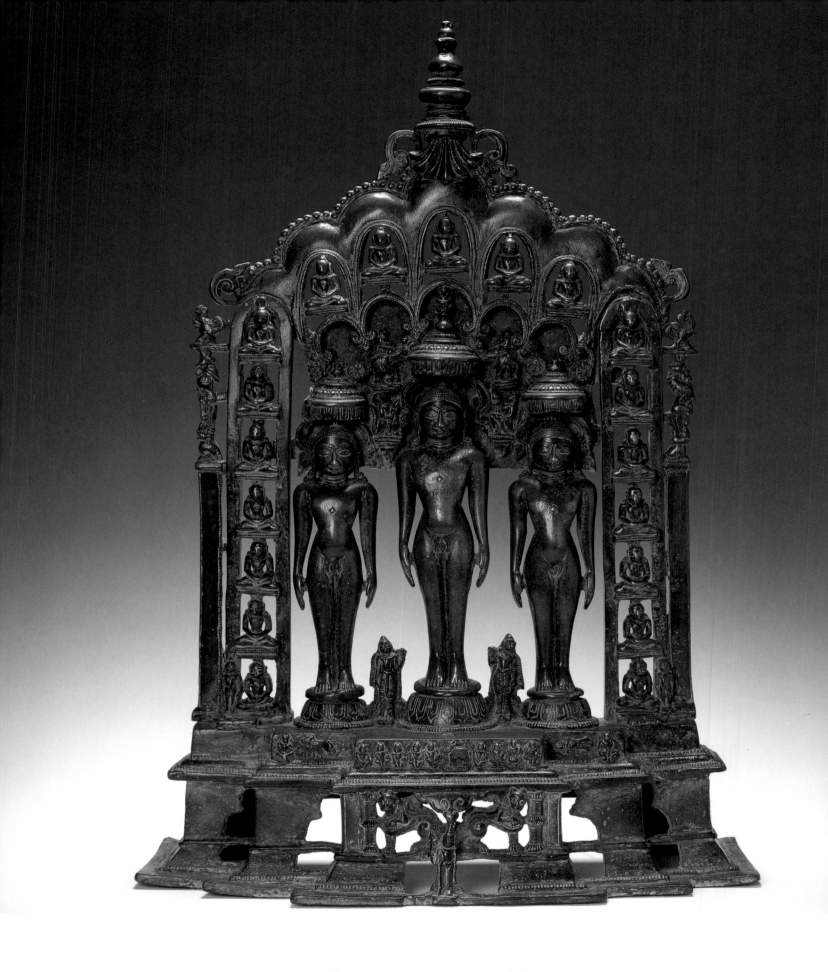

SHRINE WITH TWENTY-FOUR JINAS, 1493. India.

THE HINDU DEITY SHIVA AS BHAIRAVA, 1300–
1500. India; Karnataka state. Stone. *Gift of the
Connoisseurs' Council, 2000.6 (p. 98).*

THE HINDU DEITY DURGA, SLAYER OF THE
BUFFALO DEMON, 1000–1100. India; Tamil
Nadu state. Chola dynasty (907–1279). Granite.
The Avery Brundage Collection, B64S10 (p. 99).

*One of the unique features of this gallery is a
cubical structure recalling the mass of a Hindu
temple, with niches in its sides holding large
images of deities—such as Shiva in his "south-
facing" form—oriented to the actual compass
directions as they would be in a temple. There is
also a group of lithe and sensuous bronze
sculptures of Hindu deities, and impressive
sculptures of several of the "Seven Mothers," with
explanations and illustrative photos.*

Shiva's anger was once provoked by the god
Brahma, who obstinately refused to admit
Shiva's superiority, though it had been proven
in a recent contest. Shiva assumed his most
terrifying form as Bhairava and cut off
Brahma's fifth head. Having committed a hei-
nous sin, a despondent Shiva was forced to
wander the land with Brahma's skull stuck to
his hand, as shown in this image from
Karnataka.

Bhairava's ferocity is traditionally indi-
cated by the iconographic features encountered
in this image—fangs, unkempt hair, naked
body covered with a garland of skulls, and an
attendant dog, a creature associated with cre-
mation grounds. Yet what should be a repulsive
image is, instead, remarkably sensual and at-
tractive. The deep carving accentuates a grace-
fully swaying posture and, despite its fangs,
Bhairava's face appears rather gentle. The artist
has lavished careful attention on beautifying
the sculpture's various parts, so that the whole
is an eloquent testimony to the unsettling
attractiveness of the dreadful and horrific.

The goddess Durga, victorious in her battle
with the powerful buffalo demon, stands
calmly on his decapitated head in this south
Indian image. Her eight arms hold the weap-
ons of the male gods who created and armed
her after their own attempts to vanquish the
demon had failed. Most northern Indian im-
ages of the goddess depict her in the process
of killing the buffalo demon, stamping upon
him with one leg, and vigorously driving a
weapon into his body.

This iconographic type was not unknown
in southern India, but images of the goddess
after her moment of victory were preferred.
This iconographic preference is one of many
long-persisting differences between northern
and southern Indian art traditions. The elegant
style of this image, which draws upon earlier
regional trends, is typical of eleventh-century
southern Indian sculpture, and it especially
befits Durga's role in this tale as the protec-
tress of the world.

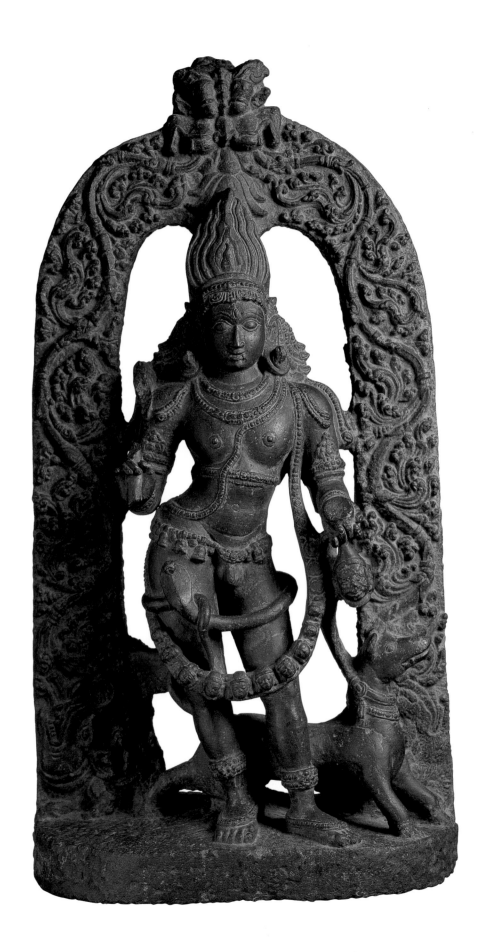

The Hindu deity Shiva as Bhairava, 1300–1500. India.

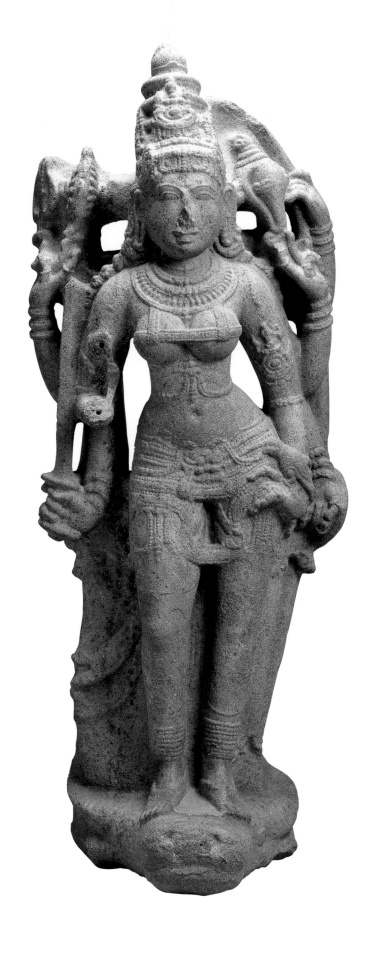

THE DEITY DURGA, SLAYER OF THE BUFFALO DEMON, 1000–1100. India.

CUP WITH HANDLES, approx. 1650–1750. Northern India or Pakistan. Mughal dynasty (1526–1858). Nephrite, gilt silver, enamel, and garnets. *The Avery Brundage Collection,* B60J961 (p. 101).

THE HINDU DEITY KRISHNA PLAYING THE FLUTE, probably 1800–1900. Southern India. Wood. *The Avery Brundage Collection,* B61S55+ (p. 102).

This gallery includes paintings and sculptures of bronze, stone, and wood showing Krishna in many moods, from the seductive flute player to the indignant destroyer of the serpent Kaliya. It also contains large sandstone and white marble architectural pieces suggesting the grandeur of the Mughal empire, together with sumptuous Mughal paintings, jades, and decorative arts. The visitor will also find sculptures, paintings, and decorative arts made under British influence, with panels discussing colonialism and its effects. A centerpiece is an extraordinary silver howdah made for show by a powerless Indian raja. Devotional objects from India's villages— artworks that have been in the museum's storage for decades—are finally on display, along with a selection of Indian jades.

Jade immediately brings to mind the great and varied treasures of China. Far less well known are the superb examples of carved jade produced in India and Iran. The Chinese were well aware of Mughal jade artisanship, which they greatly admired and, in some cases, felt was superior to their own.

This jade cup, belonging to the Mughal period (1526-1858), is notable for its thin, nearly translucent, body and the finely carved vegetal motifs on its exterior. The handles and base are of European manufacture and attest to the collection of such jades by Western admirers. The Parisian jeweler responsible for these gilt silver and enameled fittings was Jules Wièse (1818–1890). His official marks, in use between 1844 and the year of his death, appear on the base and on one of the handles.

The Mughal emperors' interest in jade can be partly attributed to their concern with maintaining ancestral traditions. Thus, jades produced in Timurid Iran were prized and actively sought by Mughal aesthetes such as the emperors Jahangir and Shah Jahan. Under their patronage, especially, Indian jade production reached new heights. (An Iranian jade once owned by Jahangir is on display in the galleries.) The fine details of this superbly worked cup indicate just how strongly the aesthetic tastes and high standards of earlier Mughal emperors would define subsequent luxury art production in northern India.

With his flute, the divine cowherd Krishna created celestial sounds that, along with his beauty and grace of movement, enchanted a number of women. Their inflamed passions were understood as an appropriate metaphor for the feeling with which devotees should approach the divine. Although all of Vishnu's ten incarnations are well-represented in Indian art, it is his form as Krishna that has inspired the greatest number of poets, painters, and sculptors. Krishna's life story easily lent itself to artistic and literary interpretations that sought, through his childhood exploits and later loves, for example, to illustrate the uninhibited and creative nature of the divine. Krishna spent his early adulthood as a cowherd in the groves of Vrindavana. In this wooden image, he is shown playing his flute while being fanned by two cowherd girls. The affectionate nudge of a cow, accompanied by its calves, indicates the bliss felt by all creatures in this pastoral land. That images of the amorous cowherd and his admirers enjoyed great popularity throughout India indicates how accessible the god was felt to be, no doubt because his exploits and desires were sometimes all too human. This wooden sculpture, from south India, probably decorated the interior of a shrine. It has never been exhibited and, in fact, represents a class of objects that find little or no representation in modern museums. One of the goals of the new galleries is to bring to public attention more examples of so-called popular art, much of which displays a remarkable aesthetic sensibility.

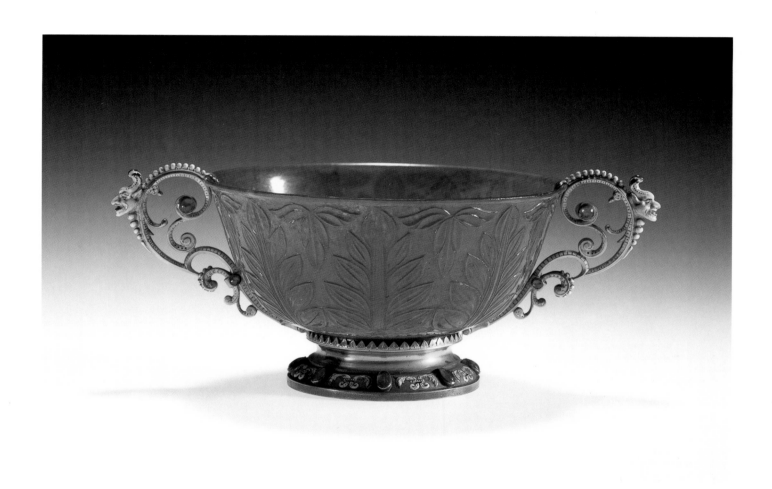

CUP WITH HANDLES, approx. 1650–1750. India or Pakistan.

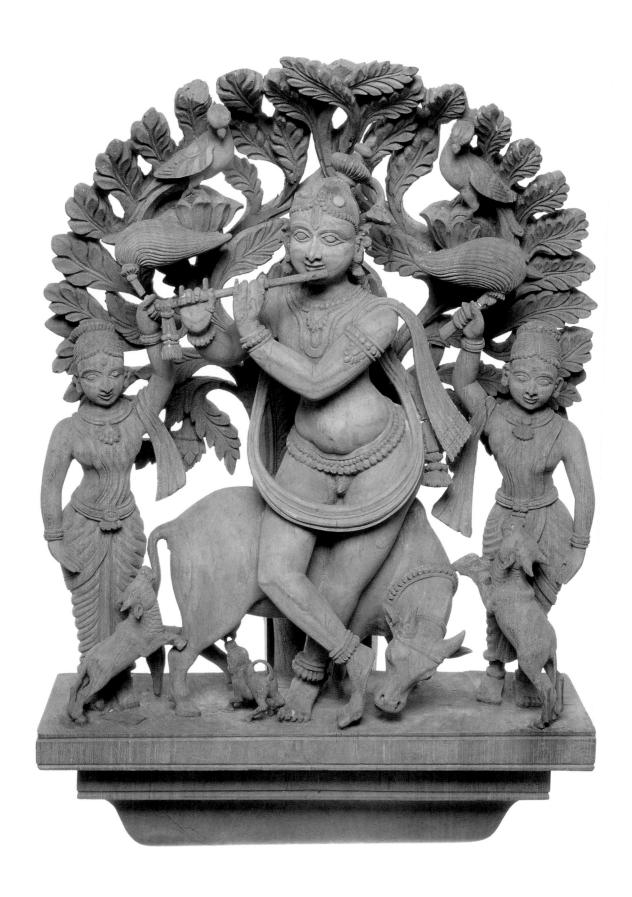

The Hindu deity Krishna playing the flute, probably 1800–1900. India.

THE HINDU DEITY KALI, 1975–1982, by Lalita Devi. India; Mithila region, Bihar state. Ink and pigments on paper. *Purchased with funds from the Society for Asian Art and museum puchase,* 1999.39.13 (p. 104).

For important festival and ritual occasions, women in the region of Mithila, in northeastern India, painted elaborate murals on the walls of their homes. In the 1960s, seeking to empower these women while also preserving their artistic traditions—both of which were suffering under intense economic and social pressures—the Indian government encouraged them to paint on commercial paper. Today, their works are the best known of India's village traditions, famed for inventiveness and boldness of line, pattern, and color. The paper medium's smaller size and ease of use encouraged experimentation, although artists continued to explore more familiar subjects that included representations of deities, scenes from epic narratives, and themes of fertility. The sheer size of this painting, which is almost as large as an average doorway, recalls a traditional mural. According to well-known iconographic conventions, the Hindu deity Kali is multiheaded, multilimbed, and adorned with skulls. She is horrific because she represents Time and thus the eventual dissolution of all things. She stands upon her consort, Shiva, who is said to become animated only through Kali's divine energy.

THE HINDU DEITY KRISHNA AND HIS BELOVED, SYMBOLIZING A MUSICAL MODE (*Dipaka raga*), approx. 1760. India; former Avadh region, Uttar Pradesh state. Pigments on paper. *Gift of Mr. George Hopper Fitch,* B84D7 (p. 105).

The lightning that streaks the night sky in this painting is an artistic device often used to symbolize desire and, indeed, appears to reflect the flames of passion being stoked by this amorous couple. The lovers purposefully evoke such emotions, which were the focus of numerous musical, poetic, and artistic works in India. The male, in particular, personifies the sound of fire and its prominent qualities, passion foremost among them. The several flickering lamps in the painting reinforce this association. This painting, like many produced during the eighteenth century in the territory of Avadh, betrays a nostalgia for Mughal culture in its opulent setting, rich colors, and delicate lines and patterns. The early diffusion of the Mughal painting style was largely due to the presence at the Mughal court of various Rajput princes who were thereby exposed to the refined aesthetic sensibilities of their overlords. The long twilight of Mughal power saw the dispersal of its workshops as artists sought new patrons.

THAKUR JAIT SINGH HUNTING A BOAR, 1800–1820, by Kunvla (active 1778–1820). India; former kingdom of Badnore, Rajasthan state. Pigments on paper. *Gift of Gursharan and Elvira Sidhu,* 1991.253 (p. 106).

Among the Rajput clans of India, hunting was a traditional pastime and images of princes and noblemen in pursuit of wild beasts abound in extant paintings. These paintings were commissioned not only to document courtly life, but to present an image of valor in keeping with Rajput heritage. Small states, such as Badnore, shared the same artistic and cultural vocabularies as their more powerful counterparts. In this painting, Jait Singh, the ruler of Badnore, drives his spear into a boar already set upon by a canine companion. The very act recalls the hunter's Rajput ancestry, for training to hunt boar on horseback was considered essential to the development of equestrian skills.

This painting is one of few examples where the artist is known. Comparison with his other known works reveals that a strong sense of color and line were among his particular strengths. One may also conclude that Kunvla delighted in creating visual congruencies. A rare glimpse into the artist's personality is provided by certain features of this painting—the curling tail of the dog, for example—is set perfectly against the background of the boar's rump.

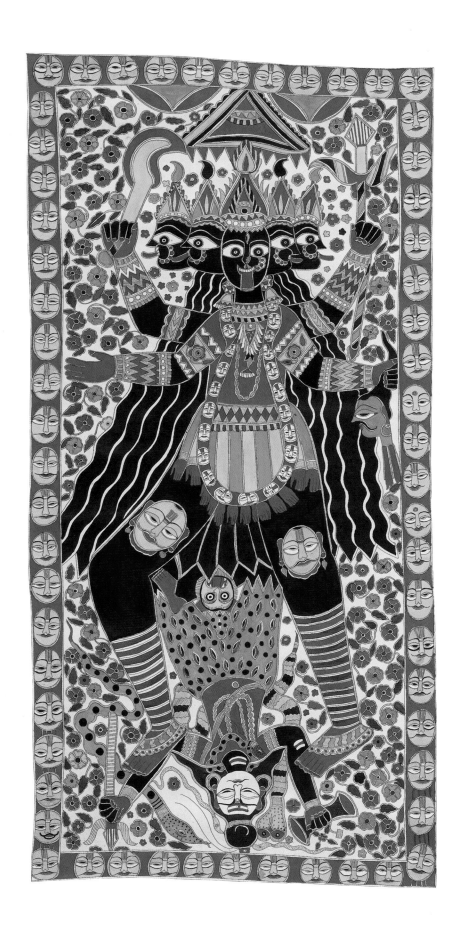

THE HINDU DEITY KALI, 1975–1982, by Lalita Devi. India.

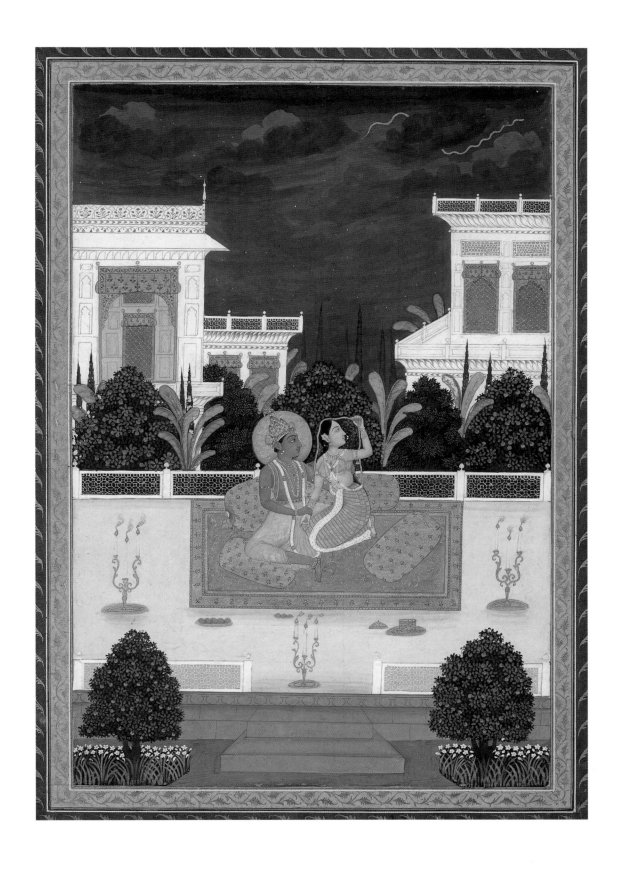

THE HINDU DEITY KRISHNA AND HIS BELOVED, SYMBOLIZING A MUSICAL MODE, approx. 1760. India.

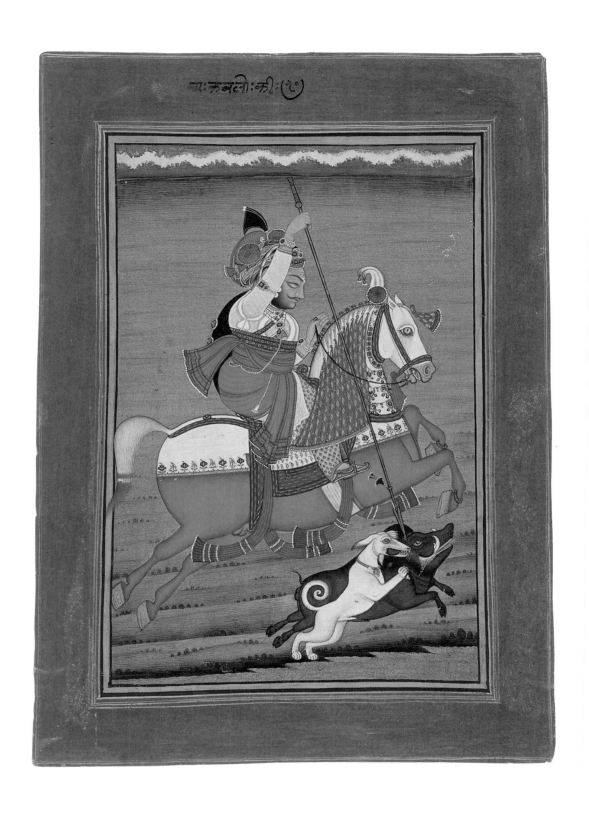

THAKUR JAIT SINGH HUNTING A BOAR, 1800–1820, by Kunvla. India.

Gallery 6
The Sikh Kingdoms

The Satinder Kaur Kapany Gallery

Paintings and other works donated by Dr. Narinder and Mrs. Satinder Kaur Kapany illustrating the life and legends of Sikhism's founder Guru Nanak make up the foundation of this gallery. Among the highlights are luxurious decorative arts from the court of the great nineteenth-century Sikh ruler Maharaja Ranjit Singh.

TURBAN HELMET, 1820–1860. Pakistan; probably Lahore, Panjab province. Helmet of steel overlaid with gold; neckguard of iron and brass. *Gift of the Kapany Collection,* 1998.69 (p. 108).

The unusual shape of this helmet was dictated by the needs of the Sikh warrior who wore it into battle, his uncut hair rolled into a topknot and set comfortably into the additional space provided atop. Uncut hair was, and still remains, an important symbol of Sikh faith. One of five emblems adopted in the face of religious persecution during the seventeenth century, it signaled the wearer's belief in an egalitarian religion that stressed the existence of a universal reality. Sikhs took up arms to defend their faith, and the martial excellence eventually attained by their forces was lauded by friend and foe alike.

This helmet is but one example of the beautiful functionality found in much Sikh military gear. The steel helmet is adorned with a decorative gold trim while the steel and brass links of the neckguard are arranged in a shimmering diamond pattern. The links themselves are said to be connected in such a manner that the whole neckguard reflects the churning waters at the confluence of the Ganga and Yamuna, India's greatest rivers.

GURU NANAK AND HIS DISCIPLE ENCOUNTER A MUSLIM CLERIC AT MECCA, 1800–1900. India; possibly Patna, Bihar state, or Lucknow, former Avadh region, Uttar Pradesh state. Pigments on paper. *Gift of the Kapany Collection,* 1998.58.23 (p. 109).

This painting, from a rare complete manuscript, illustrates a well-known encounter at Mecca between a Muslim holy man and Guru Nanak (1469–1539), Sikhism's historical founder. On a journey to this holy site, Nanak had slept with his feet toward the K'abah, a structure believed to be a locus for the divine presence. He was duly berated by the holy man for this show of disrespect. Guru Nanak's response: "Show me where God is not present so I may point my feet that way"—reveals his penetrating wisdom and is typical of his life stories.

Nanak is shown here with his Muslim disciple, Mardana. Nanak himself was born into a Hindu family, but he would disavow the caste system and the Hindu emphasis on ritual. Nor would he remain uncritical of what he considered Islamic intolerance. Instead, his teachings preached the unity of religion, placing particular emphasis on moral conduct and the equality of all people before a universal god.

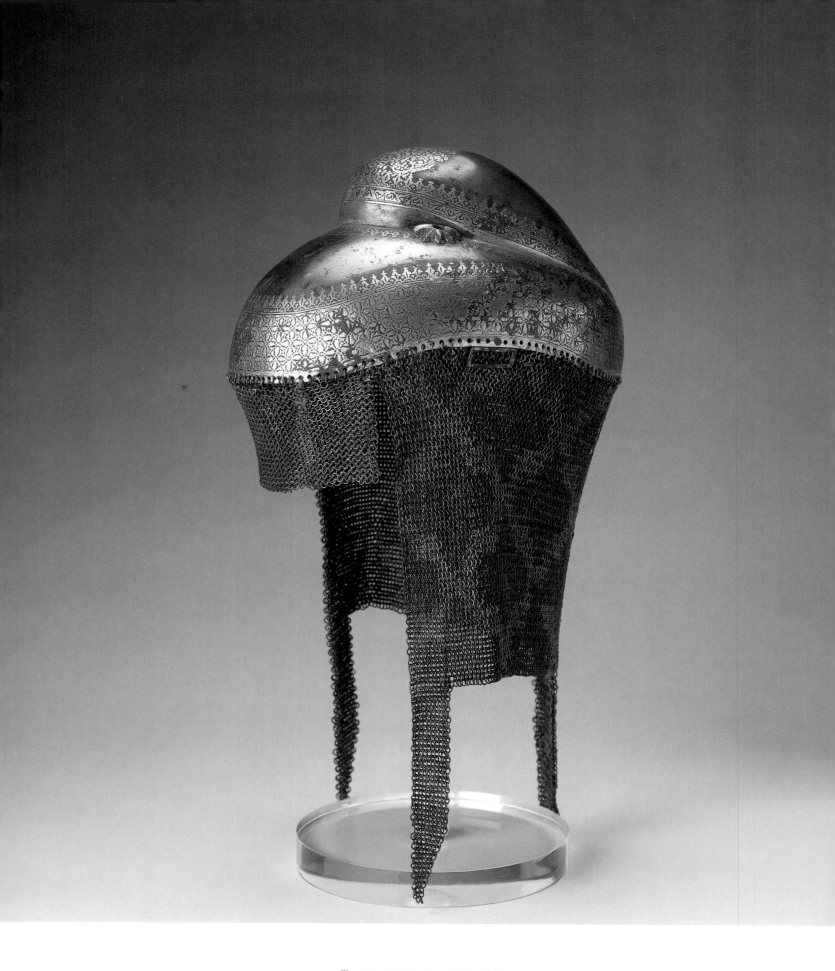

Turban helmet, 1820–1860. Pakistan.

GURU NANAK AND HIS DISCIPLE ENCOUNTER A MUSLIM CLERIC AT MECCA, 1800–1900. India.

The Persian World and West Asia

The Moghadam Family Gallery

Gallery 7

Persian and other Islamic wares also figure prominently in an exhibit of pan-Asian ceramics, located in the second-floor Loggia (see p. 216)

SMALL CONTAINER (*DURJ*), approx. 1450. Iran, Turkmenistan, Uzbekistan, or Afghanistan. Timurid period (approx. 1370-1505). White jade (nephrite). *The Avery Brundage Collection*, B60J619 (p. 113).

Though Persian and West Asian art made up a relatively small part of the Avery Brundage Collection, its five hundred ceramics, bronzes, manuscript pages, and decorative objects from that region deserve to be better known. A limited group were displayed on the loggia of the museum's former building in Golden Gate Park, but in the new Asian Art Museum the arts of the Persian world, both before and after the coming of Islam, have a small gallery of their own. This gallery is entered from the area including art from the Mughal Empire of India and Pakistan, in order to highlight the strong connections between Persian art and Mughal art.

Five-thousand-year-old Iranian ceramics are among the most ancient objects on view in this gallery. Nearby are striking figures of stags, mountain goats, and strange mythical creatures in both ceramics and bronze from the first millennium BCE.

Arts of the Islamic period fill the rest of the gallery. The museum's collection is strongest in ceramics, and intensely colored, often luster-glazed pieces survey a thousand years of Persia's brilliant ceramic tradition. Complementing the ceramics are jewelry, metalwork, architectural decoration, and the arts of calligraphy in manuscripts, bronze, and stone carving. These come not just from within the borders of today's Iran, but from other areas once under the influence of Persian culture in Afghanistan, Iraq, Turkmenistan, and Uzbekistan.

The importance of Islam in other parts of Asia—China, India, Indonesia, and the Philippines—is noted in the museum's wall texts and other educational materials. For instance, though the crucial role of Arab and Persian merchants in the Asian economy is well known, scholars are just beginning to understand the involvement of Chinese Muslims in international trade. Occasionally an artwork, such as an eighteenth-century Chinese bronze inscribed in Arabic, "There is no other than the one God" is displayed to reinforce these points.

CHEEKPIECE OF A BRIDLE IN THE FORM OF A FANTAS-TIC CREATURE, 1000–600 BCE. Iran; Luristan region. Bronze. *Avery Brundage Collection,* B60B17+ (p. 112).

ELLIPTICAL CUP, 1400–1500. Iran, Turkmenistan, Uzbekistan, or Afghanistan. Timurid period (approx. 1370–1505). Nephrite. *The Avery Brundage Collection,* B60B17+ (p. 113).

DISH WITH FLOWER AND LEAF DESIGNS, 1450-1500. Iran, probably city of Nishapur. Timurid period (approx. 1370–1505). Fritware with underglaze slip decoration. *Avery Brundage Collection,* B60P1799 (p. 114).

The enigmatic bronzes from the Luristan region of western Iran have puzzled researchers for many decades. Museums around the world hold thousands of examples, ranging from horse bits to weapons to bracelets, but few of these have been scientifically excavated. Most appeared on the antiquities market with no reliable information about where or in what context they were found. Because of their popularity, they have been widely faked.

The ethnicity, language, and religious beliefs of the people who made them are unknown, so the meanings of the motifs on the bronzes can only be guessed at. Here, a sort of sphinx, with horns or horned headdress and a predator's head at its wing tip, tramples a creature like an antelope. What is the connection, if any, with the fantastic animals of other ancient West Asian cultures, such as the human-headed, winged bulls of Assyria, for instance? We may never really know.

Objects like this one come in pairs (its mate is in the Louvre). When they have not been dismantled, the two parts are connected with a rod through the circular hole in the chest. It is usually thought that such rods served as a horse bit, and the so-called cheekpieces attached it to the bridle. Even this, however, is not entirely certain.

While jade is usually associated with China, in recent decades there has been a growing appreciation and understanding of the jade-working traditions of Persia, Central Asia, and India. While these areas had had a long tradition of working other hard stones, such as rock crystal, it was only in the fifteenth century, when the Persian world was ruled by the descendents of the conqueror Timur (Tamerlane), that nephrite—one of the two minerals Westerners call jade—began to be shaped into vessels and ornaments.

The sharp-edged boat-like form of the elliptical cup recalls earlier cups made of metal, which probably supplied the model for this one. Its dragon-shaped handle is also commonly found on earlier metal vessels.

Whereas the cup relies for its effect on its bold shape, the small white jade container relies on the elegant calligraphy painstakingly drilled and ground into its surface. (Nephrite is too hard to carve.) Its main inscription tells us that it was commissioned by Ala'uddawla (1417–1460), a great-grandson of Sultan Timur. Later, in 1621, it made its way into the possession of another of Timur's descendents, the Mughal emperor Jahangir (reigned 1605–1627). He too had it inscribed, in tiny letters along its rim: "This jade container is soul-nourishing due to Jahangir Shah. . . . So long as the vessel of the heavens revolves, let the world be Jahangir Shah's."

The painter of this dish has set the flowers, tendrils, and leaves spinning like a pinwheel. The decorator also seems to have delighted in contrasting darker motifs on a lighter background with lighter motifs on a darker background.

In the century after the death of the conqueror Timur (Tamerlane) in 1405, the Persian world, under his successors, saw an enduring fashion for things Chinese. Chinese ceramics, including blue and white, celadon, and Cizhou wares, had been imported for hundreds of years, and collections were owned by aristocratic families. Now Persian potters in many manufacturing centers copied or drew inspiration from Chinese wares to meet a demand for dishes in the Chinese style.

The group to which this dish belongs takes many motifs from Chinese Yuan and Ming dynasty Cizhou wares, and has been called by scholars the "Cizhou scroll" group. Four examples of this "Cizhou scroll" group have inscribed dates which range between 1468 and 1495. The best known Cizhou wares were painted in dark brown on tan, but some, like this dish, had black painting under a turquoise glaze. The painter of this dish has set the flowers, tendrils, and leaves spinning, like a pinwheel. The decorator also seems to have delighted in contrasting darker motifs against lighter backgrounds and vice versa

This dish was formerly in the collection of the famous Paris dealer (of Armenian extraction) Dikran Kelekian (1868–1951.) A photo of it was published in 1938 while it was on loan from Kelekian to the Victoria and Albert Museum in London.

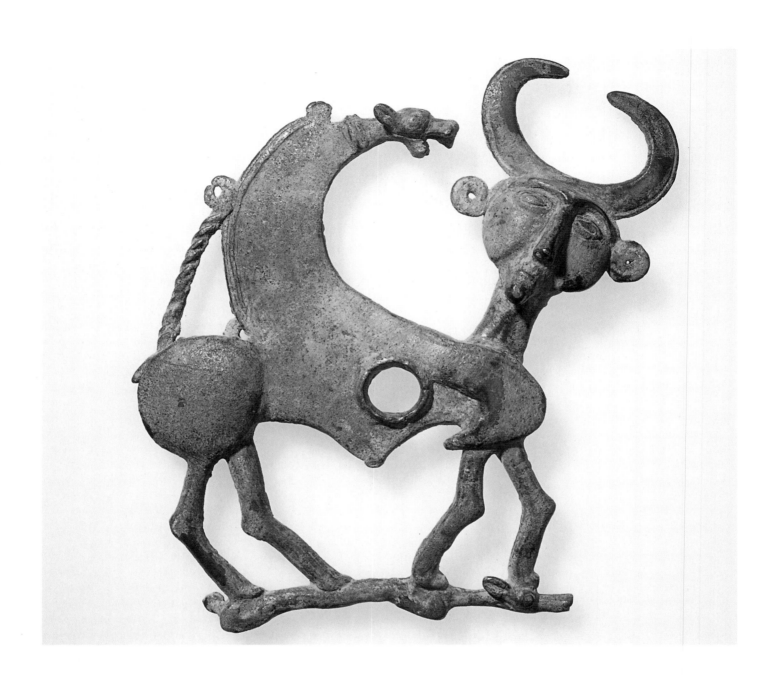

CHEEKPIECE OF A BRIDLE IN THE FORM OF A FANTASTIC CREATURE, 1000–600 BCE. Iran.

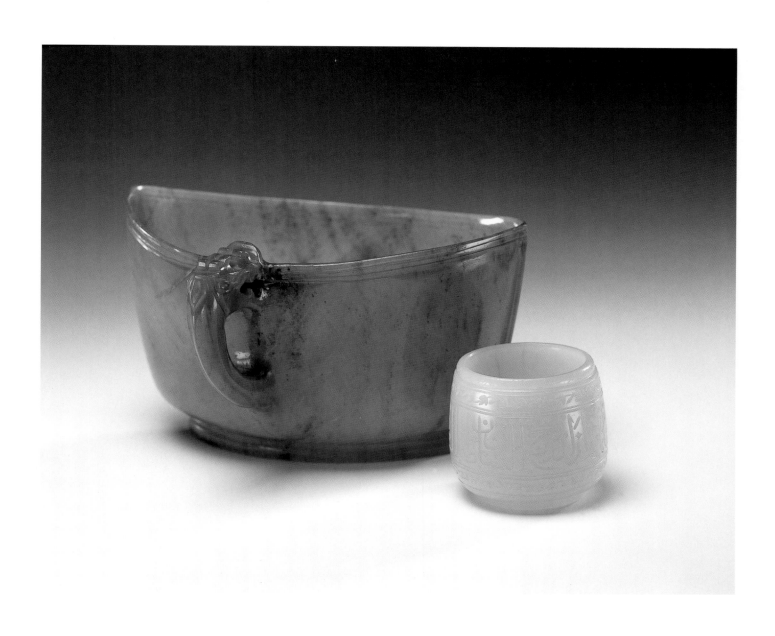

ELLIPTICAL CUP, approx. 1400–1500. Iran, Turkmenistan, Uzbekistan, or Afghanistan.

SMALL CONTAINER, approx. 1450. Iran, Turkmenistan, Uzbekistan, or Afghanistan.

KORAN, approx. 1550. Iran; Shiraz. Gold and colors on paper; binding of leather, lacquer, gold, and color. *The Avery Brundage Collection,* B76D12 (p. 116).

The Safavid dynasty (1501-1736) was heir to the great manuscript illumination traditions developed under their Timurid predecessors. A distinctive style quickly emerged, however, as Safavid artists combined various elements of local artistic traditions—the Timurid with the Turkish, and the religious with the secular. The refined Safavid aesthetic had a decisive impact on the art of the Ottoman dynasty, to its west, and of the Mughal dynasty, to its east. In fact, Safavid Korans of this very type are known to have been among the imperial possessions of both.

Shiraz, a provincial city and important cultural center in southwestern Iran, was home to some of the finest manuscript-producing workshops of the sixteenth century. Although most Korans from Shiraz give no information regarding the scribe, illuminator, or patron, the extremely high quality of this example suggests courtly patronage of the most talented artists.

Korans produced under the Safavid dynasty (1501-1736) continue earlier manuscript traditions in their luxurious gold and blue pigments. They are also notable for their finely wrought ornaments and calligraphy, as well as the addition of decorated pages before and after the main text.

Typical of Safavid Korans are ornate two-page spreads containing the opening chapter of the Koran (*Surah-al-fatihah*). This chapter begins in the central medallion of the right-hand page with the invocatory verse known as the *bismillah*: "*In the name of God, the Merciful, the Compassionate.*"

Following are six verses praising God and requesting his guidance:

> Praise be to God, Lord of the universe;
> Most Gracious, Most Merciful;
> Master of the Day of Judgment.
> You alone we worship; You alone we ask for
> help,
> Guide us in the right path:
> The path of those whom You blessed; not of
> those who have deserved wrath, nor of
> those who stray.

Small panels above the main text contain chapter information, while those below enclose additional pious verses.

KORAN, approx. 1550. Iran.

Gallery 8
Early Southeast Asia

The Society for Asian Art Gallery

DRUM, approx. 200 BCE–100 CE. Probably Vietnam. Bronze. *The Avery Brundage Collection*, B62B33 (p. 118).

A long, narrow boat is rowed out to sea. Armed men in tall, feathered headdresses, standing amidship, listen to the thunderlike beating of a bronze drum.

Some two thousand years later, that drum stands at the entrance to the museum's Southeast Asian galleries. A yard across, with high reverberant walls, it is of a 2000-year-old type that originated in northern Vietnam but is found scattered throughout both the mainland and the archipelago, suggesting wide travel or far-flung trade.

Many such drums are decorated with low relief depictions of boats, feather-decked figures, and even drums like themselves. The meaning of these scenes is far from clear—heralding a chieftain's arrival? simulating thunder to produce rain? transporting the dead to the netherworld? Like much else having to do with early Southeast Asian life, the drums' evidence is tantalizingly hard to interpret.

Subsequent Southeast Asian galleries display artwork of somewhat more familiar types: images of Hindu and Buddhist deities, fragments of the decoration of great temples, luxury items for use in royal courts. What happened between the creation of the bronze drum and these religious and courtly objects to so transform Southeast Asian cultures? Maps, text panels, and video clips sketch the story. Over several centuries, Southeast Asians became acquainted with the religions, sacred languages, and arts and sciences of India (or in Vietnam, of China), and adapted them for their own use. Eventually, flawless Sanskrit was employed from Cambodia to Java for ceremonial purposes .

Comparison to Indian art and culture is a recurring theme in the Southeast Asian galleries, as are similarities and differences among the complex and varying traditions of Burma, Cambodia, Indonesia, Laos, Malaysia, the Philippines, Thailand, and Vietnam. To clarify relationships and facilitate comparisons, the galleries are arranged chronologically, but with artworks from the mainland grouped separately from those from the islands. The final gallery, which covers the period from colonial times to the present, features art forms that have seldom survived from earlier periods, such as ivory carving, sumptuous textiles, and puppetry.

Highlights of the Early Southeast Asia gallery include bronze jewelry and richly decorated pottery vessels of the ancient Ban Chiang culture of northern Thailand. A 1400-year-old limestone burial urn from the southern Philippines, carved with the head of a human figure, is particularly remarkable.

DRUM, approx. 200 BCE–100 CE. Probably Vietnam.

Gallery 9
Southeast Asia 600–1300

The Tully and Elise Friedman Gallery

COVERED JAR, 1000–1200. Northern Vietnam. Stoneware with ivory and brown glazes. *The Avery Brundage Collection,* B62P53 (p. 120).

THE HINDU DIETY SURYA, 800–900. Indonesia; Central Java. Bronze. *Gift of the Walter and Phyllis Shorenstein Fund, the Connoisseurs' Council, and museum purchase,* 1995.21.a-b (p. 121).

HEAD OF THE BODHISATTVA AVALOKITESHVARA, approx. 925–975. Cambodia. Stone. *The Avery Brundage Collection,* B68S1 (p. 122).

Early Vietnam was often under Chinese domination but by the time this jar was made it had achieved independence under native dynasties. The Vietnamese now created ceramic wares, like this large jar, of a distinctive character, vigorous and tactile. They experimented freely, drawing inspiration from a variety of sources. The shape of this jar, with lobes outlined by rounded rectangular frames and its decoration of lotus petals in relief, strongly suggest a metalwork prototype. These forms may derive from the gold- and silverwork of Vietnam's southern neighbor, the Hindu-Buddhist kingdom of Champa. The jar's feet are in the form of crouching human figures called "Cham slaves" by the Vietnamese.

In the ninth century, Central Java must have been one of the most cultured places in the world. The greatest of its Buddhist and Hindu architectural monuments such as Borobudur and the Shiva Temple at Prambanan, and its sculpture in stone, bronze, and precious metals, are of unsurpassed profundity and refinement.

This stunning bronze represents the Hindu sun god Surya and his retinue. Surya is shown as a handsome young man wearing a sarong-like garment, elaborate jewelry, and, appropriately for one of supposed Iranian origin, a pair of boots. In contrast to the formal immobility of his pose, motion is suggested by the female archers drawing their bows at left and right, and the backward-rearing horses drawing the god's chariot.

A sense of great strength tempered by inner warmth marks the faces of sculptures of Cambodia's Angkor kingdom. Westerners have often found these faces enigmatic, so stylized, yet so conscious and alert do they seem. Mystery also surrounds this more than twice life-sized head, identifiable as the bodhisattva Avalokiteshvara by the seated Buddha image at the front of its hairdress. Buddhism came to Cambodia early in its history, some 1500 years ago, and was often important there. From the period of this sculpture, the early or mid tenth century, however, very little Buddhist art remains. Characteristics such as the details of crowns and the modeling of facial features usually make dating Angkorian sculptures fairly straightforward. But if the date assigned to this sculpture is correct, where is the other Buddhist sculpture of its period? The statue from which this head came must have been, if standing, about ten feet tall. Can the temple it came from, and its presumably equally large companion statues, have disappeared without a trace?

A Buddha image and two very important bronze bodhisattvas from a hoard discovered at Pra Khon Chai in northeastern Thailand in 1964 are notable in this gallery, as are thirty sculptures and ceramics from the great Cambodian kingdom of Angkor and its provinces, along with lintels and other architectural elements from temples of Angkor, displayed to evoke their original placement; a group of thirteenth-century stone sculptures from the kingdom of Champa, now in southern Vietnam; and bronze and stone sculpture from the ninth-century kingdom of Java that produced the superb Buddhist monument of Borobudur.

COVERED JAR, 1000–1200. Vietnam. THE HINDU DEITY SURYA, 800–900. Indonesia. >

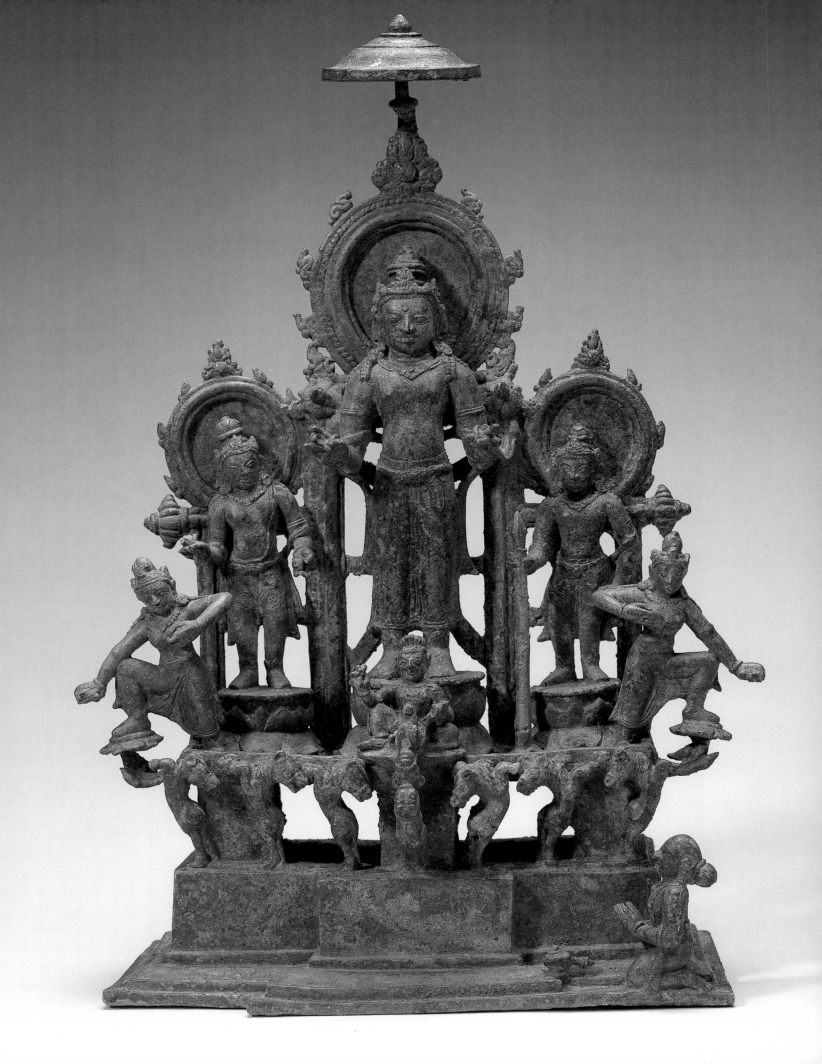

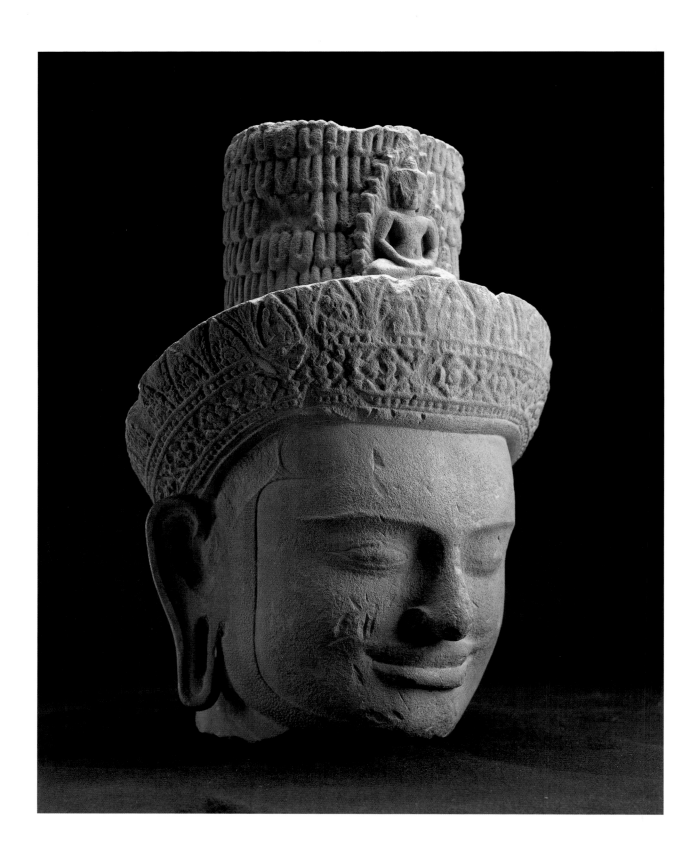

HEAD OF THE BODHISATTVA AVALOKITESHVARA, approx. 925–975. Cambodia.

Gallery 10
Southeast Asia 1300–1800

The Phyllis C. Wattis Gallery

DAUGHTERS OF THE DEMON MARA, 1470s. Southern Burma; former kingdom of Pegu. Glazed terra-cotta. *Museum purchase,* B86P14 (p. 124).

HEAD OF AN IMAGE OF THE HINDU DEITY SHIVA, approx. 1500–1600. Thailand; possibly former kingdom of Sukhothai, but said to have been excavated in the city of Ayutthaya. Leaded bronze with mother-of-pearl inlay and traces of gilding. *The Avery Brundage Collection,* B60S18 (p. 125).

PAIR OF DOOR GUARDIANS, approx. 1300–1400. Indonesia; East Java. Andesite. *Gift of the Connoisseurs' Council, Walter Jared Frost, and David Salman,* 1997.6.1-.2 (p. 126).

As the Buddha sat meditating during the period of his enlightenment, the demon Mara, a personification of negative impulses, sent his daughters to tempt him. Trying to suit any taste, they magically appeared as women of various ages and occupations. The Buddha, of course, resisted all. The daughters depicted here are said in an inscription to be assuming the form of "a virgin having no children." In addition to richly patterned skirts and scarves, they wear crowns, jeweled discs in their earlobes, and jeweled collars and pendants.

This plaque comes from a ruined temple complex in the former Mon kingdom of Pegu in Burma. Built under royal patronage, the complex included shrines dedicated to various events during and immediately after the Enlightenment.

This gallery includes crowned and uncrowned Buddha images, as well as images of guardians and Hindu deities, illustrating the quality and range of Thai sculpture in this period. Also featured are extensive selections of vessels from the Connell Collection of Thai Ceramics (Ceramic sculptures from this collection are juxtaposed with sculptures in other materials to facilitate comparison); lovely Vietnamese blue-and-white ceramics decorated with flower scrolls, dragons, and landscapes; and sculptures and miniature temples from the eastern Javanese kingdom of Majapahit.

This head can be recognized as Shiva by the third eye in its forehead and the crescent moon and Shivite symbol on the upper part of the headdress. Although the kings and the people of the Thai kingdoms were Buddhists, Hindu deities and their lore continued to be familiar. Some Hindu deities had long had a role, though a secondary one, in Buddhist mythology. Brahma and Indra, for instance, attended the Buddha when he descended from Indra's heaven after going there to preach to his deceased mother. Images of Hindu deities seem to have been used in royal ceremonies carried out by court brahmans.

A number of such images survive. Most of them have traditionally thought to have been made in the kingdom of Sukhothai (mid 1200s-1438) in north-central Thailand. Their dating has been very controversial, however, and it is far from certain where most of them were made.

Helping to date this head is a crowned Buddha image from the Sukhothai area that has an inscribed date equivalent to 1541. Both its facial features and its crown are similar to those of this head, making a similar date seem appropriate. Thermoluminescence testing has yielded a probable age for this object of 350 to 600 years.

Brandishing their weapons, baring their fangs, and glaring menacingly, these guardians seem to take their job seriously. It is hard, however, not to see them as mock-ferocious. In Southeast Asia (as elsewhere), bouncers and their kin often cannot avoid coming across as slightly (and in these instances, charmingly) ridiculous.

These figures would have flanked the entranceway of a Hindu temple in the kingdom of Majapahit (approx. 1300–1500) centered in East Java. After the fall of Majapahit, much of the rest of Indonesia embraced Islam, and Hindu culture in Indonesia survived primarily on the island of Bali.

An excavation between 1910 and 1915 in the Mojokerto region of East Java brought these figures to light. A former Asian Art Museum curator, Kristina Youso, continues the story: "They were subsequently presented as a gift to the then Dutch governor general of East Java, Mr. van Aalst, by the local Javanese regent. In 1918, when van Aalst retired, he received permission to export the figures. Van Aalst eventually settled, with his collection, in California."

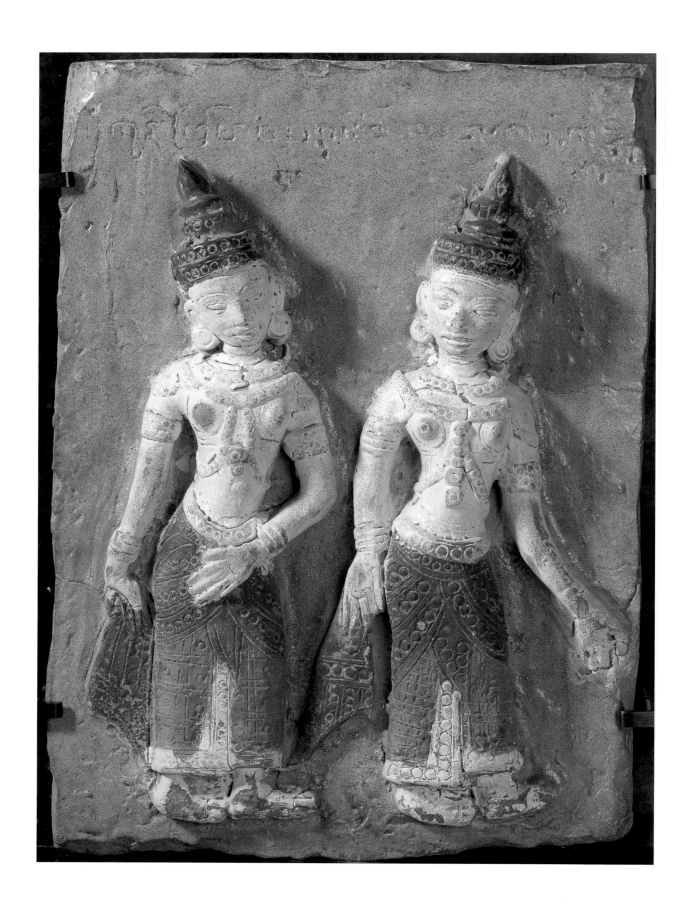

DAUGHTERS OF THE DEMON MARA, 1470–1480. Burma

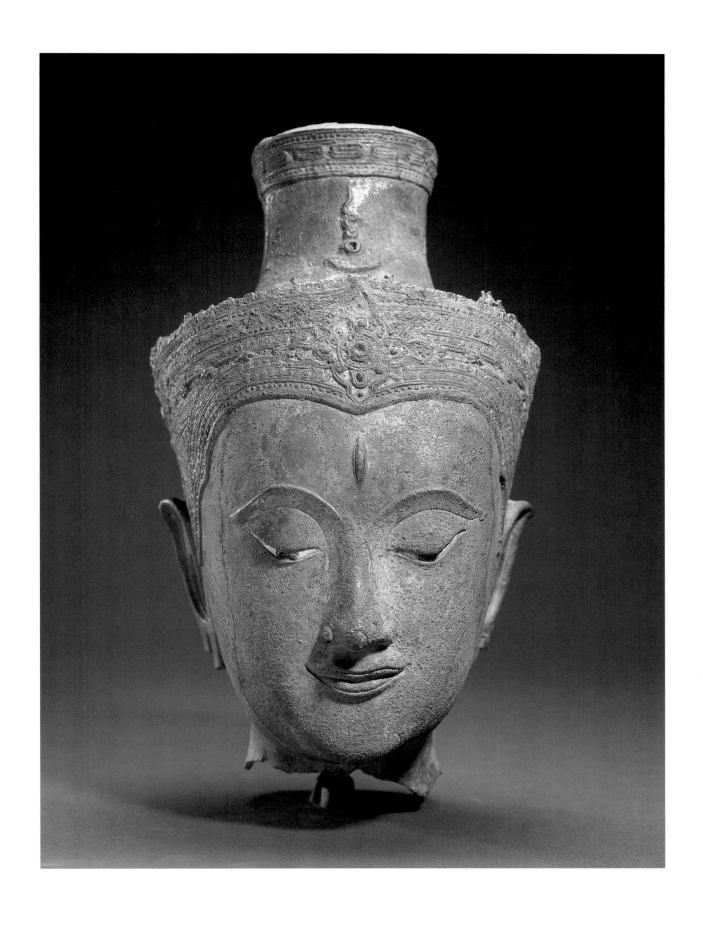

HEAD OF AN IMAGE OF THE HINDU DEITY SHIVA, approx. 1500–1600. Thailand.

PAIR OF DOOR GUARDIANS, approx. 1300–1400. Indonesia.

DAGGER (*KRIS*), approx. 1600–1800. Indonesia; Sumatra and Java. Steel, gold, wood, and enamel. *Gift of the Christensen Fund*, R1988.6.53 (p. 128).

THE TALE OF CHANDAKUMARA, FROM AN ILLUS-TRATED MANUSCRIPT, 1650-1750. Central Thailand; former kingdom of Ayutthaya. Ink and pigments on paper, *Museum purchase*, 1993.11.2 (p. 129).

HEADCLOTH, 1900–1960, Southern Philippines; Sulu archipelago, Tausug people. Tapestry weave silk. *Museum purchase*, 1993.25 (p. 130).

When a hero in a Javanese dance-drama turns around, we see, at the small of his back, tucked into his sash, his most important ac-couterment, the *kris,* or dagger. In the old days many Malay and Indonesian men routinely wore a kris, but now the weapon appears only at ceremonial occasions. Great krises are still treasured, however, and not just for their beauty or venerable age. They have significant symbolic associations, and some are said to have the power to turn away flames, control floods, or fly to their master's defense. Gold decorates both the blade and sheath of this exceptionally fine kris. Its hilt is intricately carved with foliate motifs from which emerge the eyes and snout of a little creature.

In the final Southeast Asian art gallery, containing works since 1800, we find a grimacing head from a famous set of sculptures of hermits suffering various pains and diseases at Wat Pho in Bangkok; Thai decorative arts from the period of "The King and I"; a panoply of krises—heirloom ceremonial daggers—from many islands of Indonesia as well as Malaysia, the Philippines, and Thailand (Several have been said to be of "national treasure quality"); and rotating selections of fine old Javanese puppets carved of wood and dressed in batik and velvet costumes, from the collection of Mimi and John Herbert, recently received by the museum—the puppets represent the heroes and villains of the Indian epic Mahabharata and other literary works and folk tales.

Before his last life, in which he attained buddhahood, the Buddha-to-be lived many previous lives perfecting the necessary virtues and capacities. The stories of the last ten lives are particularly well known in Thailand, and are frequently represented in murals and manuscripts. Here the climactic moment of the seventh story is depicted. The Buddha-to-be was Chandakumara, the wise son of a fool-ish king. One night the king dreamed of living in a luxurious paradise. The next day he was determined to gain entrance to the paradise, and against the warnings of his son accepted the word of an evil advisor that to do so he must sacrifice many of his relatives and his people. As the sacrifice was about to begin, the wife of the young prince appealed to the gods to intervene. Indra, the king of the gods, did so, and everyone was saved. Indra is shown wielding a mallet to break down the ceremo-nial parasols decorating the place of sacrifice. Courtiers pay homage to the wise prince while the people punish the evil advisor.

This painting, though damaged, is an important example of the sumptuous manu-script illustration of the Thai kingdom of Ayutthaya. The destruction of the capital by the Burmese in 1767, together with the dep-redations of insects and the elements, have allowed few such paintings to survive.

Dozens of fine textiles are included in the museum's Southeast Asian collection, and selections are displayed on rotation in the new galleries. This striking cloth from the Sulu Islands in the southern Philippines would have been folded and wrapped by a man into vari-ous sorts of head covering. Studying its com-plicated patterns shows how carefully the weaver has established symmetry and regular-ity, then introduced subtle variations. Dia-monds, crosses, chevrons, and zigzags—many having multiple stepped borders—crowd together in a dazzling display. Then, just as the mind grasps the pattern, the eyes play a trick, and figure and ground suddenly reverse. In the Sulu archipelago, as in most of Southeast Asia, fine cloth was highly prized, and textiles were among the most important articles in interna-tional trade. Sometimes large pieces of cloth, and even completed garments, were im-ported. Sometimes, however, as here, luxury yarn was imported to be woven locally.

DAGGER, approx. 1600–1800. Indonesia.

The Tale of Chandakumara, 1650–1750 (detail). Thailand.

HEADCLOTH, 1900–1960. Philippines.

THE WITCH RANGDA, approx. 1800–1900. Indonesia; Bali. Painted wood. *Gift of Thomas Murray in memory of his father Eugene T. Murray, 2000.37* (p. 132).

CROWNED AND BEJEWELED BUDDHA IMAGE AND THRONE, approx. 1850–1900. Burma (Myanmar). Lacquered and gilt wood and metal with mirror inlay. *Gift from Doris Duke Charitable Foundation's Southeast Asian Art Collection,* F2002.27.1 and .2 (p. 30).

In Balinese mythology, Rangda is a powerful, frightening witch associated with the warlike Hindu goddess Durga.

Rangda appears in one of the best-known Balinese ritual dance-dramas as the black-magic-wielding opponent of the lion-monster *barong ketet.* The costume representing Rangda, like this sculpture, emphasizes her shaggy hair, bulging eyes, curving fangs, pendulous breasts, and extremely long fingernails.

In the dance drama, the barong seems, at one point, to be loosing the struggle with Rangda. Warriors attempt to assist the barong by attacking Rangda with their daggers (krises), but she uses her magic power to make them turn their weapons against themselves. They survive, and the performance ends with Rangda not killed, but driven away.

This sculpture is unusual in style, lacking the elaborate surface decoration of much traditional Balinese sculpture. Technical examination has revealed layers of different colored paint under the present paint, and many old repairs. These facts suggest age and extensive use.

Such an elaborate throne and Buddha image would have been an important fixture of a nineteenth-century Burmese Buddhist temple, and similar ones can still be seen in temples today.

The significance of the crowned and bejeweled Buddha image varied in different places and periods. According to a tradition known in Thailand and Burma for the last several centuries (and perhaps considerably longer), an arrogant king named Jambupati once attempted to awe the Buddha with his grandeur. In response, the Buddha manifested himself in the most magnificent crown and royal finery to teach that the grandeur of buddhahood vastly outshines that of earthly kingship.

The original crown of this Buddha image disappeared long ago. The one the image now wears was made in traditional techniques and style in 2002 by U Win Maung, an expert artisan in Mandalay, Burma. (The photo shows the throne as it was displayed at Doris Duke's New Jersey estate.) The rest of the Buddha image's royal decorations appear to be original.

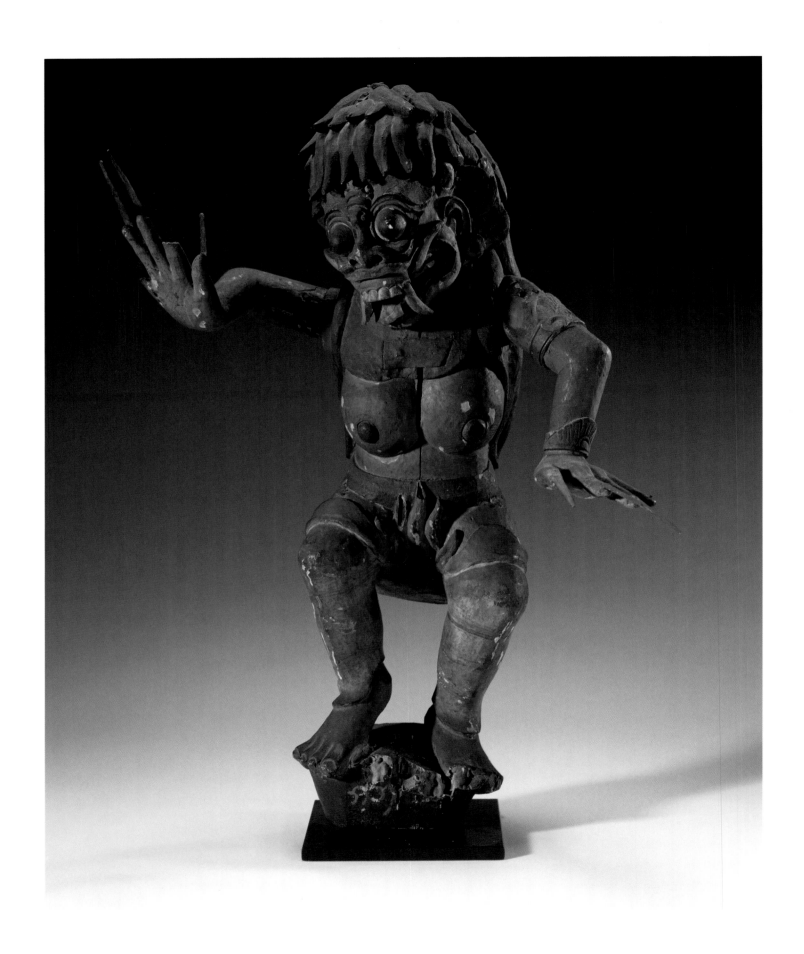

THE WITCH RANGDA, approx. 1800–1900. Indonesia.

The Himalayas and the Tibetan Buddhist World

The Richard C. Blum and Senator Dianne Feinstein Gallery

AUREOLE OF A SHRINE, 1600–1700, Nepal. Gilt copper repoussé, *The Avery Brundage Collection,* B60S201 (p. 133).

THE BUDDHA RATNASAMBHAVA, late 1200s–early 1300s. Tibet; Sakya monastery. Colors on cotton. *Museum purchase, City Arts Trust Fund,* 1991.2 (p. 134).

The more than 170 objects on display in the Himalayan gallery have come from Bhutan, Nepal, Tibet, and other areas influenced by Tibetan Buddhism, such as China and Mongolia. As one enters from the Southeast Asian galleries, one first encounters objects from Nepal, a country where Hinduism and Buddhism co-existed peacefully. The Newari artisans of the Kathmandu valley in Nepal not only made the valley famous in the Tang dynasty for gilt repoussé reliefs but also traveled far and wide decorating the temples of Tibet—during the Yuan dynasty (1260–1368), they even worked for Kublai Khan in what is now Beijing.

Except for one early example, the paintings are displayed together in a single large glass case. The glass can be rolled aside, which makes changing paintings much easier than in the museum's former facility in Golden Gate Park, when numerous screws had to be removed from individual painting frames during a rotation. Some objects that have lain buried for years in storage now see the light of day at last.

The last section of the gallery is devoted to the art of Bhutan. This Himalayan Kingdom is noted for its Buddhist art and its finely woven textiles, of which the museum has a notable collection.

This excellent example of copper repoussé best exemplifies the proficiency of Newari artisans and the persistence of Indian motifs. It was once placed behind a standing figure of a deity, now lost.

The sun bird Garuda surmounts the shrine with his arms outstretched in flight and his feet firmly entrenched on a pair of serpent deities, his arch enemies. The Nepalese are fond of this motif and often include it in their compositions. Although Garuda's principal function is as the mount of the Hindu deity Vishnu, it is not unusual to find him as the crowning motif in Nepalese shrines, Buddhist and Hindu alike. The crocodile-like mythical beasts on the crossbars (*makaras*) are also of Indian origin, as are the lions with riders and bird figures. Here they have been transformed into typical Nepalese motifs with their tails twisted into convoluting masses of leafy tendrils.

A set of three *thangkas* (devotional paintings on cloth) from the Sakya monastery of Tibet was among a number of objects acquired by the museum after the Loma Prieta earthquake of 1989. There were originally five thangkas from this monastery, showing the five Transcendent Buddhas. Commissioned by lamas of the Sakya order of Tibetan Buddhism, the main figure is the golden yellow Buddha Ratnasambhava, the "Holder of the Jewel Treasury." He is attended by a pair of standing Bodhisattvas and is surrounded by sixteen rows of smaller images of the five Buddhas. At the bottom is a row of gods and goddesses, including the white Mahakala and both a white and a red Ganesha, who support Buddha Ratnasambhava in his bestowal of the spiritual wealth of Buddhism.

In the thirteenth century, Newari artists were often commissioned to produce this type of large and detailed thangka by the powerful Sakya monasteries that controlled Tibet under the patronage of Kubilai Khan. The Newari style of this thangka is seen in the predominance of warm red colors, in the large central figure surrounded by small figures in niches, and in the ornate throne surmounted by the sun bird Garuda and bordered with curling lotus tendrils and various animals.

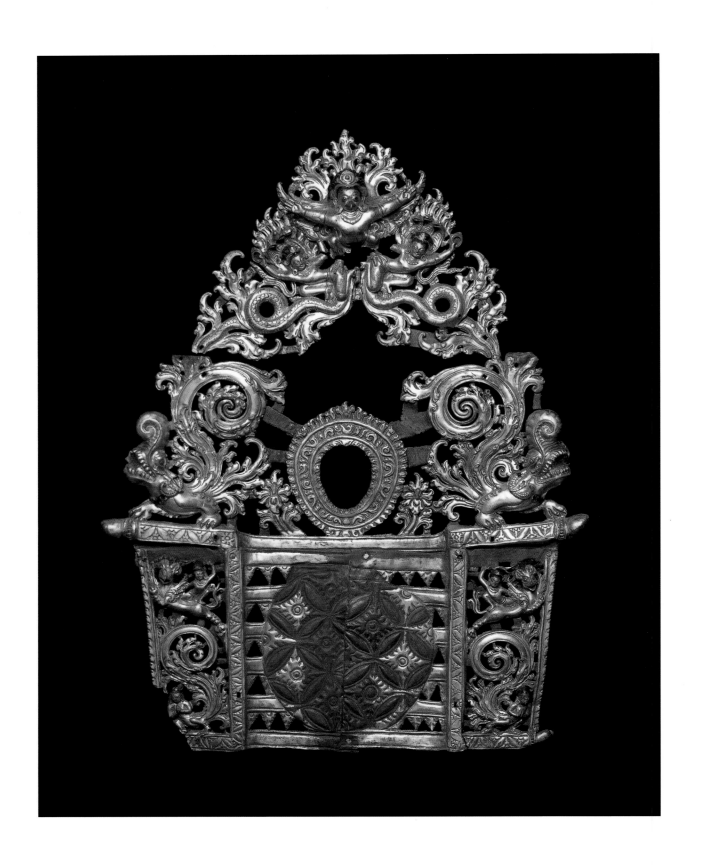

AUREOLE OF A SHRINE, 1600–1700. Nepal.

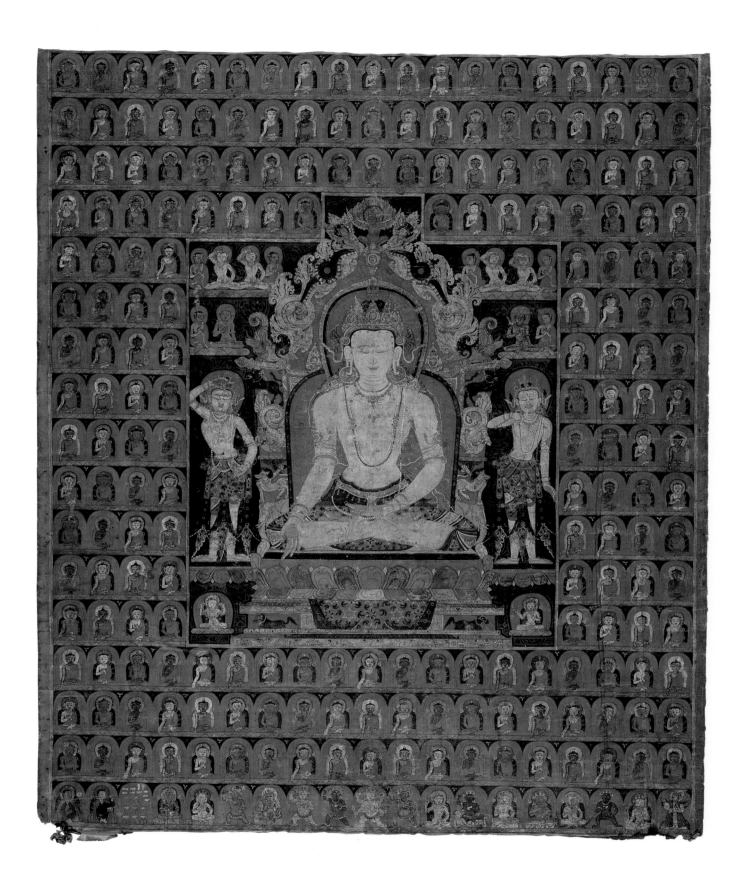

THE BUDDHA RATNASAMBHAVA, late 1200s–early 1300s. Tibet.

THE BUDDHIST DEITY GREEN TARA, early 1200s. Xixia; Western Xia Tangut Empire. *Kesi* (slit silk) tapestry. *Museum purchase, City Art Trust Fund, 1992.59 (p. 137).*

THE BUDDHIST DEITY SHAMVARA, 1600–1700. China. Gilt bronze. *The Avery Brundage Collection,* B60B179 (p. 138).

TSONG KHAPA AS THE BODHISATTVA MANJUSHRI, 1700–1800. Tibet. Colors on cotton. The Avery Brundage Collection, B62D33 (p. 139).

Prior to the arrival of this tapestry, the Hermitage of St. Petersberg was the only museum in the world possessing a *kesi* tapestry of a Tara from the Tangut empire. The Asian Art Museum now owns this rare piece from the same period. This important work is one of a few surviving textiles from prior to 1227, when the Xixia kingdom—whose tenth- through thirteenth-century domain was an area of the Silk Route between China and Central Asia—was conquered by the Mongols. The Tangut people of Xixia were devoted to Tara and made many images of her.

Tara means "Savioress." Green Tara and White Tara are the most beloved goddesses in Tibetan Buddhism. Green is associated with the active compassion of Enlightenment. The goddess holds two lotuses in her hands, symbolizing universal compassion that cares equally for every living being, great or small. Her left hand is raised in the gesture of granting refuge, while her right hand is lowered in the gesture of granting boons.

This image was made in the seventeenth century in the tradition of Yongle period (1403–1424) bronzes, a time when superb images were made for the Chinese emperors as well as for gifts to the high monks of Tibet. The casting, the minute details, and the excellent artisanship make this one of the treasures of the Himalayan gallery.

When Tibetan deities are shown in sexual union, they represent the union of skillful means and wisdom, which leads to enlightenment. Shamvara, who is popular in Tibet, Mongolia, and Nepal, is a principal god (*yidam*) of Tantric Buddhism. His embrace of the goddess Vajravarahi indicates that he is in a state of supreme bliss (*shamvara*). In order to attain this everlasting bliss, he has mastered the attributes held in each of his twelve hands. Each of these represents the ability to remove some obstacle or to perfect some virtue. Shamvara's stepping on the deities beneath his feet symbolizes that he is no longer constrained by the extremes of samsara (the endless cycle of death and rebirth) and nirvana (a state of perfect eternal happiness attained by human beings on achieving buddhahood).

After Tsong Khapa (1357–1419), the founder of the Gelug order of Tibetan Buddhism passed away, he appeared five times to his disciple Khedrub Jey, the second abbot of Ganden monastery. These visionary meetings between master and disciple became popular subjects in thangka painting of the Gelug sect.

In the third vision, Tsong Khapa appeared as Manjushri, the bodhisattva of wisdom. The youthful Manjushri, red in color and resplendent with jewels, is seated on his snow lion mount. His left hand, poised in the gesture of argument, holds a lotus supporting the sacred text of transcendent wisdom, and his right hand wields a flaming sword to cut the chains of karma and dissipate the clouds of ignorance. Khedrub Jey appears as the monk kneeling in the lower right corner, offering a golden mandala to his teacher.

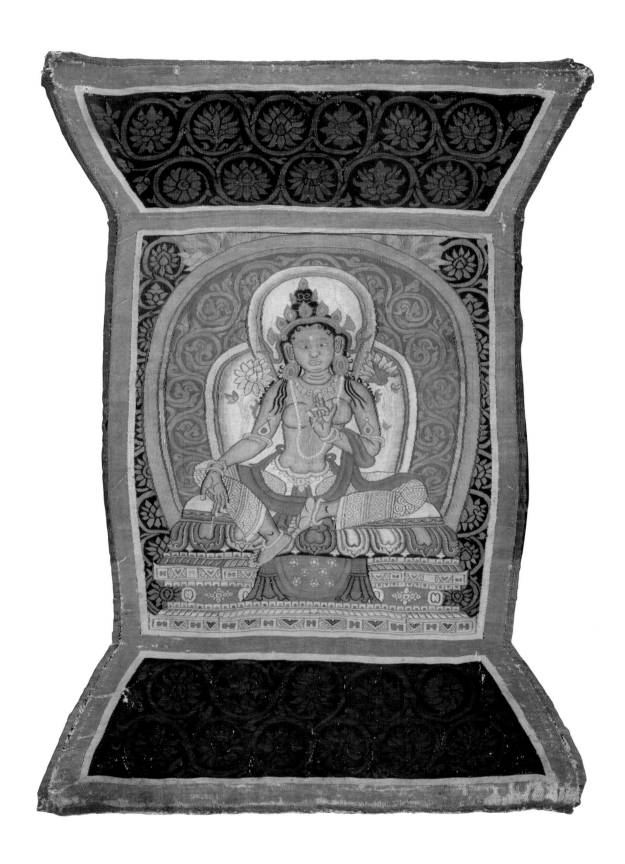

THE BUDDHIST DEITY GREEN TARA, early 1200s. Xixia.

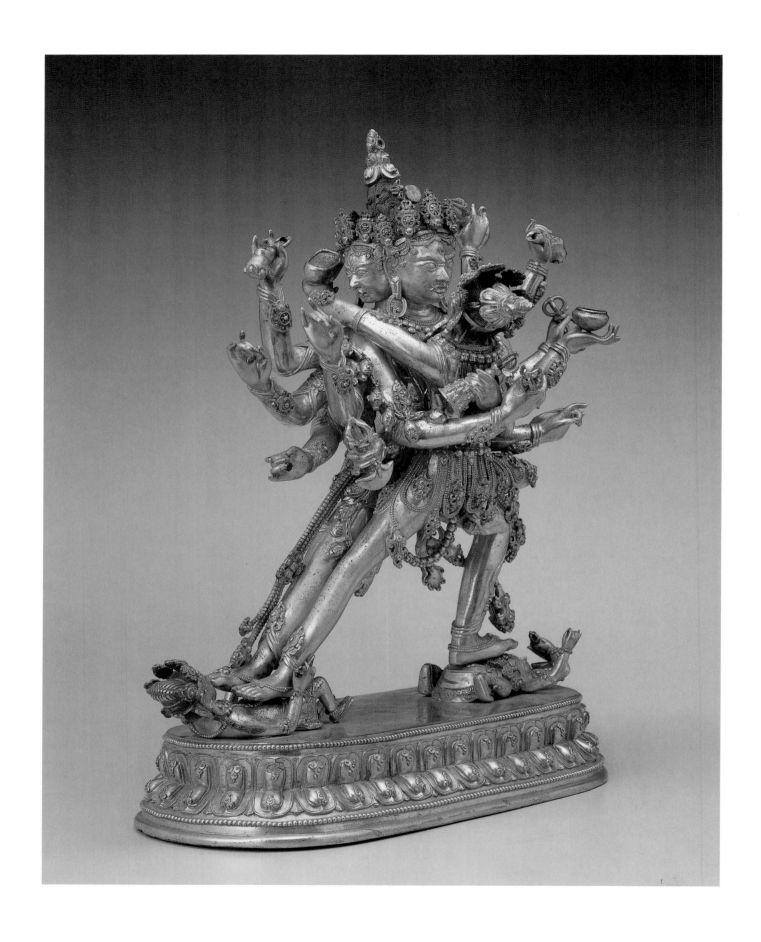

The Buddhist deity Shamvara, 1600–1700. China.

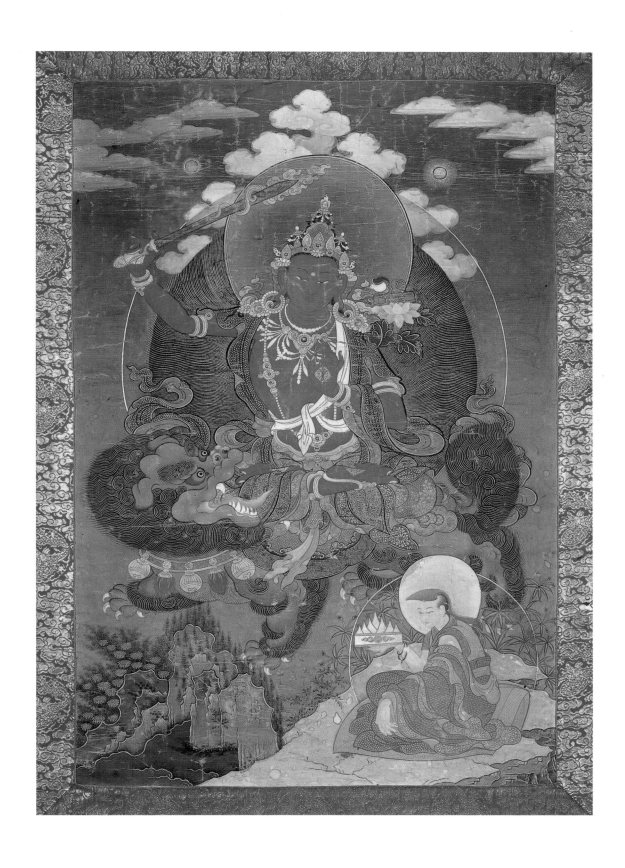

TSONG KHAPA AS THE BODHISATTVA MANJUSHRI, 1700–1800. Tibet.

CABINET FOR STORING OFFERINGS, 1700–1800. Tibet. Painted wood. *Museum purchase, 1997.17.a-.c (p. 141).*

CENSER, 1700–1800. Tibet. Gilt silver. *The Avery Brundage Collection, B60M104 (p. 142).*

DAGGER AND SCABBARD, 1800–1900. Bhutan. Iron blade; scabbard of wood, ray skin, gilt silver, and turquoise. *Gift of Marjorie Bissinger and museum purchase, B86W1 (p. 143).*

Decorated with flaming skulls and festooned with intestines hung with flayed human and animal skins, eyeballs, and organs, this black cabinet for storing cone-shaped dough offerings made of butter and roasted barley flour (*torgam*) was once stored in the *gongkhang* of an unknown temple in Tibet. Forbidden to women and girls, the *gongkhang* is a special room set aside for the worship of wrathful deities, where only initiated males could enter. It is filled with paintings with black backgrounds, images of wrathful deities, animal skins, and weapons.

Dough offerings for worshipping fearsome deities bear sharp and pointed decorations, while those for peaceful deities are more rounded. As befitting such a purpose, this torgam is literally covered with horrific decorations such as skull cups holding the wrathful offering of the five senses (eyes for sight, tongue for taste, nose for smell, ears for hearing, and heart for touch.), the wild ass belong to the terrifying goddess Palden Lhamo, and severed body parts. The top of the cabinet is painted to resemble the ocean of blood upon which Lhamo would ride, with body parts floating amid the waves.

This large censer was once used in the great temple of Palkhor Chodey in Gyantse, Tibet. During major religious ceremonies, rare herbal incenses were burned in this censer as it swayed at the end of a silver chain carried through the rows of meditating Lamas and monks in the temple. The fragrance of the incense is associated with the divine environments and mystic realms into which the monks enter in their meditations.

The inscription on the base of the censer offers worship to the Lama, the principle god (*yidam*) and the Three Jewels (the Buddha, the Doctrine, and the Community of Monks). It notes the names of the monks who donated the censer and even gives the price they paid (415 silver coins). Finally it dedicates the merit of their donation to the early spiritual liberation and enlightenment of the donors' parents along with all other living beings.

In Bhutan, it is the custom for men to carry daggers, and the quality of the dagger indicates the rank of its owner. A dagger such as this one would have belonged to someone of high rank. This dagger, with its fabulously crafted scabbard, has a tapering blade of iron. The silver hilt and pommel are decorated with an openwork design of Buddhist symbols among foliage. The wooden scabbard is covered with ray skin, silver open work, and turquoise. The latter consists of animals and Buddhist symbols scattered among a foliated background.

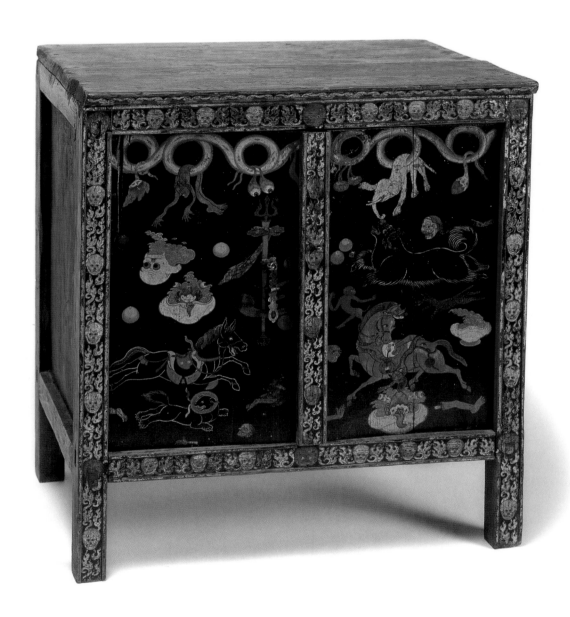

CABINET FOR STORING OFFERINGS, 1700–1800. Tibet.

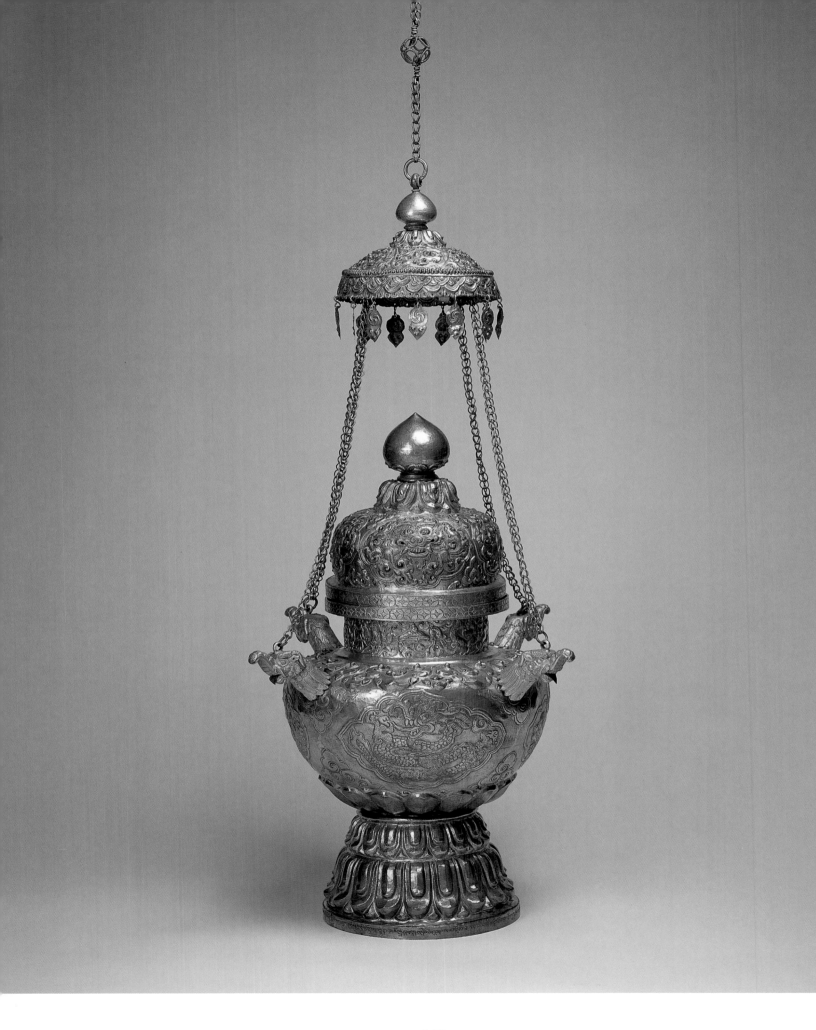

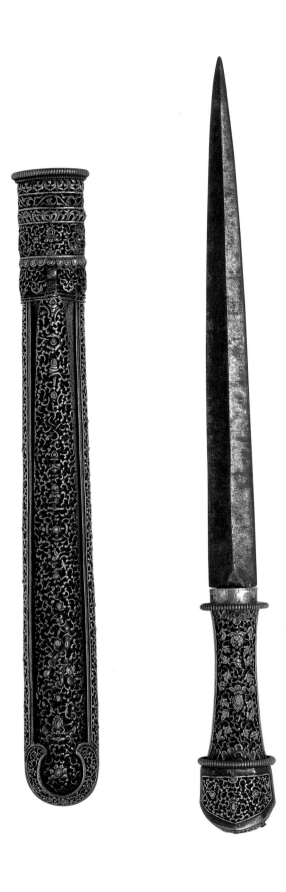

DAGGER AND SCABBARD, 1800–1900. Bhutan.

China

Gallery 13
Chinese Jade Treasury

The Doris Shoong and Theodore Bo Lee Gallery

The core of the Asian Art Museum's collection was assembled by Chicago industrialist Avery Brundage (see p. 16). A focus of Brundage's collecting was the arts of China, which now make up about half of the museum's collection. Yet in its latter years in Golden Gate Park, the galleries dedicated to Chinese art were often either closed or in a much reduced state.

While Chinese art was well represented through a series of marvelous temporary exhibitions, the treasures of Avery Brundage and many others were relegated to storage as the first-floor galleries were used for traveling exhibitions and other needs. At the new Asian Art Museum, this is no longer necessary. Eight galleries on two floors in the west and north wings are devoted to the Chinese collection, with approximately 1,100 objects on display.

As visitors follow the recommended course through the museum, they arrive at the Chinese galleries on the third floor after passing through those dedicated to the arts of South Asia, West Asia, Southeast Asia, and the Himalayas. The Chinese galleries combine thematical and chronological arrangements: by and large the third floor contains the early material while the second floor holds the later; however, the third floor begins with a gallery of jades and concludes with a gallery devoted to Buddhist art.

The first Chinese gallery features jade objects. By totally enclosing the gallery, painting the walls a deep blue, and incorporating the most up-to-date lighting systems, a dramatic "jewel box" effect is created. This provides a visual break from the preceding galleries and shows this collection to its full potential. The cases are densely installed, with approximately 300 pieces—this is a gallery for visual appeal, with limited didactic information. Jades are also be presented in other galleries, where their role in Chinese culture and their relationship to other arts is more fully discussed.

BASIN WITH DRAGON AND DRAGONET, China. Late Song or Yuan dynasty (1200–1368). Nephrite. *The Avery Brundage Collection,* B60J839.

TUBE-SHAPED ORNAMENT, China. Warring States period (approx. 480–221 BCE). Nephrite. *The Avery Brundage Collection,* B60J589.

DEER PRESENTING A PEACH, 1700–1800. China. Qing dynasty (1644–1911). Nephrite. *The Avery Brundage Collection,* B60J374.

TUBE-SHAPED ORNAMENT, approx 480–221 BCE. China.

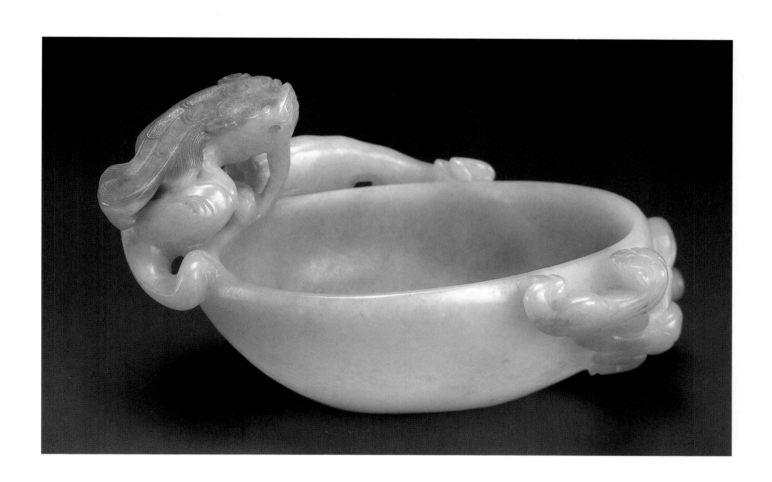

Basin with dragon and dragonet, 1200–1368. China.

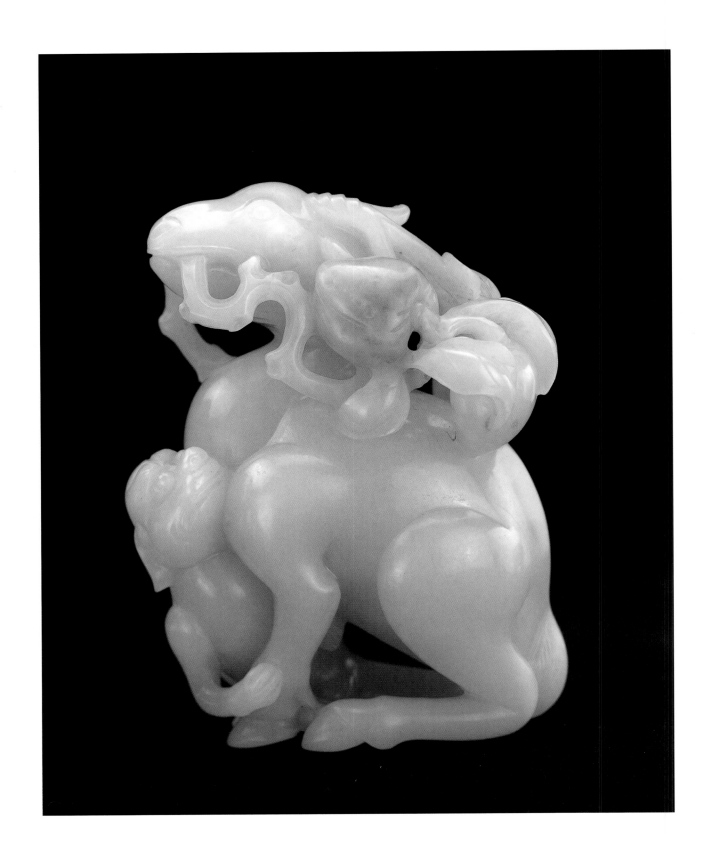

The Edward E. Hills Fund and Geoff and Amy Yang Family Gallery

DOUBLE-HANDLED JAR, approx 2300–2000 BCE. China; Gansu or Qinghai province. Neolithic period, Machang phase of the Majiayao culture. Earthenware with painted decoration. The Avery Brundage Collection, B60P1110 (p. 148).

The angular design on the side of this vessel has been variously interpreted as a human body or a frog. Neolithic period pottery can be divided into two very broad groups: painted pottery, found mainly in northwest China, and unpainted pottery, found mainly along the east coast.

This gallery is dedicated to ritual and funerary arts from the Neolithic period to the beginning of imperial China. It features some of the great treasures of the Avery Brundage Collection. Old friends like the bronze rhino-shaped vessel, the bronze ceremonial wine vessel known as the Yayi jia, *the bronze ritual food vessel known as the* Ran fangding, *and many others can be found here.*

Free-standing cases in the center of the gallery hold some of the great treasures of the early Chinese collection. The labels and text panels for this group are written to be easily understood by the novice visitor taking a general tour of the new Asian Art Museum. Along the walls of this gallery are densely installed floor-to-ceiling cases that allow an in-depth study of a wide range of themes. Videos, text panels, and didactic panels join labels in providing contexts for the objects and explanations of technology, use, and evolution of styles.

CHARIOT fitting. China. Warring States period (approx. 480–221 BCE). Bronze with silver inlay. *The Avery Brundage Collection,* B60B702 (p. 149).

Chariot fittings were an important product of the foundries of Bronze Age China when warfare with neighboring people and among rival clans was a constant fact of life. These chariots and the horses drawing them were deco-rated with symbols of power and protection. The decorations may have served the combined purposes of intimidating opponents, establishing the rank of the person in the chariot, and warding off evil spiritual forces. Elaborate horse-drawn chariots with large numbers of bronze fittings are frequently found in separate burials near (or attached to) major Bronze Age tombs where they might have served to protect the site from evil spiritual forces and to mark the rank of the occupant. This dragon-headed fitting would have been one of a pair from which a crossbow would have hung at the ready within the chariot.

RITUAL WINE VESSEL (*HU*), approx. 480–400 BCE. China. Late Spring and Autumn period or early Warring States period (approx. 480–221 BCE). Bronze. *The Avery Brundage Collection,* B60B1075 (p. 150).

Chinese vessels of the Shang and Zhou dynasties are richly decorated with a repertoire of both real and imaginary animals and abstract designs. The human form, however, is almost never present. It is something of a surprise, therefore, to find two separate traditions of bronze décor that feature narrative passages in which human figures predominate appearing during the fifth century BCE.

This large wine vessel is an example of the type in which the decoration was created as part of the casting process. The blank areas around the decoration would once have been filled with a colored paste. It is widely believed that these depictions of narratives are simplified reflections of a pictorial tradition that would have appeared on buildings, on lacquered wood, or on textiles that have not survived.

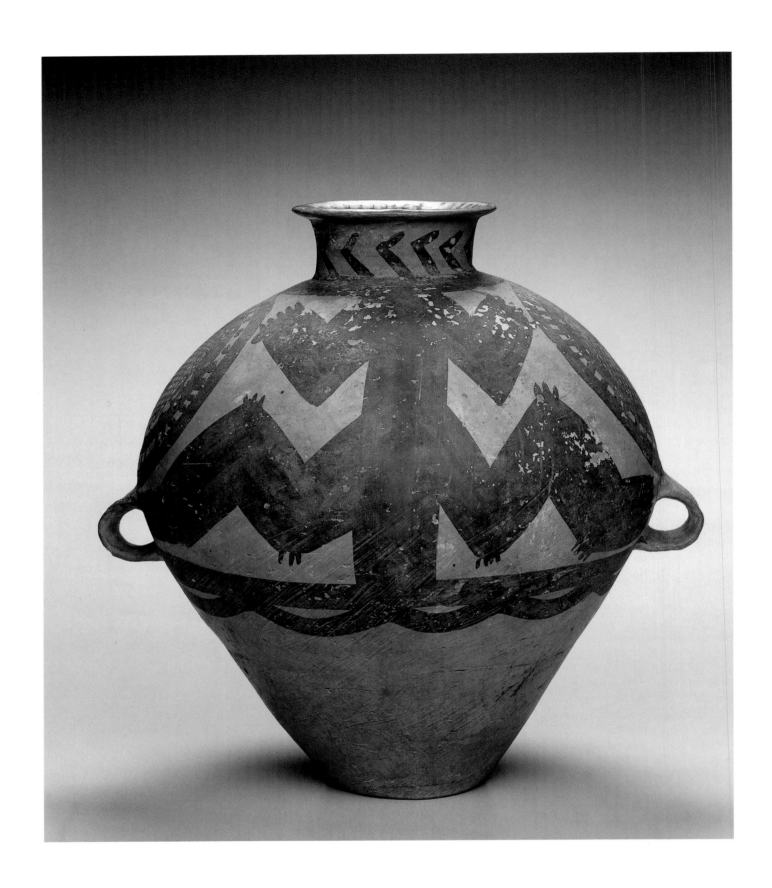

DOUBLE-HANDLED JAR, approx. 2300–2000 BCE. China.

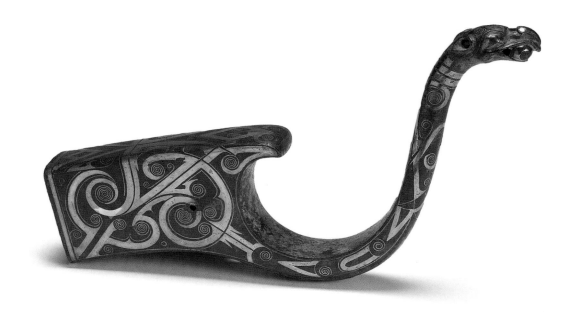

Chariot fitting, approx. 480–221 BCE. China.

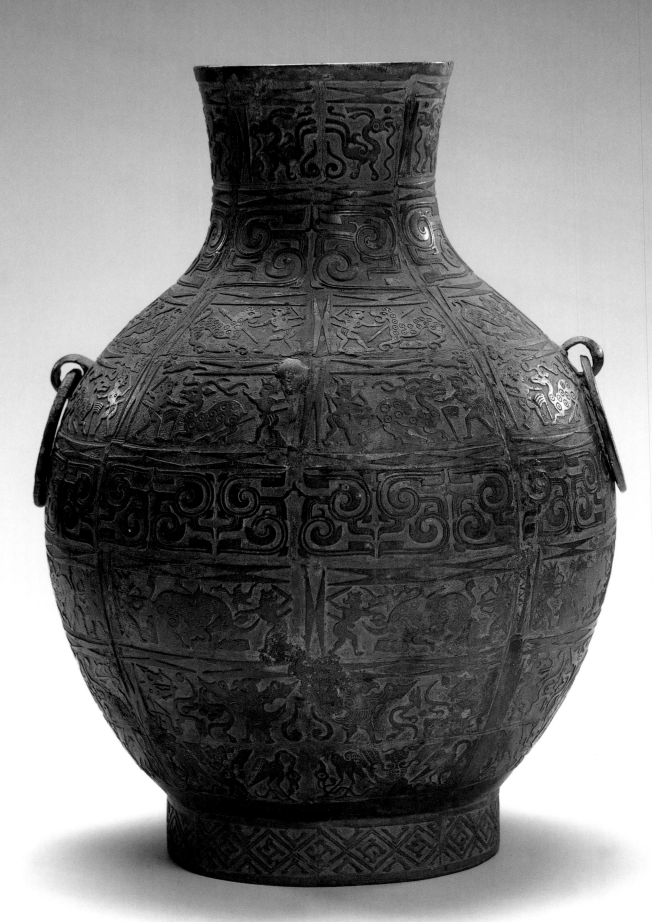

Ritual wine vessel, approx. 480–400 BCE. China.

The Henry R. Luce Gallery

PORTION OF A SARCOPHAGUS, approx. 500–535 CE, China. Northern Wei dynasty (approx. 386–534 CE). Limestone. *The Avery Brundage Collection,* B60S142+ (p. 152).

STEMMED CUP. China. Tang dynasty (618–906 CE). Silver with gold inlay. *The Avery Brundage Collection,* B60B712 (p. 153).

PAIR OF GUARDIANS, approx. 680–750. China. Tang dynasty (618–906). Pottery with three-colored glaze. *The Avery Brundage Collection,* B60S51+, 52+ (p. 154).

The large, flat slabs that made up the sides and top of this sarcophagus contain some of the best surviving examples of the pictorial arts of the Three Kingdoms and Six Dynasties period (221–589 CE). The slabs in this piece, which show animals and human figures in a landscape setting, contain many of the stylistic elements associated with the late Northern Wei dynasty (386–535). The focus is on the figures and animals, which are disproportionately large in contrast to the landscape, which is made up of rocks, trees and other plants, clouds, and water. All are depicted in a flat, linear fashion.

Both the shape and the décor of this stemmed silver cup with gold inlay reveal influence from styles prevalent in the court of the Sasanian empire in Persia. Many of the pieces created under this influence were vessels of gold and silver meant for use at the court or in formal situations.

Among of the most bizarre sculptures made in China are the tomb guardians of the Tang dynasty. Made in pairs to be placed one on each side of the passage leading into the tomb chambers, these figures were intended to frighten away any unwelcome visitors from the spiritual or real worlds. Most pairs are made up of one human-headed and one animal-headed beast. In this pair, the animal face is glazed while the human face is not. Not glazing the face of the human headed beast allowed for greater detail in the sculpting and painting.

Ritual and funerary art displays continue in the northwest corner of the third floor with objects dating from the Han through the Tang dynasty. One of the works featured in this gallery is a spectacular late Han dynasty (approx. 150–220 CE) "Money Tree," purchased in 1995 by the Connoisseurs' Council, a group of collectors who contribute objects to the museum each year (see p. 31). It is joined by mirrors featuring images and symbols with similar cultural meanings; luxury objects made out of gold, silver, and other metals; and tomb elements such as the museum's famous Northern Wei sarcophagus. The main feature, however, is a large number of funerary sculptures that allow the exploration of recuring motifs such as animals real and imaginary, changes in ideals of feminine beauty, issues of architecture, images of paradises, and the influence of the Silk Road.

Portion of a sarcophagus, approx. 500–535. China.

Stemmed cup, 618–906. China.

PAIR OF GUARDIANS, approx. 680–750. China.

The Leslie Sun, Akiko Yamazaki, Jerry Yang, and R. Gwin Follis Foundation Gallery

SEATED BODHISATTVA AVALOKITESHVARA (CHINESE: GUANYIN), probably late 1300s–early 1400s. China. Ming dynasty (1368–1644). Wood with gesso and polychrome decoration. *The Avery Brundage Collection,* B60S584 (p. 156).

Stylistically this piece is similar to sculptures created in China during the late Yuan and early Ming dynasties when Tibetan style Buddhism was a strong influence at court.

STANDING BODHISATTVA AVALOKITESHVARA (CHINESE: GUANYIN), probably late 600s. China. Tang dynasty, (618–906). Gilt bronze. *The Avery Brundage Collection,* B60B661 (p. 157).

The dynamic pose and sensual quality of this gilt bronze sculpture exemplify a renewed interest in South Asian styles at the Chinese court during the Tang dynasty as well as the increasing importance the Chinese placed in Guanyin as a figure of compassion.

HEAD OF A BODHISATTVA. China. Northern Qi dynasty, (550–577). Limestone. *The Avery Brundage Collection,* B60S32+ (p. 158).

A complex series of political and military events made the Northern Qi state in northeast China a major center for the development of Buddhism during the twenty-seven years of its existence. The leaders of the Northern Qi court were fervent, if not fanatical, followers of Buddhism, and were the patrons of innumerable building projects. A major focus of their efforts was the great rock-cut cave complex at Xiangtang shan in southern Hebei and northern Henan provinces. It is difficult to imagine the scale of the figure to which this tall head would have been attached, but such large works were not uncommon during this period. The rounded, rather youthful face and smooth contours of this piece are typical of stylistic developments during the Northern Qi dynasty.

The entire north wing of the third floor is dedicated to Chinese Buddhist art. One first encounters the museum's famous 338 CE Buddha, still the earliest-known dated sculpture of the Buddha, along with a series of gilt bronze sculptures. One continues through the Northern Wei, Sui, and Tang dynasties, represented by works in a variety of mediums. Finally, one arrives at later Buddhist art, including paintings and sculpture created as late as the reign of the Qianlong emperor of the Qing dynasty (1736–1795). Because of space limitations and the nature of the old galleries at Golden Gate Park, it had always been difficult to display this collection to its full potential—there are a number of large, dramatic sculptures that require substantial psychological as well as physical space. This gallery offers a spectacular solution to those issues, as each major sculpture has its own niche.

As with the other early galleries, the major pieces of Buddhist art are featured in the most accessible locations, while other pieces are grouped by theme and period in dense installations toward the back of the gallery. Labels and text panels present the basic information, while videos and laminated cards present more in-depth investigations of particular issues. The Buddhist gallery also has an informal seating area, where visitors can take a break, contemplate some of the sculpture, and read publications relevant to the collection.

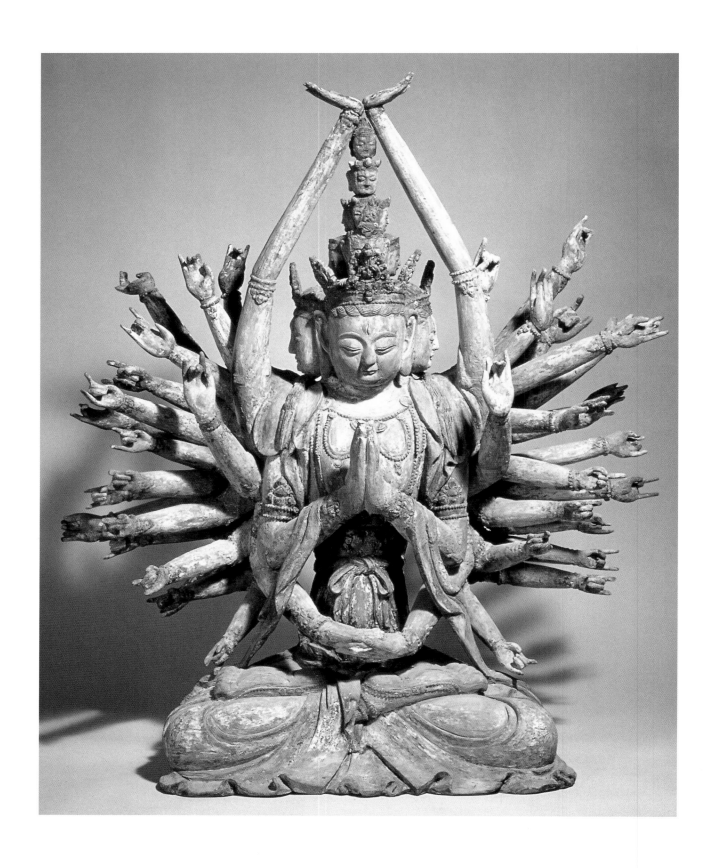

SEATED BODHISATTVA AVALOKITESHVARA (CHINESE: GUANYIN), probably late 1300s–early 1400s. China.

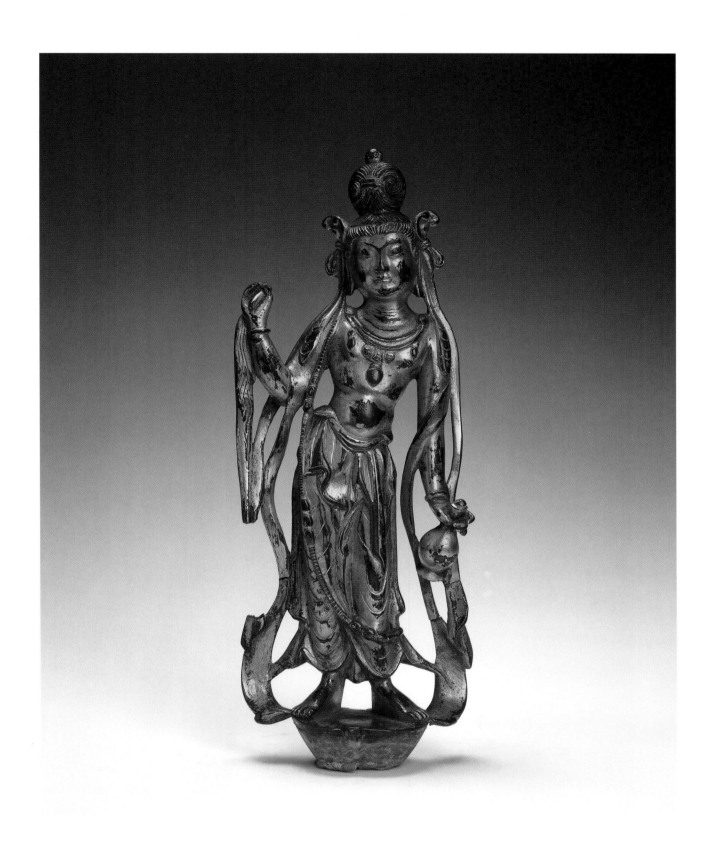

Standing bodhisattva Avalokiteshvara (Chinese: Guanyin), probably late 600s. China.

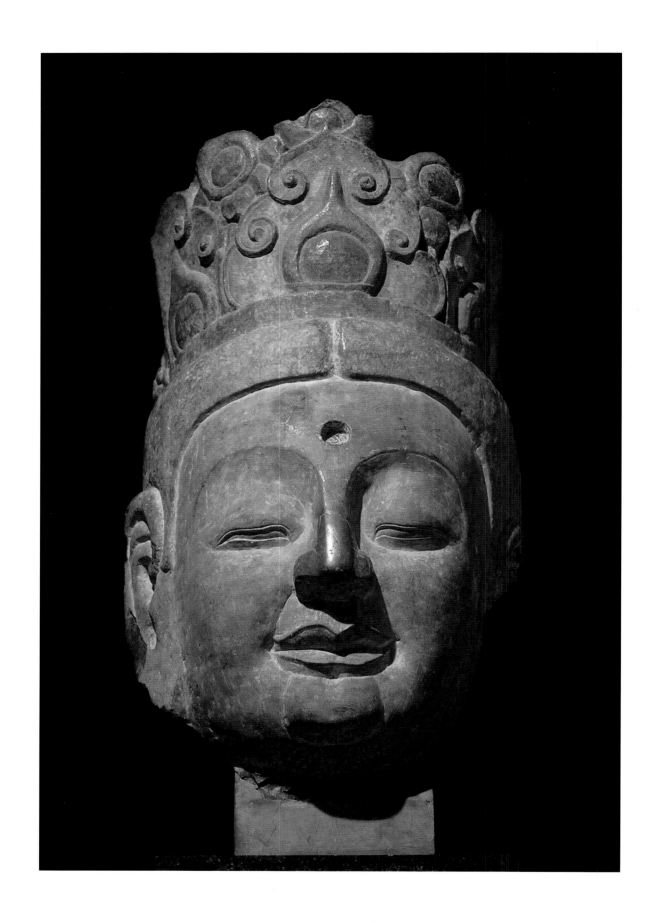

Head of a bodhisattva, 550–577. China

Visitors continue their tour of the new Asian Art Museum galleries by descending a stairway to enter the second floor through a gallery dedicated to the arts of the Song through the Qing dynasties. While many think of the Avery Brundage Collection in terms of its great early bronzes, jades, and Buddhist sculpture, the arts of this period form the true core of the Chinese collection. For example, approximately 2000 of the 2300 ceramics in the Chinese collection date from these dynasties.

This large gallery begins with a long, relatively narrow space lined with cases along one side. Visitors can cross a bridge from Samsung Hall, so this is likely to be an entry point for those who do not follow the established tour route. The cases in this space are dedicated to forms of meaning in Chinese visual arts. These cases include works in several mediums, inluding textiles, jades, and ceramics, all arranged to highlight themes of blessings, marriage and children, passing the imperial exams, rank, prosperity and abundance, and longevity.

PLATE WITH BIRTHDAY GREETING. China. Qing dynasty, mark and reign of the Yongzheng mark emperor (1723–1735). Porcelain with underglaze blue and overglaze enamel decoration. *The Avery Brundage Collection,* B60P192 (p. 160).

Rarely are plants and objects combined on Chinese artworks simply for their decorative value. Most often these combinations have some auspicious meaning. This might be because they are associated with particular virtues or because their names make a rebus (visual pun). This plate is a good example; the fungus (*lingzhi*), the narcissus (*shuixian*), the nandina (*tianzhu*) and the rocks (*shoushi*) together form the phrase *zhixian zhushou,* or "fungus fairy [a Taoist deity] offers birthday greetings." This plate was used for serving food during birthday banquets in the palace.

LADY'S COURT VEST (*CHAOGUA*), dated December 5, 1595. China. Ming dynasty, date and reign of the Wanli emperor (1573–1620). Silk gauze embroidery in canvas stitch and satin stitch, and over-embroidered in silver and gold couching. *Purchase: The Avery Brundage Collection,* 1990.214 (p. 161).

This vest is a tour de force of the art of embroidery: every element, including the solid red ground, was created with very fine knots. No evidence of the base silk is visible. Only a member of the imperial family could have been the patron for such a time-consuming process. Among the auspicious imagery are the character for long life and a Buddhist symbol meaning "10,000," which together have the meaning of 10,000 longevities, a term reserved for the emperor or empress. This message, combined with the red color on this vest indicates that it was intended to be worn at the birthday celebration for the owner; the cut indicates this person was a woman. Inscribed on the inside of one lapel is the date December 5, 1595. From this information, it can be deduced that this piece was made for the empress dowager Li, mother of the Wanli emperor (reigned 1573–1620). Li's fiftieth birthday was on December 7, 1595.

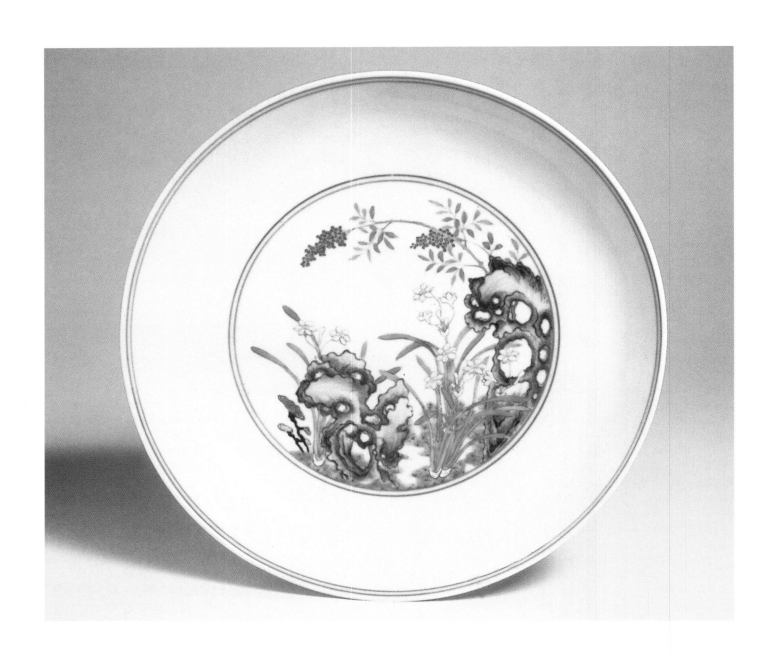

PLATE WITH BIRTHDAY GREETING, 1723–1735. China.

LADY'S COURT VEST, dated December 5, 1595. China.

From this narrow entrance the gallery opens into a large area lined with floor to ceiling cases, surrounding a a large central case. The complexity of the period and the richness of the museum's collection have mandated an approach different than that taken in the other Chinese galleries. Rather than featuring the most important pieces in the most readily accessible locations, the objects in the Song through Qing section of the gallery are arranged by theme: Imperial Art, Daily Life, Popular Religion, Archaism, Tea, Landscape, Flower and Birds, and the Scholar Elite. Each theme is treated independently in one or two cases. The objects within each of these thematic installations are arranged chronologically, allowing the visitor to view the evolution of each concept over almost a millennium.

At the western end of this large gallery is a space dedicated to the arts of China's scholar elite. Included are examples of furniture, paintings and calligraphy, and objects that were specifically designed for display on a scholar's desk. This group makes a perfect introduction to the next gallery, which features Chinese painting and calligraphy.

The origin of ceramic head rests can be traced back to the Tang dynasty (618–906). During the Song they were made in vast quantities in a wide variety of shapes. It is said that these pillows are quite comfortable once a person is used to sleeping on them. The gentle curve and the height are meant to be perfect for supporting the head. Certainly they would have been ideal for preserving the elaborate coiffeurs popular among women at the Song court. This example is one of the most refined of its type, with a remarkably well sculpted boy and lotus leaf.

Tea was the rage during the Song dynasty. This was true at almost every level of society from the emperors (one wrote an important treatise on tea) to monks at Chan Buddhist monasteries. It was also true in states around China, like Japan and the Liao, which were a ready market for teas grown in China and also for the products associated with tea. Under ideal circumstances, tea was meant to be drunk from specially designed bowls while one was surrounded by beautiful objects. This remarkably thin and elegant lacquered object served as a stand for holding one of these bowls.

PILLOW IN THE FORM OF A BOY AND A LOTUS LEAF, approx. 1000–1200. China.

Tea bowl stand, 1127–1279. China.

Incense Burner, probably 1500–1644. China. Ming dynasty (1368–1644). Bronze with gold. *The Avery Brundage Collection,* B60B69 (p. 166).

Brush holder, dated 1661, by Zhang Xihuang (active during the 1600s). China. Qing dynasty (1644–1911). Bamboo. *The Avery Brundage Collection,* B60M356 (p. 167).

This bronze vessel belongs to a group that is notoriously hard to date. The basic shape is derived from the tripod vessels of the late Bronze Age. This vessel, however, served as an incense burner. When in use it would have been partially filled with sand which would have supported the sticks of incense. Among the other characteristics of this group of vessels are the splashes of gold, created by mercury gilding, that decorate an otherwise uniform brown surface. Nearly every example has the mark of the Xuande emperor of the Ming dynasty (reigned 1426–35) cast in the bottom; this was an almost legendary period for the casting of bronze vessels of this type. In part as an homage, this mark is cast into many later vessels of this type. Very few, if any, of the surviving examples were actually cast during the Xuande emperor's reign.

Traditionally the Chinese have considered painting and calligraphy to be the high visual arts. Functional arts such as ceramics, bamboo carving, lacquers, bronze vessels, and so on were rarely signed. Often very little is known about the people who created them. The exception is objects made during the scholar movement of the late Ming dynasty (around the first half of seventeenth century) and later. Brand names were an important consideration for these ultra-sophisticated collectors, so the artists who made objects for them often signed their pieces. This bamboo brush pot is a good example. Zhang Xihuang was a resident of Jiaxing in Zhejiang province. He is noted for bamboo carvings that are closely related to contemporaneous paintings of the scholar elite. He most often depicted landscapes accompanied by long inscriptions. His technique, which involved carving away the background areas and leaving the motifs in the skin of the bamboo, created an effect that is in keeping with the refined tastes of the scholar elite.

INCENSE BURNER, probably 1500–1644. China.

BRUSH HOLDER, dated 1661, by Zhang Xihuang. China.

Gallery 18
Chinese Painting

The P. Y. and Kin May Tang Gallery

FLOWERS OF THE TWELVE MONTHS, by Yun Bing (approx. 1670–1710). China. Qing dynasty (1644–1911). Album of 12 leaves, ink and colors on silk. *The Avery Brundage Collection,* B65D49.a. (p. 170).

Although the patriarchal nature of Confucian society made it difficult for women artists to achieve a high degree of fame, there were certainly many accomplished women painters and calligraphers. Yun Bing is one of the better known women painters of the 1600s and 1700s. She was the most successful descendant of Yun Shouping, one of the leading artists active at the court in the early Qing, who was famous for his paintings of flowers and related topics. Yun Bing was best known for her finely detailed and brilliantly colored paintings of flowering plants, a style influenced by Yun Shouping and the taste of the time.

PINE LODGE AMID TALL MOUNTAINS, by Wu Bin (active 1590–1625). China. Ming dynasty (1368–1644). Hanging Scroll, ink on paper. *Gift of the Avery Brundage Collection Symposium Fund and the M.H. de Young Memorial Museum Trust Fund,* B69D17 (p. 171).

One of the great pleasures of opening a new facility is the opportunity it provides to pay special attention to works in the permanent collection. This large painting by the late Ming dynasty eccentric painter Wu Bin has long been recognized as one of the great masterpieces by this artist and one of the finest Chinese paintings at the Asian Art Museum. The painting is large—the image itself is more than ten feet tall—and was in such poor condition that it has been impossible to display. In preparation for the move to the new museum, a grant was obtained from the Institute for Museum and Library Services to help conserve a number of the museum's important works of art. This was among the objects selected. It was sent to the studio of Ephraim Jose to be remounted and conserved. In addition to being splendidly remounted, cleaning has made sections that had been nearly obscured by decades of accumulated grime much clearer. With proper care such a remounting should last for around 200 years.

SUMMER MOUNTAINS, MISTY RAIN, dated 1668, by Wang Hui (1632–1717). China. Qing dynasty (1644–1911). Handscroll, ink on paper. *Gift of the Tang Foundation, presented by Leslie Tang, Martin Tang and Nina Tang to the Asian Art Museum of San Francisco in celebration of Jack C. C. Tang's sixtieth birthday,* B87D8 (p. 172).

The ideal of the artist of the scholar elite was to be an amateur who painted only for himself and his friends rather than for a living. This ideal was often distant from actual practice and the scholar artist often found himself painting in exchange for room and board, for works of art, or for money. The career of Wang Hui demonstrates some of the ambiguities in this system. For much of the early part of his career, Wang was a protégé the two of the greatest scholar-artists of his time, Wang Shimin and Wang Jian. At the time this handscroll was painted, he had come to the attention of the great early Qing connoisseur Zhou Lianggong, who was to be a fervent supporter of Wang Hui for many years to come. This handscroll was painted for Zhou and has a long inscription by Wang Shimin extolling Wang Hui's virtues. There is no doubt that Wang Hui was richly rewarded for this and many other works he created during his long career; and yet his style served as the foundation for paintings by later artists of the scholar class.

The walls in the northwest corner gallery on the second floor are lined with floor to ceiling cases with the newest and most advanced nonglare, crystal-clear glass. The first installation features paintings the P. Y. and Kin May Wen Tang family has given or lent the museum, including their fantastic, freshly remounted Ni Zan hanging scroll and Wang Hui's Summer Mountains, Misty Rain, *a gift of the Tangs to the Asian in 1989.*

FLOWERS OF THE TWELVE MONTHS (detail), 1670–1710, by Yun Bing. China

PINE LODGE AMID TALL MOUNTAINS, 1590–1625, by Wu Bin. China.

SUMMER MOUNTAINS, MISTY RAIN, dated 1668, by Wang Hu. China.

Gallery 19
Chinese Imperial Arts 1644–1911

The James and Elizabeth Gerstley Gallery

THRONE. China. Qing dynasty, probably reign of the Qianlong emperor (1821–1850). Lacquered wood. *The Avery Brundage Collection,* B61M15+ (p. 173).

THE BUDDHA VAJRADHARA. China; possibly Chengde Hebei province. Qing dynasty, probably reign of the Qianlong emperor (1736–1795). Wood, lacquered and gilt, inlaid with semi-precious stones. *The Avery Brundage Collection,* B60S81 (p. 174).

Leaving the painting and calligraphy gallery, one enters a space devoted to the imperial arts of the Qing dynasty. The inspiration for this gallery came from a photograph of the interior of the Shufangzhai, one of the studios of the Qianlong emperor (reigned 1736–1795). Studying this photograph, museum curators realized that it would be possible to nearly duplicate that installation using the objects from the museum's collection. As a result, this gallery features three cases arranged in a format that is similar to the Shufangzhai studio and filled with nearly identical objects. These objects reflect the height of Qing imperial taste, as well as that of Mr. Brundage.

With these cases as a starting point, Chinese department curators looked closely at other Qing dynasty objects in the collection. The number of large and spectacular objects commissioned by the Qing imperial family is extensive. Among them are a monumental twelve-panel lacquer screen commissioned by the Kangxi emperor; a pair of large zitan tables (zitan is a high grade of rosewood), one with jade inlays and both the name of the room they were intended for and the mark of the Qianlong emperor incised underneath; and a spectacular red lacquer throne. With this range of material, the curators were able to divide the gallery into three sections: one devoted to the altar, one to the throne, and one to the studio.

Thrones were among the most important pieces of formal furniture in the imperial household in Beijing. Larger in scale and usually less restrained in style than chairs and other furniture designed for day to day use, these pieces were often lacquered and decorated with the same repertoire of auspicious symbols that appear in ceramics, textiles and other related imperial arts. The most elaborate thrones were very large in scale and decorated in gold and yellow (the imperial color) lacquer. Presented on high platforms, these were part of the regalia of imperial rule. This red lacquer throne is somewhat smaller than the largest examples, and is decorated with dragons, characters for long life, and floral motifs. It was likely to have been intended for use by one of the members of the imperial family but probably not the emperor himself.

The Manchu emperors of the Qing dynasty maintained close relations with the leading religious families in Tibet, and Tibetan style Buddhism was practiced by many at court. The Qianlong emperor (reigned 1736–1795) had a particularly strong attachment. Many spectacular works of art were commissioned by the imperial family for use in Tibetan Buddhist temples in Beijing or other centers in north China. These works were created under the supervision of Tibetan monks in a style that is definitely Tibetan. Many, however, were produced at the imperial workshops, most likely by Chinese artisans. This Buddhist Deity combines the ancient Chinese tradition of lacquered wood sculpture with iconography and an interest in inlaid stones that is definitely Tibetan.

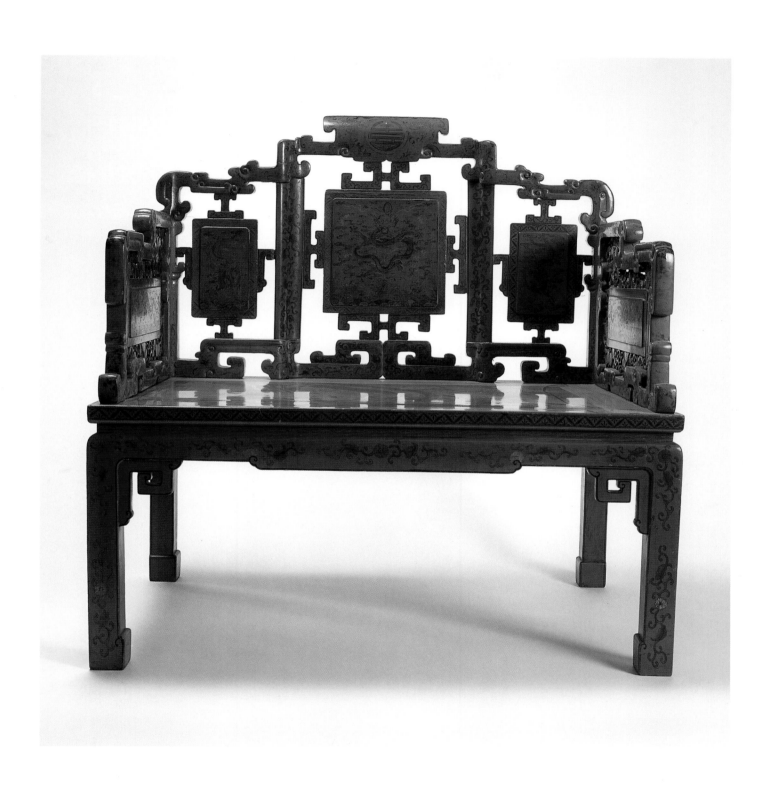

THRONE, probably 1821–1850. China.

173

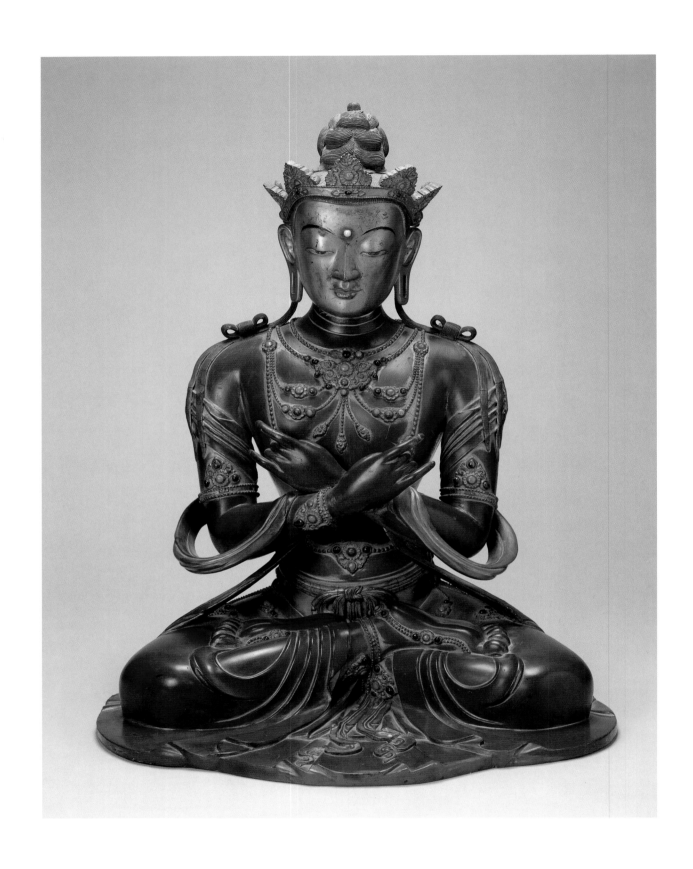

THE BUDDHA VAJRAHARA, probably 1736–1795. China.

Gallery 20
Chao Shao-an and Chinese Painting since 1900

The Chao Shao-an Gallery

The final Chinese gallery features modern and contemporary Chinese painting and calligraphy. Dedicated to Chao Shao-an, a leading mid to late twentieth-century master of the Lingnan school of painting, the first installation consists solely of works given to the museum by the artist in 1992. Future rotations will continue to feature works by master Chao, along with works from the Asian's strong and growing collection of twentieth-century paintings.

Avery Brundage actively collected paintings by living Chinese artists, particularly those painting in traditional styles. Clarence Shangraw, Curator Emeritus of Chinese Art, was also interested in this field, and in part through his efforts thirty-six paintings collected by Jack Anderson were given to the Asian in 1994. Along with the seventy-five paintings given by Chao Shao-an, recent gifts from private collectors in San Francisco and Hong Kong have brought the total number of twentieth-century paintings to more than one hundred fifty.

The political and philosophical turmoil that enveloped China during much of the twentieth century is clearly reflected in several artistic movements. Many critics saw the styles of the scholar elite, which had dominated Chinese painting since the 1600s, as too exclusive and overly tied to tradition.

It was in this environment that the Lingnan School developed in the southern Chinese city of Canton. Central to the philosophy of the painters of this school was making their art approachable to the general public. Many of the founders of the Lingnan School had studied in Japan and were familiar with the reform movements there. These artists advocated a thorough study of traditional Chinese painting methods; the integration of Western technique such as perspective and chiaroscuro with Chinese tradition; and direct observation and sketching from nature. Rather than the abstract and imaginary landscapes of the scholar elite, these artists created paintings of animals, flowers and birds, and actual scenes that had an immediate appeal. These artistic goals are clearly reflected in this large composition by Chao Shao-an, the leading master of the Lingnan School of painting in the second half of the 1900s.

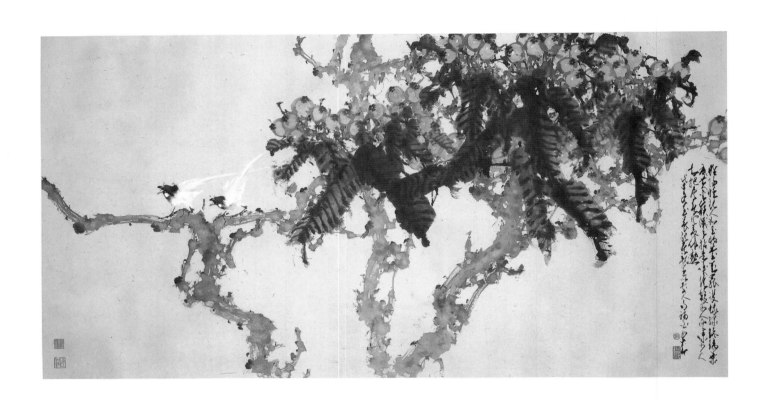

LOQUATS, dated 1968, by Chao Shao-an. China.

Korea

The Koret Foundation Korean Gallery Suite

GUARDIAN KING OF THE WEST, 1796–1820, by Jiyeon and others. Korea. Joseon dynasty (1392–1910). Hanging scroll, ink and mineral colors on linen cloth. *Gift of the Museum Society Auxiliary and the Connoisseurs' Council, 1990.2* (p. 178).

Entering the Korean galleries at the new Asian Art Museum brings one face-to-face with a formidable figure: a ten-foot-tall painted image of the guardian king of the West. The guardian king wears a warrior's armor decorated with a monster mask. He holds a trident and a thunderbolt suggestive of his power and determination to ward off all intruders. His widespread feet and glaring eyes also indicate his readiness to protect his domain.

Though his appearance may be frightening, the guardian king—as his name suggests—is actually protecting visitors to the galleries, according to Korean tradition. In spring and autumn each year many Koreans, believers in Buddhism and nonbelievers alike, make excursions to Buddhist temples located deep in the mountains. As they walk into mountain temple precincts, they encounter at one of first temple gates large images of guardian deities facing the four cardinal directions. Such deities protect the temple, the religion, and its believers.

With the guardian king watching over the galleries, the visitor can enter with assurance.

In this representation of the Guardian King, a frame on the upper right of the painting bears the inscription "The heavenly king who sees everything and protects the western direction of the world." (Because it is light sensitive, this scroll cannot be permanently displayed, and it will be rotated with other paintings.)

Proceeding into the new Korean galleries, one discovers ceramics, sculptures, paintings, textiles, ornaments, and lacquer wares carefully selected to present an overview of Korean art and culture, highlighting the achievements of the Korean people from prehistory to modern times. They include both famous works and objects from the Asian's collection that have never before been on display.

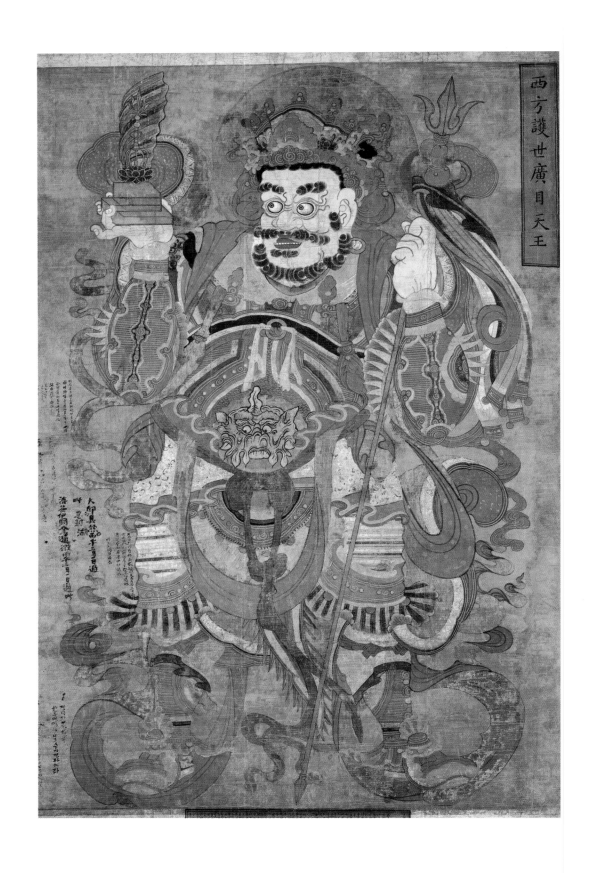

Guardian king of the West, 1796–1820, by Jiyeon and others. Korea.

DUCK-SHAPED VESSEL, approx. 200–300. Korea; ancient region of Gaya (42–562). Three Kingdoms period (57 BCE–668 CE). Earthenware. *The Avery Brundage Collection,* B63P13+ (p. 180).

STAND WITH A JAR, approx. 400–562. Korea; ancient region of Gaya. Three Kingdoms period (57 BCE–668 CE). Stoneware. *Gift of Juliet Boone,* 1991.150.a–.b (p. 181).

EWER WITH COVER, 1100–1150. Korea. Goryeo dynasty (918–1392). Stoneware with celadon glaze. *The Avery Brundage Collection,* B60P123+ (p. 182).

Because birds inhabit the land, the water, and the sky, ancient Koreans believed they were messengers to the unknown world. In some villages, birds can still be seen as finials on tall wooden poles, suggesting their earlier importance. Of all the birds, ducks were especially favored by Koreans because they were believed to mate for life. The prominent opening on the back and tail of this duck indicates that it was used for serving wine or pouring purified water at special rituals and ceremonies. The simplified form of the bird and its whimsical expression distinguish this piece.

The Three Kingdoms period saw the production of a variety of vessel shapes, ranging from small cups with stands to magnificent pedestals and globular jars sometimes with impressed cord decorations. From the beginning of the third century, many ceramic forms were thrown on potters' wheels and fired in climbing kilns constructed on gentle slopes. These impermeable stonewares served as practical objects for daily life as well as for burial purposes.

The potters of the Gaya states are believed to have developed stands to accommodate the round-bottomed jars and bowls. At first these stands were modest in height, as in this example, which supports a thinly potted globular jar with a round bottom. On this otherwise unglazed piece, several streaks of glaze were formed by accident when ashes from the kiln fire fell onto one side of the shoulder area. This enhances the casual charm of the jar.

Under the patronage of the royal court, the aristocracy, and the Buddhist elite—whose taste for luxury and refinement was unprecedented in the history of Korea—spectacular achievements were made in the arts. To meet the standards demanded by their patrons, Goryeo artisans created the most beautiful blue-green glazed wares (popularly known in the West as celadons).

Since their earliest making, these glazed wares have been held in the highest esteem. In 1123 an emissary from the Chinese imperial court praised the beauty of the jade-colored glaze and the elegant forms of these ceramics, which in the thirteenth century were dubbed "the first under heaven." Throughout Asia, Goryeo celadons (*cheongja* in Korean) continue to be admired by connoisseurs as among the most precious items created by Korean artisans.

Among the highlights of this gallery are slate daggers from the Bronze Age (1000 BCE–300 BCE), ornaments of the Silla kingdom (57 BCE–668 CE), stonewares of the Three Kingdoms period (57 BCE–668 CE) and the Unified Silla dynasty (668–935), Buddhist images and objects from 600–1300, and ceramics of the Goryeo dynasty (918–1392).

At the first turn in the gallery appears the museum's duck-shaped vessel, a favorite of children and those young at heart.

Technological progress and changing aesthetic values are evident in ceramics dating from the Three Kingdoms period (57 BCE–668 CE) to the present. The robust stonewares exhibited here define the energy of this period, and the elegant celadons reflect the refinement of the Goryeo dynasty (918–1392).

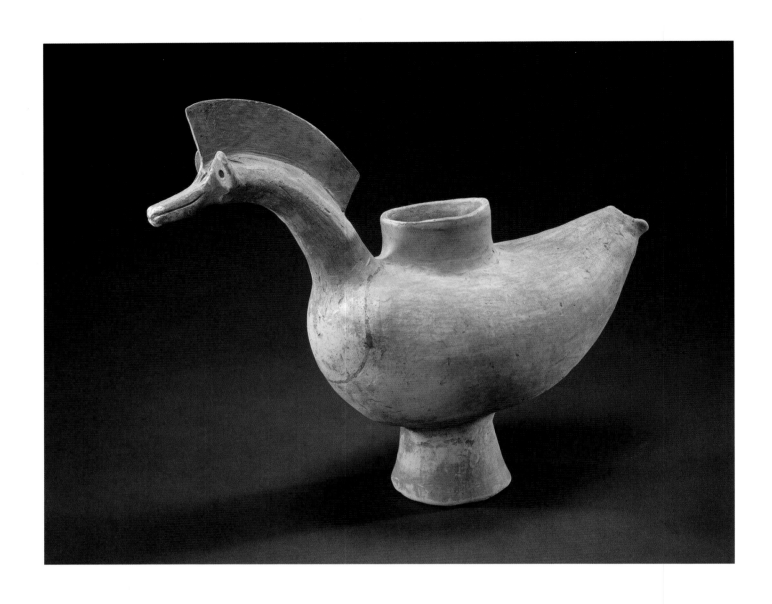

Duck-shaped vessel, approx. 200–300. Korea.

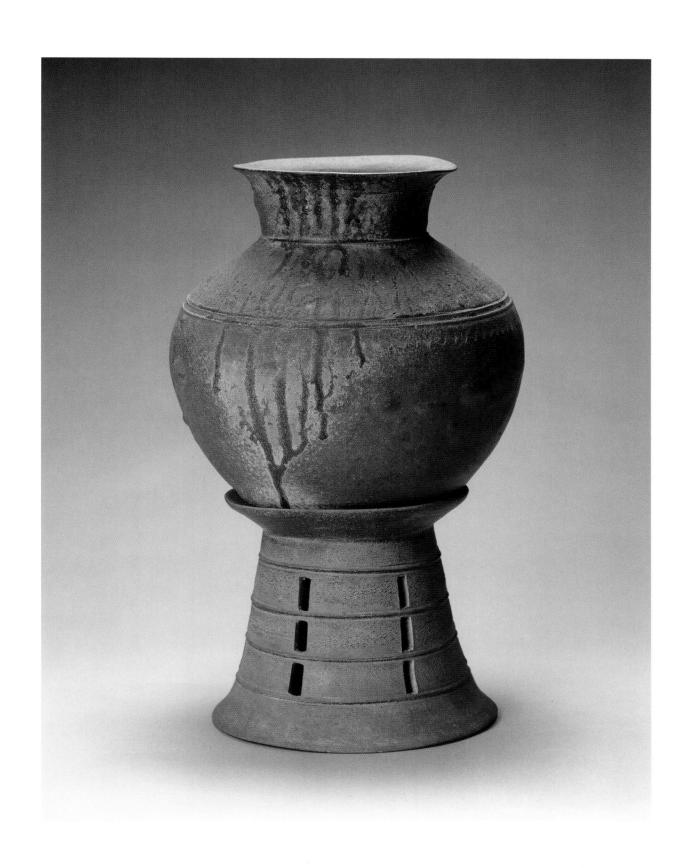

Stand with a jar, approx. 400–562. Korea.

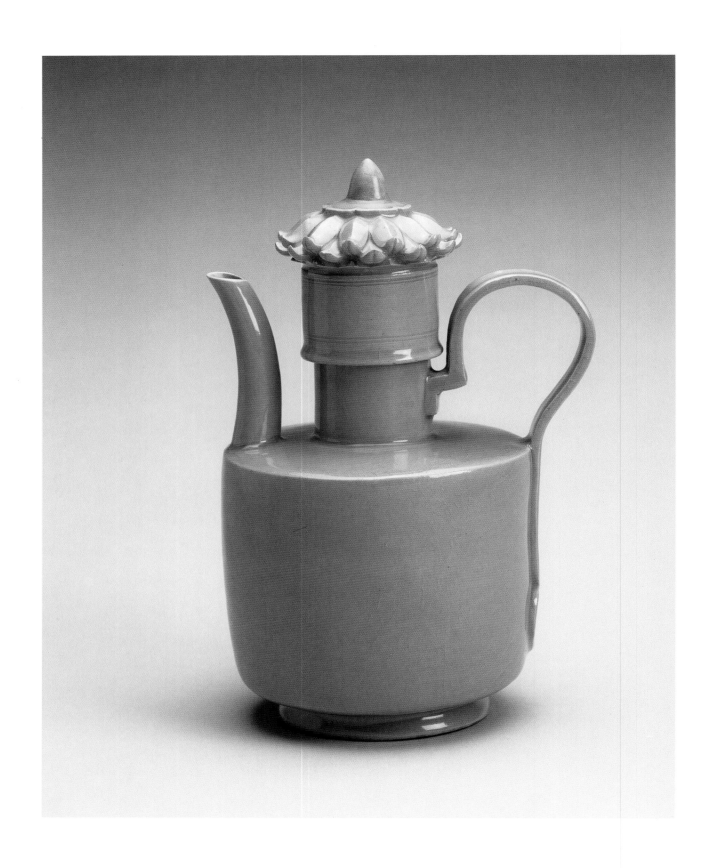

EWER WITH COVER, 1100–1150. Korea.

The In Ju and Chung Hyang Kay Gallery

BOTTLE, approx. 1500–1590. Korea. Joseon dynasty (1392–1910). Stoneware with painted decoration over white slip. *The Avery Brundage Collection,* B65P63 (p. 184).

JAR, approx. 1600. Korea. Joseon dynasty (1392–1910). Glazed porcelain, *The Avery Brundage Collection,* B60P110+ (p. 184).

JAR, approx. 1800–1900. Korea. Joseon dynasty (1392–1910. Porcelain with underglaze decoration. *Gift of Mr. NamKoong Ryun,* 2001.9 (p. 185).

Stonewares decorated with white slip under the glaze were called *buncheong*. Because buncheong were the offspring of inlaid celadons, the earliest decorative motifs on these pieces were executed using stamping, incising, and carving techniques. As time passed, various other techniques were incorporated into the decoration of buncheong: the earliest of these was painting with iron pigments; later, buncheong were covered with white slip using coarse brushes; and in the latest pieces of the period, they were dipped directly into white slip. In this work the major motif is the fish, which symbolizes abundance as well as the spirit of scholars aspiring for a higher goal.

Unlike porcelain wares, which were initially made exclusively for court usage, buncheong were made for everyone, commoners and aristocracy alike. The production of buncheong lasted only two hundred years, ceasing after the Japanese invasions of Korea in the late 1500s.

From the beginning of the new dynasty, the Joseon rulers and scholar-officials, who were steeped in Confucianism, preferred simple white porcelain wares over the elegant celadons that had been favored during the preceding Goryeo dynasty (918–1392). To Josean leaders, the color white symbolized purity, honor, and modesty. For instance, King Sejong (reigned 1418–1450) ordered that only white porcelain wares be used at his table.

Globular porcelains such as this one were called "moon jars." They were favored not only because their white color was suggestive of Confucian virtues but also because the form represented fertility and gentle, embracing qualities associated by many people, during that period, with women.

Among decorated porcelain wares, those made by adding cobalt under the glaze, commonly known as "blue and white," were first produced with cobalt imported from China during the second quarter of the fifteenth century.

The tiger-and-magpie theme, popular in Korean folk painting, was used to decorate this jar. Two groups of this motif appear in underglaze cobalt on opposite sides of the jar. In the past, Koreans believed that tigers embodied the spirit of the mountains and had the power to ward off all evil and harm, and that magpies were harbingers of good news.

On this jar one of the tigers holds a long smoking pipe in its mouth. This humorous motif is a pictorial interpretation of a familiar phrase used at the beginning of Korean children's stories: "Once upon a time, long, long ago, when the tiger smoked a pipe. . . ."

The second Korean gallery is dedicated to arts of the Joseon dynasty. It features ceramics (stonewares, porcelains, and other decorated wares) and paintings (folding screens, hanging scrolls, and handscrolls).

First one encounters simple buncheong stonewares and understated porcelains that reflect the twin characteristics—vigor and restraint—of the Joseon dynasty (1392–1910). These are followed by paintings. During the past decade, the efforts of many people have gone into increasing the size of the Asian Art Museum's Korean painting collection. The Asian Art Museum includes an area devoted to the display of hanging scrolls and folding screens rarely shown in its former building in Golden Gate Park because of space constraints.

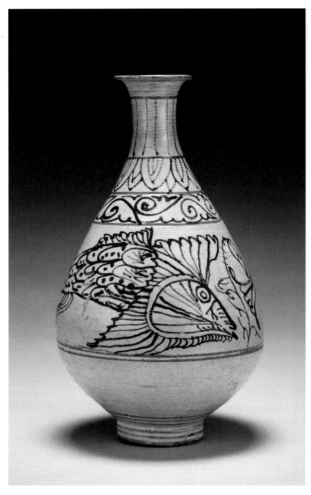 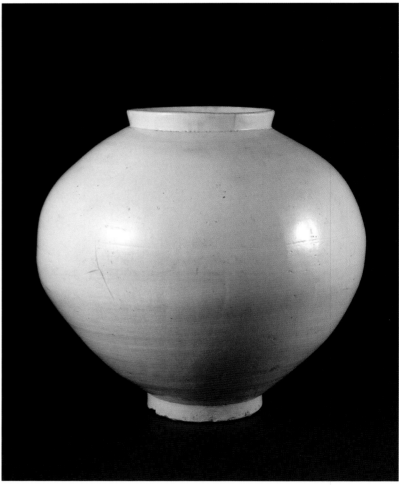

BOTTLE, approx. 1500–1590. Korea. JAR, approx. 1600. Korea.

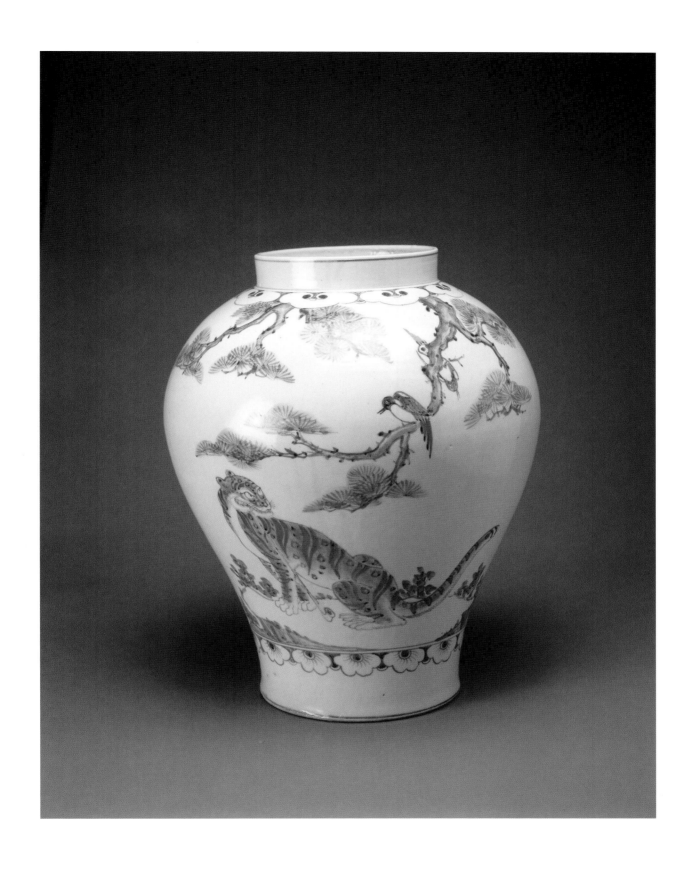

Jar with tiger and magpie, approx. 1800–1900. Korea.

SCHOLAR'S ACCOUTREMENTS (detail), approx. 1860–1874, by Yi Eung-nok (1808–after 1874). Korea. Joseon dynasty (1392–1910). Eight-panel folding screen, ink and colors on paper. *Acquisition made possible by the Koret Foundation, the Korean Art and Culture Committee, and the Connoisseurs' Council; remounting funded by the Society for Asian Art,* 1998.111 (p. 187).

Paintings such as this one represent the objects scholars had—or wished to have—around them in a study. This subject matter, called *chaekkeori,* became extremely popular in Korea during the eighteenth and nineteenth centuries. Its popularity was perhaps due to the preference of King Jeongjo (reigned 1776–1800) for having a chaekkeori painting in his presence. He is believed to have said that he did not have time to read after he had ascended the throne, so having a chaekkeori painting made up for this lack in a small way.

Like his father and grandfather, Yi Eung-nok (also known as Yi Hyeong-nok), the court painter of this work, specialized in painting scholars' accoutrements, which suggests there was a great demand for this theme at the court and among the gentry. For this work Yi chose a large bookcase in which to arrange his still-life objects, among them books with narcissus and peacock feathers in a vase. He also incorporated the Western techniques of linear perspective and modeling to create an illusion of space, mass, and volume. Yi ingeniously included his name in the painting in the middle of the screen, among a group of seals on the top shelf.

BAMBOO, approx. 1590–1600, by Yun In-ham (1531–1597). Korea. Joseon dynasty (1392–1910). Hanging scroll, ink on paper. *Gift of the Connoisseurs' Council and the Korean Art and Culture Committee,* 2001.5 (p. 188).

In Korea, people often painted bamboo and orchids during their personal or national crises. Because bamboo is an evergreen, flourishing even in winter, it symbolizes steadfastness and the unbreakable spirit. It became the first subject matter to win the hearts of Korean scholar-painters. This work is by the scholar-painter Yun In-ham, who held the position of Second Minister of the Board of Punishment *(Hyeongjo champan)* during the second Japanese invasion of Korea by Hideyoshi's forces in 1597.

Yun's composition is quietly grand. His brush strokes are strong and confident, and his handling of light and dark is superb. His treatment of the full moon, half hidden by a branch, is extremely effective in creating a contemplative mood. His use of water in the foreground connects him to sixteenth-century painters such as Sin Jam (1491–1554) and Yi Gyeong-yun (1545–1611). Yun signed the work with his pen name, Jukjae, meaning "bamboo studio," in reference to his fame as a painter of ink bamboos.

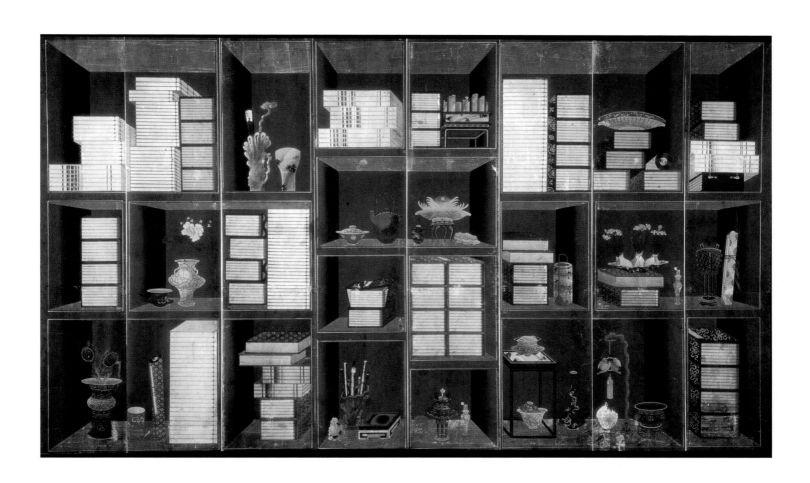

SCHOLAR'S ACCOUTREMENTS (detail), approx. 1860–1874, by Yi Eung-nok. Korea.

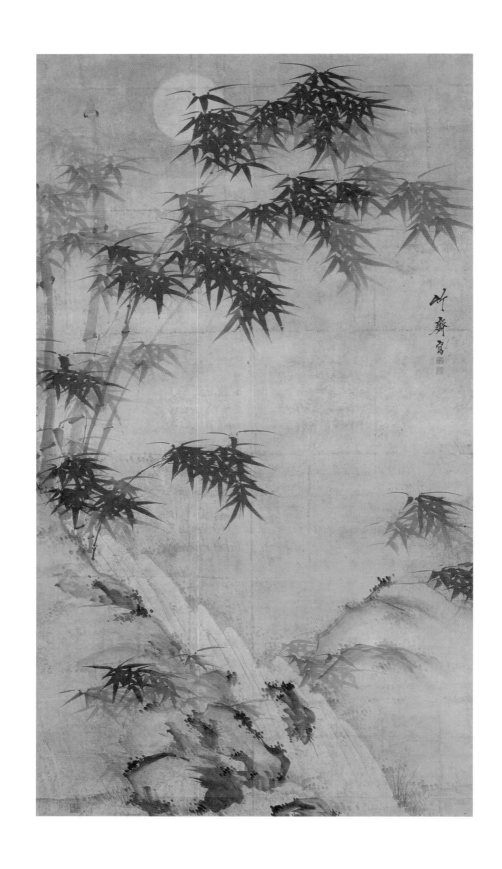

Bamboo, approx. 1590–1600, by Yun In-ham. Korea.

Gallery 23
Korea 1392 to the present

The Korea Foundation Gallery

GRAPEVINE, 1870, by Choe Seok-hwan (1808–?). Korea. Joseon dynasty (1392–1910). Eight-panel folding screen, ink on paper. *Gift of the Koret Foundation and the Korean Art and Culture Committee,* 2001.29 (p. 190).

Beginning in the sixteenth century, the grapevine became a popular subject for painting. Grapevines were usually done in ink, with no colors added. The popularity of this theme is understandable, as clusters of grapes can easily be seen as a metaphor for having many sons, which was of paramount importance in Joseon society.

Choe Seok-hwan, who specialized in grapevine paintings, here created a dynamic composition by using the eight panels as if they were an undivided pictorial surface.

Choe's mastery can be seen in his expert manipulation of subtle tonal gradation, his use of strong contrasts between light and dark, the varying thickness and strength of his brush lines, and most of all the drama and excitement of his composition.

The inscription on the last panel reads: "Painted by Nangok at the age of sixty-three in the autumn of 1870, when chrysanthemums are blooming." Nangok was Choe's pen name. The leaf-shaped seal also reads "Nangok," and the square seal reads "Choe Seok-hwan."

In the third Korean art gallery, which features paintings, lacquer wares, contemporary ceramics, textiles, and ornaments, are two walls created to accommodate an increasing number of Korean paintings from the Joseon dynasty through the present. Contemporary ceramics are on display here, representing the diverse concerns and aims of Korean potters active today. And to celebrate the artistic achievements of Korean women, a special area has been created to display works made by and for women.

VASE, 1998, by Park Young-Sook. The Republic of Korea (1948–present). Stoneware with underglaze white slip and copper oxide decoration. *Gift of Dr. and Mrs. Marvin Gordon,* 1999.48 (p. 191).

The potter Park Young-Sook considers this work to be *buncheong* stoneware (see left caption p. 183). She used clay containing a small amount of iron and applied white slip on the surfaces, both interior and exterior, under the glaze. Although she consciously connects her work to the buncheong tradition of the early Joseon dynasty, her innovation can be seen in the form itself as well as in the bold design of reeds and an egret, the barely discernable brown line on the rim, and the copper oxide blobs.

WRAPPING CLOTH, 1950–1960. The Republic of Korea (1948–present). Silk patchwork. *Gift of Mrs. Ann Witter,* 1998.57 (p. 192).

Until recently, wrapping cloths *(bojagi)* occupied a prominent place in the daily lives of Koreans of all classes. They were used not only for wrapping but for covering, storing, and carrying all kinds of objects—small and large, ordinary and precious.

Patchwork wrapping cloths *(jogakbo)* such as this piece were made exclusively by and for the common people. Unlike wrapping cloths made of single large pieces of cloth for palace use, the intricate composition of patchwork wrapping cloths was created by stitching together small pieces of fabric of varying sizes and contrasting colors. Korean women found delight and satisfaction in their artistic activity, in part because these lovingly wrought objects allowed them to express their best wishes for the recipients: their daughters, sons, nieces, nephews, and friends. These wrapping cloths were all made by anonymous women.

GRAPEVINE, 1870, by Choe Seok-hwan. Korea.

Vase, 1998, by Park Young-Sook. Korea.

WRAPPING CLOTH, 1950–1960. Korea.

BRIDAL ROBE, 2001, by Han Sang-Su. The Republic of Korea (1948–present). Silk embroidered with auspicious motifs in silk and gold thread. *Gift of Mrs. Ann Witter,* 2002.6

In Korea, the bridal robe is called *hwarrot,* which means "flower robe." This particular robe was done in the palace embroidery style and was influenced by the one worn by Princess Bokon (1818–1832) in 1830. The meticulous embroidery and delicate, naturalistic floral designs on this robe are characteristic of the palace style and are quite different from the bold, abstract designs in brilliant colors embroidered on those worn by the brides of the gentry class.

The colors used on this robe, red for the exterior and blue for the lining, symbolize feminine and masculine, earth and heaven, and light and dark in the East Asian cosmology. In addition to small flowers, fruits, and butterflies symbolizing conjugal happiness, fertility, wealth, and long life, emblems of Taoist (double gourds, castanets, fans, crutches, and lotuses) and Buddhist (two fish, wheels, vases, and parasols) treasures were also incorporated. Not included are numerous items commonly embroidered on nonroyal bridal robes, among them the characters congratulating the union of two families; only one of the well-known ten longevity symbols (the mushrooms of long life) was used.

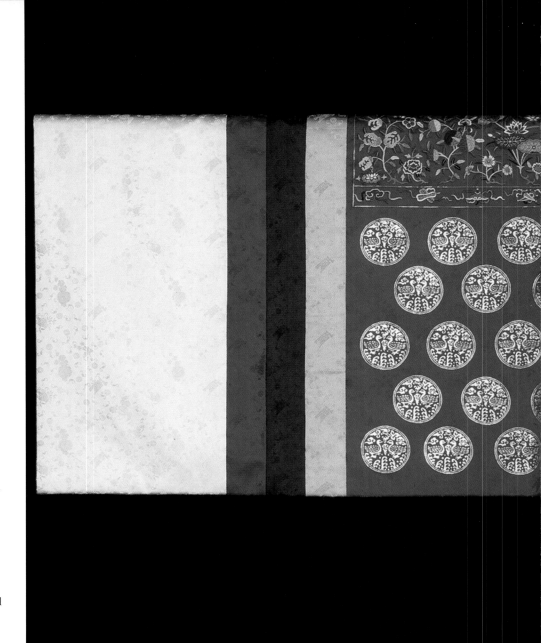

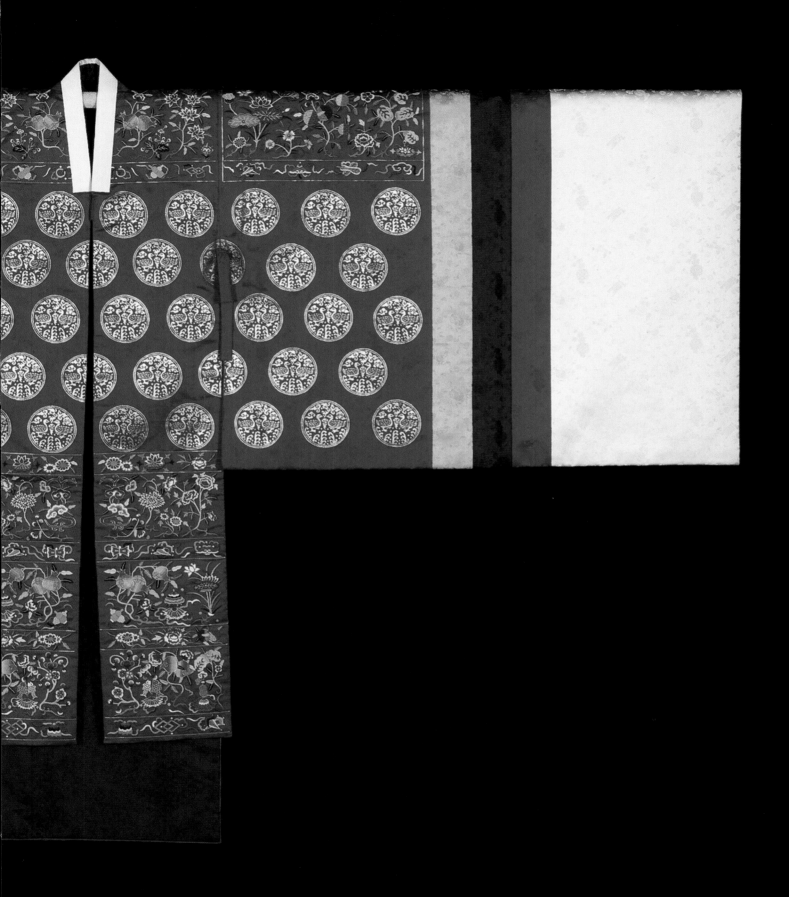

Gallery 24
Thematic Exhibition Gallery

The Atsuhiko Tateuchi and Ina Tateuchi Foundation Gallery

Gallery 25
Early Japan

The Japanese Affiliated Companies of the Japanese Chamber of Commerce Gallery

The objects in this gallery, located between the Korean and Japanese collections, rotate periodically. They are chosen mainly from the museum's permanent collection—galleries on the ground floor present larger special and traveling exhibitions—to illustrate selected themes relating to Asian art and culture.

Selected works from the museum's Japanese collection have been arranged by theme and chronology in seven contiguous galleries: Early Japan, Japanese Buddhist Art, Japanese Arts of Daily Life, Japanese Paintings and Screens, Japanese Porcelain and Prints, Japanese Tea-Related Arts, and the Betty Bogart Contemplative Alcove. Located on the second floor in the south wing, the Japanese galleries can be entered from the thematic exhibition gallery by following the museum's recommended tour. They can also be reached by proceeding directly from the second-floor landing of the escalator, across the bridge upon exiting the glass elevator located in the South Court, or across another stainless steel bridge from Samsung Hall.

HANIWA IN THE FORM OF A WARRIOR, approx. 500–550, earthenware. Japan; excavated at Fujioka, Gunma prefecture; Kofun period (250–542). *The Avery Brundage Collection,* B60S204 (p. 197).

Haniwa (literally, "clay cylinders") were quickly formed and fired in the open. Figures such as this warrior were placed on and around the enormous tomb mounds (*kofun*) of regional chiefs. The location of this object's excavation suggests that the Kofun culture, which began in central Japan, had by this later phase expanded toward the north. The loosely organized Kofun chiefdoms were gradually consolidated into a unified state. After Buddhism became firmly rooted in Japan, the custom of building kofun ceased.

STONE BRACELET. Japan. Kofun period (250–542). Jasper. *The Avery Brundage Collection,* B62S56 (below).

With its flat, asymmetrical oval shape and fluted surface, this bracelet is reminiscent of a wheel; thus, such objects are commonly called *sharinseki* (literally, "wheel-shaped stones"). These were made specifically as a burial object to be placed alongside the deceased as a symbol of social privilege.

STONE BRACELET, 250–542. Japan.

This gallery features superb examples of Japan's pre-Buddhist arts. The works displayed span the era between 4000 BCE and 600 CE. Unglazed earthenware objects, clay figures of animals and humans, and bronzes give a picture of the evolution that took place in daily life and ritual during this period.

 The most celebrated work in this grouping is a haniwa *warrior datable to approximately 500–600 CE. The figure, which stands erect in complete warrior's gear and armor, would have been placed at the site of a* kofun, *the tomb of a powerful leader.*

HANIWA IN THE FORM OF A WARRIOR, approx. 500–540. Japan.>

Gallery 26
Japanese Buddhist Art

The Henry Cornell Gallery

At the entrance a pair of wooden temple dogs (komainu) greets visitors. Inside the gallery they come upon large sculptures and colorful paintings securely installed in state-of-the-art floor-to-ceiling cases with ultraclear, nonglare glass. Two of the sculptures in this gallery— images of Brahma (Japanese: Bonten) and Indra (Japanese: Taishakuten)—are internationally renowned. These two Hindu deities were adopted by Buddhism in its early stages in India; in the Japanese pantheon they commonly appear as attendants of the historical Buddha.

Another group treated prominently in Gallery 2 is a sculpture of the Buddha Amitabha (Japanese: Amida), who is seated and flanked by two standing guardians. These religious figures were originally made to be seen and worshiped only from the front, which is evident in their display on a freestanding platform in the center of the gallery: Their front aspects were well modeled, with fine detail, while their backs were more roughly finished.

Brahma (Japanese: Bonten) and Indra (Japanese: Taishakuten), dry lacquer. Japan; Kofukuji temple, Nara; Nara period (710–794). Dry lacquer. *The Avery Brundage Collection,* B65S12 and S13 (p. 199).

These Buddhist statues from the Kofukuji temple were executed in dry lacquer, a technique in which several layers of cloth were soaked in liquid lacquer and applied to a shaped clay core. The cores were removed when the lacquer had dried, leaving a lightweight hollow sculpture. Such dry-lacquer images of Bonten and Taishakuten are rare because of the painstaking nature of the technique and the fragility of the materials.

Taima mandala. Japan. Nanbokucho period (1333–1392). Hanging scroll, ink, colors, and gold on silk. *The Avery Brundage Collection,* B61D11+ (p. 200).

This large mandala depicts a heavenly paradise into which Pure Land Buddhists hope to be reborn. In the center, the Buddha Amitabha (Japanese: Amida) is depicted teaching a way to reach the Western Paradise. This mandala is a painted reproduction of a large tapestry of the same subject that until 1217 had gone unnoticed in Taima-dera, the temple at Taima. After the original tapestry was discovered, many copies were painted from it and distributed to important temples.

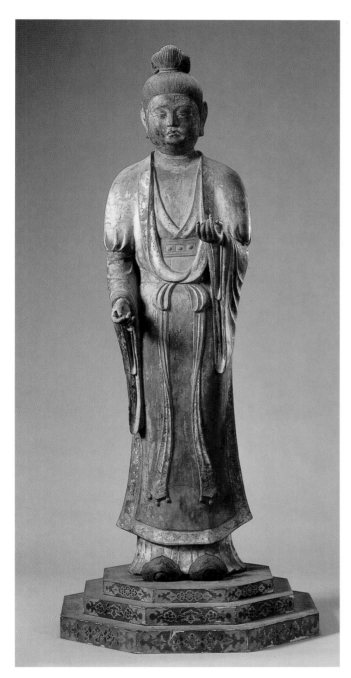
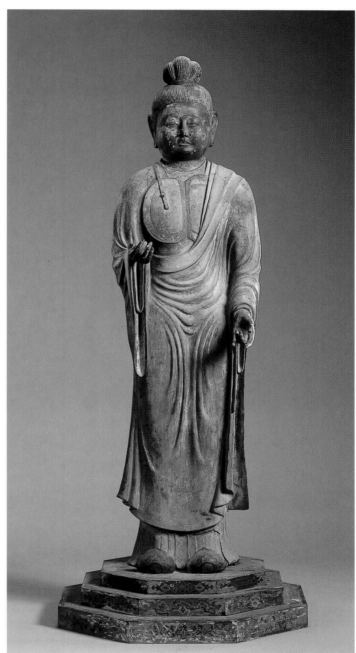

BRAHMA (JAPANESE: BONTEN) AND INDRA (JAPANESE: TAISHAKUTEN), 710–794. Japan.

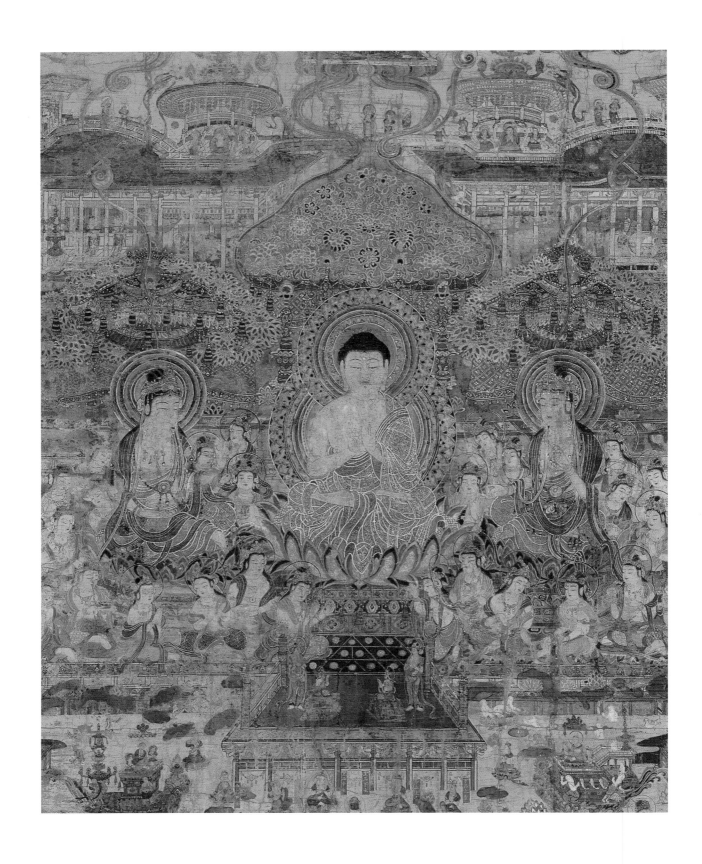

TAIMA MANDALA, 1333–1392 (detail). Japan.

Gallery 27
Japanese Arts of Daily Life

The Constance and J. Sanford Miller Gallery

This gallery features fanciful inro *(seal containers) and netsuke (carved toggles used to fasten small containers to kimono sashes), two kinds of accessories used by commoners, as well as arms and armament produced for the samurai class. The upper ranks of the samurai, especially during the peaceful Edo period (1615–1868), displayed their power and wealth through their taste for splendor, particularly in such items. Made of luxurious materials, these pieces are characterized by both refinement and spectacle, which are evident in their design and technical virtuosity.*

RECUMBENT DEER. Japan. Edo period (1615–1868). Netsuke, ivory with inlaid eyes, signed "Okatomo." *The Avery Brundage Collection,* B70Y190 (p. 202).

SEATED GUARDIAN LION. (*KARASHISHI***)**, Japan. Edo period (1615–1868). Netsuke, ivory with inlaid eyes. *The Avery Brundage Collection,* B70Y910 (p. 202).

FEMALE DIVER. Japan. Edo period (1615–1868). Netsuke, ivory, signed "Dosho" (1824–1884). *The Avery Brundage Collection,* B70Y380v (p. 202).

Used by commoners, *inro* and netsuke are modest items compared to the ornate samurai arms and armament from the same period. Fashioned from many kinds of materials, the lighthearted and humorous netsuke illustrate themes from Japanese literature, theater, folk stories, legends, fantasies, and historical and social events.

SAMURAI'S CAMPAIGN VEST (*JINBAORI***)**. Japan. Edo period (1615–1868). *The Avery Brundage Collection,* 1988.38.1750–1860. Silk brocade, wool, fur, and ivory buttons (p. 203).

With its large armholes and a back slit, this functional sleeveless vest was designed for a warrior to wear over his armor. The taste of the warrior class for splendor is expressed in their use of luxurious, exquisitely tailored materials in bright colors.

RECUMBENT DEER, 1615–1868. Japan.
SEATED LION, 1615–1868. Japan.
FEMALE DIVER, 1615–1868. Japan.

SAMURAI'S CAMPAIGN VEST, 1750–1860. Japan.

The Maryellie and Rupert H. Johnson, Jr. Gallery

Spectacular paintings and screens are displayed in large glass cases on all four sides of this gallery. In the center of the gallery are cases containing lacquer ware as well as colorful Kyoto and Ko Kutani (Old Kutani) ceramic ware. The paintings and screens in this gallery are frequently changed, offering visitors the opportunity to see different examples of these kinds of works. On display are important pairs of screens and hanging scrolls from the Muromachi (1392–1573) and Momoyama (1573–1615) periods. During these early periods, Japanese ink painting developed and matured, and painting in color also developed, particularly in the Momoyama period.

TAMING THE OX, by Sekkyakushi (active 1400–1450). Japan. Muromachi period (1392–1573). Hanging scroll, ink on paper. *The Avery Brundage Collection,* B69D46 (p. 205).

This painting expresses the Zen Buddhist message that Enlightenment must be attained through controlling wild thoughts. Here, the ox represents the unenlightened mind, which could rampage like a wild animal. Zen meditation was a religious discipline through which one might tame "the ox of the mind."

READING STAND (*KENDAI*), approx. 1700–1800, lacquered wood with silver, gold, and mother-of-pearl inlay. Japan. Edo period (1615–1868). *Gift of Frank Stout, William and Midori Wedemeyer, and David and Mary Bromwell,* 1999.1.a-.c (p. 208).

A reading stand is used to hold books or music scores while a person is reading or chanting. The most striking decorative feature of this stand is a pair of large openwork butterflies facing each other in its center. Over the lozenge-patterned ground drift many other butterflies raised and covered with gold and silver.

A PORTUGUESE (NANBAN) SHIP ARRIVING IN JAPAN. Japan. Momoyama period (1573–1615). Six-panel screen, ink, colors, and gold on paper. *The Avery Brundage Collection,* B60D77+ (p. 206–207).

The term *nanban* was used by the Japanese to refer to the Portuguese, the first Westerners they encountered; later, the term was applied to Westerners in general. This screen illustrates the arrival of a nanban ship at a Japanese port. The captain and his crew have just landed, and some of the men are still unloading cargo.

LARGE PLATE, 1600–1700, Ko Kutani ware, porcelain. Japan. Edo period (1615–1868). *The Avery Brundage Collection,* B64P31 (p. 209).

This plate is boldly decorated with ferns and the tips of spruce branches in deep green and black. Young shoots of purple ferns rise high against a yellow background filled with small sunbursts.

TAMING THE OX, 1400–1450, by Sekkyakushi. Japan

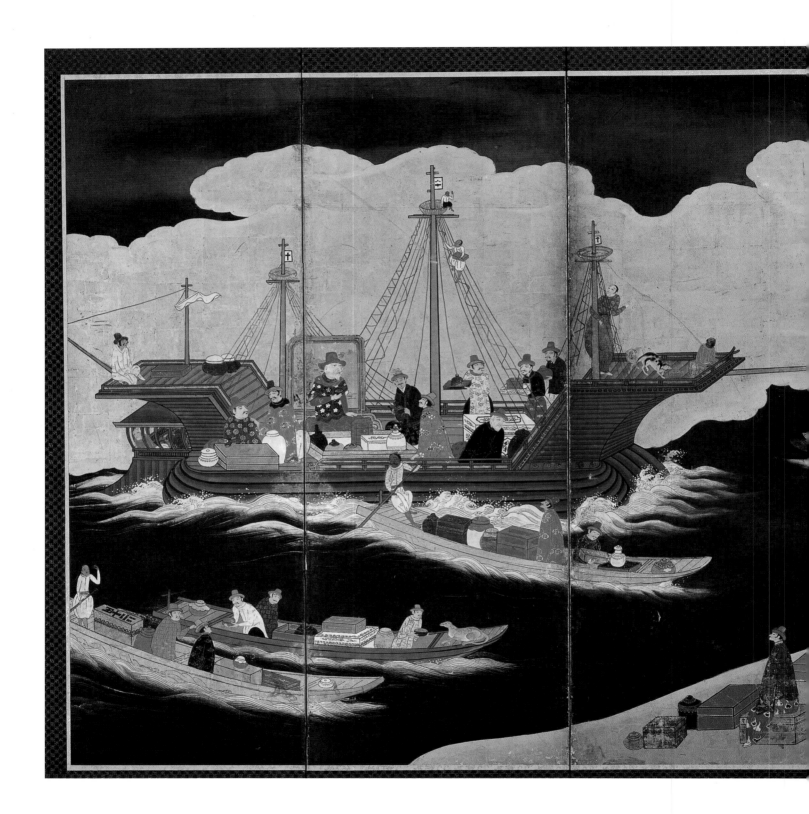

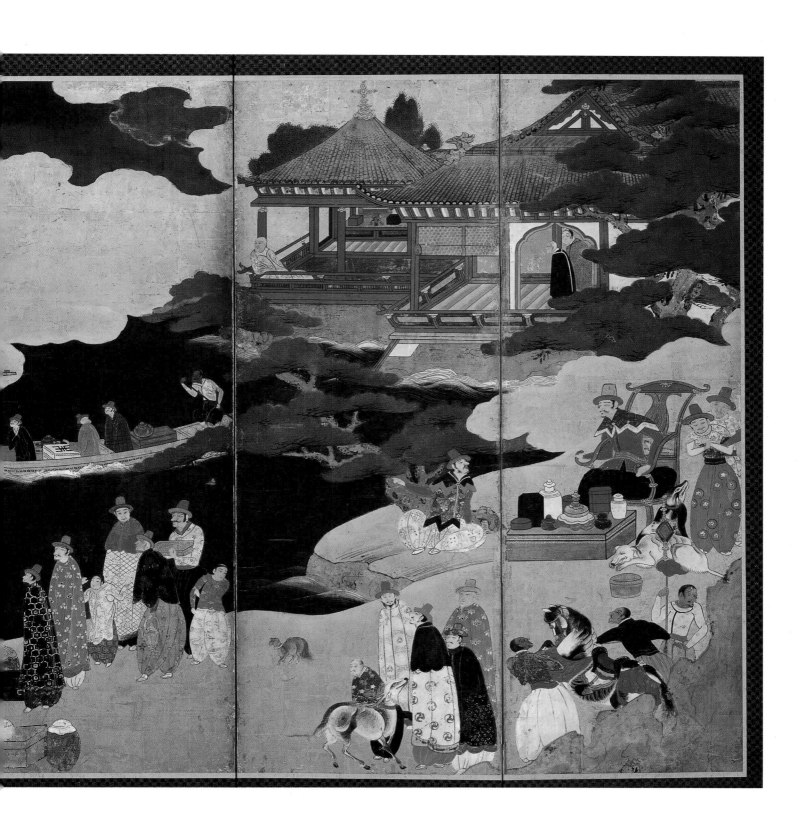

A PORTUGUESE SHIP ARRIVING IN JAPAN, 1573–1615. Japan.

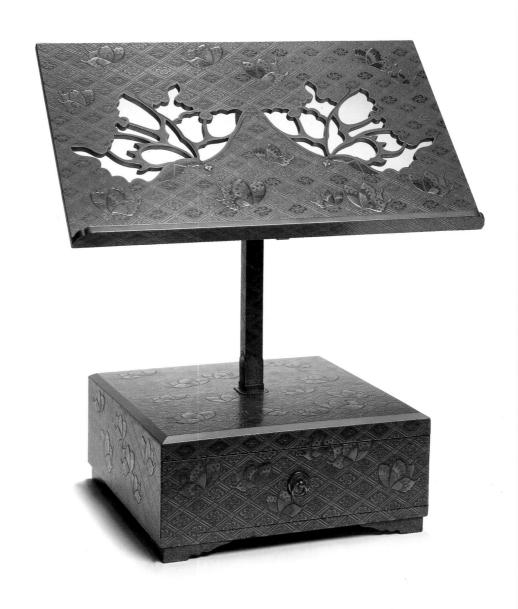

READING STAND, approx. 1700–1800. Japan.

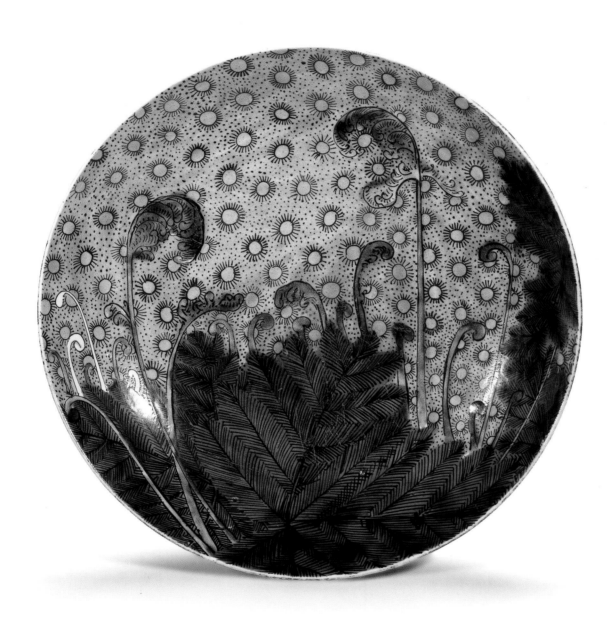

LARGE PLATE, 1600–1700. Japan.

Gallery 29
Japanese Porcelain and Prints

The Marjorie Walter Bissinger Gallery

THE URAMI WATERFALL IN NIKO, 1853, from *Famous Views in the Sixty-Odd Provinces*, by Ando Hiroshige, block cut by Yokogawa Takejiro; published by Kishimuraya Heisuke. Japan. Edo period (1615–1858). Woodblock print on paper, *Gift of Oliver and Elizabeth Johnson*, 1994.48.

This small gallery functions not only as a display space but also as a point of access to and from the escalator. In order to block light from the skylight over the escalator, a tall wall was erected in the middle of this gallery. Large glass cases attached to the side that faces the escalator display Imari, Kakiemon, and Nabeshima works in porcelain whose colors are not affected by exposure to light. The wall's interior side provides a light-safe display space for classical woodblock prints and modern prints done in various techniques.

The print depicts the famed Urami Waterfall in Niko, Shimozuke province (present-day Tochigi prefecture). The giant rocks jutting from the cliff caused the water to shoot out so far that travelers on the mountain path below could view the waterfall from its hind side (*urami*); for this reason it was named the Urami Waterfall. Some time later, strong winds and rain caused the giant rocks to tumble off the cliff. The water now falls straight down, and people can no longer view it from behind.

*The **Urami** **Waterfall** in **Niko**,* 1853, by Ando Hiroshige. Japan.

Gallery 30
Japanese Tea-Related Arts

The Henri and Tomoye Takahashi Gallery, including the Masako Martha Suzuki Teahouse

This delightful space is devoted to two major art forms: the teahouse and the bamboo basket. With three mats, an alcove, and a sliding door in front, the teahouse provides a functioning space for tea ceremonies and demonstrations. A preparation room (mizuya) in the back can be viewed from the side of the teahouse. Designed in Japan by architect Osamu Sato in the authentic rustic style, this teahouse looks simple but in fact is made of the finest-quality wood, paper, bamboo, and plaster, choices that reflect the preference of many Japanese for elegant simplicity. The components of the teahouse were precut by Nakamura Yoshiaki, a highly skilled carpenter in Japan, and they were assembled in the gallery.

The other half of this gallery is devoted to Japanese bamboo baskets. A gift of more than eight hundred superb baskets from the Cotsen Collection was recently added to the museum's collection. Thanks to the generosity of Mr. Lloyd Cotsen, both new viewers and the many who were captivated by the baskets in the 2000 exhibition Bamboo Masterworks: Japanese Baskets from the Lloyd Cotsen Collection *now have a chance to further explore this delightful large collection. The baskets are shown thirty to forty at a time, rotating in six-month intervals.*

Since the Japanese basket achieved its highest artistic level parallel to the development of the tea ceremony, an exhibit devoted to tea-related arts could contain no better combination of elements than those in this gallery. Moreover, the gallery presents an extraordinary potential for tea-related educational programs.

FRESH WATER JAR FOR THE TEA CEREMONY (*MIZUSASHI*), 1615–1700, *iga* ware (stoneware with ash glaze). Japan; Edo period (1615–1868). *Gift of the Asian Art Museum Foundation of San Francisco,* B68P4 (p. 213).

This water jar's irregular shape and uneven surface lend it an evocative natural form called *yaburebukuro* (literally, "torn bag"). The jar was wheel thrown then shaped by hand to make a heavy body with a tall, wide neck. The handles were added separately. The jar's green glaze was formed accidentally from kiln ash.

BAMBOO BASKETRY SCULPTURE ENTITLED *WAVE CREST,* approx. 1998, by Yako Hodo (born 1940). Japan; Tokyo. Bamboo. *The Lloyd Cotsen Japanese Bamboo Basket Collection,* F2002.40.30 (p. 214).

Yako Hodo's *Wave Crest* is an outstanding example of contemporary Japanese bamboo basketry sculpture, which has departed from traditionally functional objects and entered the realm of abstract sculpture. Using traditional square-mesh plating, Hodo has woven bamboo into wide and narrow ribbons, then rolled and entwined them into a dynamic spherical form. This open and animated construction has been achieved through the interplay of the artist's flawless technique with the rustic beauty of the material.

FRESH WATER JAR FOR THE TEA CEREMONY, 1615–1700. Japan.

BAMBOO BASKETRY SCULPTURE ENTITLED *WAVE CREST*, approx. 1998, by Yako Hodo. Japan.

Gallery 31
Betty Bogart Contemplative Alcove

Jack Bogart, Peter B. and Kirsten N. Bedford, and R. J. Bertero Family Fund, and in memory of Betty Bogart

From the twin bridges leading from the Grand Hall into the Japanese galleries the visitor encounters two striking contemporary works: to the right, a large work composed of six panels by Hiromichi Iwashita (born 1942); to the left, enclosed within a special space, a stone fountain by Masatoshi Izumi (born 1939). These objects were generously donated to the museum, the Izumi fountain by Mr. Johnson S. Bogart and the Iwashita work by Dr. and Mrs. David Buchanan.

For the panels, Iwashita laboriously chiseled a rhythmically flowing pattern in wood. A layer of paper was added, then coated with red gouache and finished with graphite pencil. This resulted in a softening of the surface and an unusual color effect: the gouache can be seen through the graphite, creating an appearance neither gray nor red but a complex charcoal color. Changes in lighting bring out different patterns in the chiseled surface. As with many Japanese works, the fine artisanship of these panels is veiled by their seeming rusticity.

The Japanese inclination toward the rustic also emerges in Izumi's fountain. Inspired by traditional Japanese stone basins placed near the entrances to teahouses, temples, and shrines, Izumi crafted this object from Japanese basalt, a dark,

hard stone that resembles marble. The exterior is a rugged, oxidized brown color; cross-sectioning reveals the dull gray of the basalt inside. Izumi ground and polished the surface of the cross-section by hand with a whetstone and water for many months, until the artist achieved a slightly concave surface with a mirror-like smoothness. A pump continuously recirculates a small amount of water to the basin. The slowly flowing water gives the fountain the illusion of stillness. A built-in bench by this fountain gives visitors the opportunity to pause and meditate.

BASIN, 2000, by Masatoshi Izumi. Japan.

Asian Ceramics: Trade and Exchange (loggia)

The Asian Art Museum's collection includes more than 3,500 ceramics from all over Asia. These range in date from 4500 BCE to the present, and in homeland from Turkey to Indonesia to Japan. In almost every gallery, ceramics take their place beside paintings, sculpture of bronze and stone, and artworks in a variety of other mediums.

The main galleries are generally divided by region or country, and by time period. To suggest how readily artistic ideas and techniques flowed around Asia, following the land and sea routes of travel and trade, beautiful ceramics from many countries will be displayed in thematic groupings in the 1917 building's historic second-floor loggia. Among these thematic groupings will be Chinese ceramics for Asian markets, Chinese and Japanese ceramics for European markets, Connections between China and West Asia in ceramics, and Ceramics from shipwrecks in the South China Sea.

BIRD-HEADED EWER, approx. 650–750. China; Henan province. Tang dynasty (618–906). Glazed earthenware. *The Avery Brundage Collection,* B60P214.

BIRD-HEADED EWER, approx. 1200. Iran. Glazed earthenware. *The Avery Brundage Collection,* B60P1997.

The idea of a ewer with a bird's head—usually that of a rooster—had ancient roots in Persia, where such vessels were produced in both metal and ceramic. Tang China, with its extensive trade with West Asia and its taste for things foreign, imitated and developed the shape. In Persia itself, bird-headed ewers, such as this turquoise-glazed one, continued to be made for many centuries.

Concretion of ceramics from the Hoi An shipwreck, approx. 1450–1525. Vietnam. Pottery and other materials embedded in hardened oceanic sediment. *Acquisition made possible by Betty and Bruce Alberts, Will and June Arney Roadman, Annie and Cameron Dorsey, Jean and Lindsay MacDermid, Rhoda Stuart Mesker, and Ann Witter,* 2000.31

In 1997–1999 a joint project by Vietnamese and foreign archeologists recovered more than 150,000 intact ceramic dishes and vessels from a shipwreck found off the Vietnamese coast near the city of Hoi An. This cargo, largely made up of high-quality Vietnamese blue-and-white ware, is only one of the most spectacular discovered in Asian waters in recent decades. These finds have transformed our understanding of Asia's ceramic industries and of the ship-born trade that spread their products far and wide.

This concretion from the Hoi An wreck contains a large number of blue-and-white jars and lidded containers. At one end is attached a carved stone object that appears to be a sort of stand, or perhaps an architectural component. Careful examination and preliminary x-ray analysis show that the concretion also contains a piece of deer antler and the handle and part of the blade of a short sword.

CONCRETION OF CERAMICS FROM THE HOI AN SHIPWRECK, approx. 1450–1525. Vietnam.

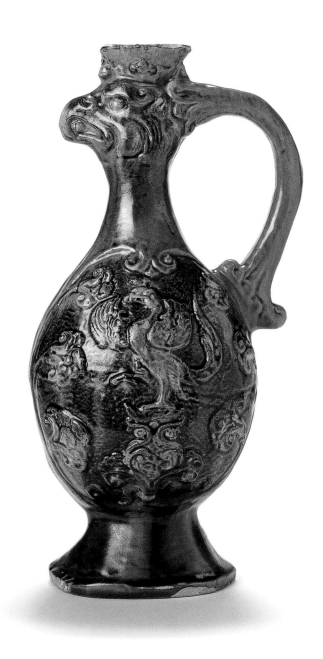

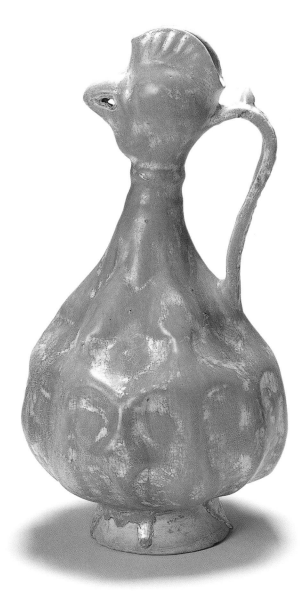

BIRD–HEADED EWER, approx. 650–750. China. **BIRD–HEADED EWER**, approx. 1200. Iran.

217

Into the Future

THE MUSEUM'S COLLECTION is the vital foundation on which all of its programs and activities are built. The preceding review can only hint at its riches. Even as the museum moves into its new home, the collection continues to grow. Recent acquisitions of Sikh art, Japanese bamboo baskets, and Indonesian rod puppets and other works from Southeast Asia have been described (p. 31). Now, as this book goes to press, the museum has announced its receipt of the important Yeh Family Collection of Chinese painting and calligraphy.

The donation consists of about a hundred uniquely significant works collected by several generations of the Yeh family. Perhaps established by Yeh Yanlan during the mid-nineteenth century, the collection was defined by Yeh Gongchuo (1881–1968). Yeh Gongchao (also known as George Yeh, 1904–1982) and his son, Max Yeh (b. 1937), a professor of comparative literature and author of fiction and nonfiction with an emphasis on history and art, continued the legacy. Both Yeh Gongchuo and Yeh Gongchao were active in public service, and the collection constitutes a rare documentation of the artistic concerns of the educated elite in China in recent centuries. It is particularly strong in calligraphy, with examples from as early as the seventh century and as late as the twentieth—the collection also includes a number of important paintings by leading artists of the early- and mid-twentieth century. In addition, it encompasses a range of objects from the studios of the educated elite, embracing such arts as seal carving and fan making. Together these works document the tastes and values of this group through the modern period and reflect the massive social and cultural changes from the end of dynastic China into the tumultuous twentieth century. Highlights of the collection will be shown at the museum in a special exhibit scheduled to open in November 2004.

Many Asian philosophers have taught that the universe is in a constant state of change. As it is for the museum's collection and programs, so it is for the building itself, and plans for additions are already under way. When the library building was constructed, the north wing, which was to house the stacks, was made shorter than the south wing, because the library collection had been destroyed in the great 1906 earthquake and space demands were modest (p. 48). Now, in a second phase of the museum conversion, the wing will be extended along McAllister Street to Hyde Street. This will virtually double the museum's special exhibition space, bringing it to a total of fifteen to sixteen thousand square feet and enabling the staging of larger and more varied special shows as a complement to the museum's permanent collection galleries. The second phase will also see the construction of a state-of-the-art auditorium at Hyde Street, which will allow the museum to bring more world-class performances to the public (see "Cultural Outreach," p. 23). The 16,000-square-foot auditorium will seat approximately 350 people.

Fundraising for the second construction phase has been given a jump start by a generous donation of $5 million from Senator Dianne Feinstein and Richard Blum. Since it was then-mayor Feinstein's 1988 Restoration Plan for Civic Center (p. 49) that launched the district's revitalization—including the move of the Asian Art Museum—it is fitting that this gift should help to propel the museum into the future. Thanks to this kind of determined community support, the Asian Art Museum will, in the century that lies ahead, continue to shine as a brilliant bridge to understanding for all to enjoy.

Exhibition Chronology

Exhibitions organized by or shown at the Asian Art Museum

1967

Fantastics and Eccentrics of Chinese Painting

Chinese Art from the Collection of H.M. King Gustaf VI Adolf of Sweden

1968

Chinese Treasures from the Avery Brundage Collection

Unknown India: Ritual Art in Tribe and Village (*organized by the Philadelphia Museum of Art*)

Selected Works of World Art: Avery Brundage Collection (*sent to the National Museum of Anthropology, Mexico City, for the 19th Olympiad*)

1969

Indian and Southeast Asian Stone Sculptures from the Avery Brundage Collection

1970

Animal Style Art from East and West

Chinese Treasures from the Avery Brundage Collection (*Osaka Exchange Exhibition*)

In Pursuit of Antiquity: The Earl Morse Collection of Chinese Ming and Qing Dynasty Paintings

Paintings from the Abe Collection and Other Masterpieces of Chinese Art (*Osaka Exchange Exhibition*)

1971

Chinese Gold, Silver and Porcelain: The Kempe Collection (*organized in Stockholm*)

1972

Ancient Indonesian Art of the Central and Eastern Javanese Periods (*organized by Asia House*)

Chang Dai-chien: A Retrospective Exhibition

Chinese Blue-and-White Porcelains from the Leventritt Collection

1973

A Flower from Every Meadow: Indian

Miniature Paintings (*organized by the Asia House Gallery, New York*)

Hans Popper Collection of Oriental Art

New Acquisitions from the Edward M. Nagel Collection

1974

Blue-and-White Ceramics from Various Countries

Japanese Netsuke from the Avery Brundage Collection

Visions of Tantric Buddhism

1975

The Exhibition of Archaeological Finds of the People's Republic of China

Four Centuries of Japanese Screens

Rarities of the MusÈe Guimet (*organized by the Asia House Gallery, New York*)

1976

A Decade of Collecting

Emaki and Other Handscrolls

Indian Drawings and Painted Sketches, 16th through 19th Centuries (*organized by the Asia House Gallery, New York, and the Fogg Art Museum, Harvard University*)

Selections from the Rudolph Schaeffer Collection of Oriental Art

1977

Chinese Ceramics from Japanese Collections (*organized by the Agency for Cultural Affairs of the Japanese Government and U.S. participating institutions*)

Chinese Folk Art: Objects from American Collections, 15th–20th Centuries

1978

I-Hsing Wares (*organized with the China Institute in America*)

Westerners in Japan: 1639–1880–(*organized by–the Kobe City Museum of Namban Art and the*

Meadow Brook Art Gallery of Oakland University, Michigan)

1979

5,000 Years of Korean Art (*organized with the National Museum of Korea*)

Chinese Porcelains Found at Drake's Bay

Folk Traditions in Japanese Art (*organized by the International Exhibition Foundation*)

Treasures of the Orient

1980

Chinese Calligraphy

Neolithic Painted Pottery from Northwestern China

Religious Art of Nepal

Song of the Brush: Japanese Paintings from the Sanso Collection (*organized by the Seattle Art Museum*)

Treasures from the Rietberg Museum (Zurich)

1981

Nagasaki and Yokohama Prints from the Richard Gump Collection

Netsuke: Myth and Nature in Miniature

Southeast Asian Sculptures: Buddhism and Hindu Themes and Styles

Treasures of the Orient II

1982

The Art of Tea in East Asia

Arts of the Ch'ing Court (1644–1912)

The Effie B. Allison Collection of Kosometsuke and Other Chinese Blue-and-White Porcelains

Gandharan Sculpture: An Alexandrian Heritage

K'ang-hsi Porcelains

1983

Bamboo Carving of China (*organized by the China Institute, New York*)

Gems of Chinese Art

Kakiemon Porcelain: A Colorful Tradition

(organized with the Mitsui Group of Companies, Japan)

Treasures from the Shanghai Museum: 6,000 Years of Chinese Art (organized with the San Francisco–Shanghai Sister City Program)

1984

Asian Masterpieces in Wood

Auspicious Spirits: Korean Folk Paintings and Related Objects (organized by the International Exhibition Foundation, Washington, D.C.)

Japanese Ceramics

Medieval Stone Sculpture from Eastern India

Selected Masterpieces of Near Eastern Art

1985

The Art of Wine in East Asia

Art with the Written Word from China and Japan

The Hundred Flowers: Botanical Motifs in

1986

Essence of Indian Art

Indian Sculpture from the Asian Art Museum

Ganesha: The Elephant-Headed God

Marvels of Medieval China: Those Lustrous Song and Yuan Lacquers

San Francisco Bay Area Collects Asian Art: The Museum's 20th Anniversary

Twentieth-Anniversary Exhibition: Highlights of Gifts to the Asian Art Museum

Stones of Eternity: Chinese Jades from the Asian Art Museum

1987

Ancestral Dwellings: Furnishing the Han Tomb

Later Japanese Lacquers

Paths to Enlightenment: Saints and Bodhisattvas

Shigeo Fukuda, From Japan: Venus Transmogrified

1988

Asian Embroideries

Extraordinary Persons: Japanese Art of the Premodern Era 1553–1853

Myths and Rebuses in Chinese Art

Suzuki Lacquers: Recent Works by Mutsumi and Misako Suzuki

Traditional Chinese Flower Arranging (with flower arrangers from the National History Museum, Taipei)

1989

Curators' Choice: Metalworks from Asia

Looking at Patronage: Recent Acquisitions of Asian Art

Views from Jade Terrace: Chinese Women

Artists, 1300–1912–(organized by the Indianapolis Museum of Art)

1990

Master of the Lotus Garden: The Life and Art of Bada Shanren (organized by Yale Univerity Art Gallery)

The Qing Master Potter

Women Auspicious and Divine: Images of Southeast Asia and India

Yani: The Brush of Innocence (organized by the Nelson-Atkins Museum of Art, Kansas City)

Yokohama: Prints from Nineteenth-Century Japan (organized by the Arthur M. Sackler Gallery, Washington, D.C.)

1991

Sculpture of Indonesia (organized by the National Gallery of Art, Washington, D.C.)

Wisdom and Compassion: The Sacred Art of Tibet (organized with Tibet House, New York)

1992

Beauty, Wealth and Power: Jewels & Ornaments of Asia

Brushstrokes: Styles and Techniques of Chinese Painting

1994

Latter Days of the Law: Images of Chinese Buddhism 850–1850

Tomb Treasures from China: The Buried Art of Ancient Xian

1995

The Black Ship Scrolls

A Chorus of Colors: Chinese Glass from Three American Collections

Mongolia: The Legacy of Chinggis Khan

Profusion of Color: Korean Costumes & Wrapping Cloths of the Choson Dynasty

Vessels of a Culture: Korean Ceramics

1996

Living Masters: Recent Paintings by C.C. Wang

Mingei: Two Centuries of Japanese Folk Art

Splendors of Imperial China: Treasures from the National Palace Museum, Taipei

Yoong Bae: Late Works

1997

The Art of Chao Shao-an

Four Centuries of Fashion: Classical Kimono from the Kyoto National Museum

India: A Celebration

Joy Under the Blossoms: Lacquered Picnic Sets from the Osaka Municipal Government

Paintings by Masami Teraoka

1998

At Home & Abroad: 20 Contemporary Filipino Artists

Essence of Style: Chinese Furniture

Hokusai & Hiroshige: Great Japanese Prints from the James A. Michener Collection, Honolulu Academy of Arts

Hopes & Aspirations: Decorative Painting of Korea

1999

The Arts of the Sikh Kingdoms (organized by the Victoria and Albert Museum, London)

From the Rainbow's Varied Hue: Textiles of the Southern Philippines (organized by the UCLA Fowler Museum of Cultural History)

Inside/Out: New Chinese Art (organized by the Asia Society, New York, and the San Francisco Museum of Modern Art)

2000

Alienation and Assimilation: Contemporary Images and Installations from the Republic of Korea

(organized by the Museum of Contemporary Photography of Columbia College, Chicago)

Bamboo Masterworks: Japanese Baskets from the Lloyd Cotsen Collection (organized by the Asia Society, New York)

Between the Thunder and the Rain: Chinese Painting from the Opium War through the Cultural Revolution, 1840–1979

The Golden Age of Chinese Archaeology: Celebrated Discoveries from the People's Republic of China '(organized by the National Gallery of Art, Washington, D.C.; and the Nelson-Atkins Museum of Art, Kansas City; in cooperation with the State Administration of Cultural Heritage and Art Exhibitions China, The People's Republic of China)

New Millennium Painting and Calligraphy by Madame Chiang Kai-shek and the Master of Chinese Painting and Calligraphy

2001

Carpets from China

Empire of the Sultans: Ottoman Art from the Khalili Collection (organized by Art Services International)

Taoism and the Arts of China

(organized by the Art Institute of Chicago)

Zen: Painting & Calligraphy, 17th–20th Centuries

Donors to the new Asian Art Museum

(Listing as of October 31, 2002)

The Asian Art Museum gratefully acknowledges the
generous support of the following donors who have
helped create the new museum in Civic Center

Founders
Reiko and Chong-Moon Lee

Richard C. Blum and Senator Dianne Feinstein
Samsung Electronics Co., Ltd.
The Starr Foundation
State of California
The County and City of San Francisco and the Voters

Benefactors
Jack and Jane Bogart
The William K. Bowes, Jr. Foundation
California Arts Council
Estate of C. Laan Chun
Henry Cornell
Tully and Elise Friedman
Richard N. Goldman
Sarah and William Hambrecht
Nancy B. Hamon
The Edward E. Hills Fund
The William G. Irwin Foundation
Maryellie and Rupert H. Johnson, Jr.
Koret Foundation
Doris Shoong and Theodore Bo Lee
The Henry Luce Foundation
Connie and Bob Lurie
Estate of Joan Diehl McCauley
Maura and Robert Morey
The Bernard Osher Foundation
The David and Lucile Packard Foundation
Marianne and Richard H. Peterson
Ji Ing, Ronald and Leo Soong in memory of T.A. Soong
Henri and Tomoye Takahashi
Tang Family in honor of P.Y. and Kin May Tang
Atsuhiko Tateuchi and Ina Tateuchi Foundation
Phyllis C. Wattis
Judy and Brayton Wilbur
Akiko Yamazaki and Jerry Yang
Geoff and Amy Yang and Family in memory of
 Raymond Y.L. Yang

Guarantors
Isha and Asim Abdullah
Bank of America Foundation
Marjorie Walter Bissinger
Madeleine H. Russell Fund of the Columbia
 Foundation
Joan L. Danforth
Helen and Raj Desai in honor of the Crane Family and
 Desai Family
In honor of Kyoko Masuyama Daniel by Sam,
 Remy and Rose
The Herbst Foundation, Inc.
Dr. Narinder S. Kapany in honor of Satinder Kaur
 Kapany

Korea Foundation
Constance and J. Sanford Miller
Hamid and Tina Moghadam
National Endowment for the Humanities
Janet and Clint Reilly
Rosina and Anthony Sun
Masako Martha Suzuki
Wells Fargo Foundation

Investors
John and Barbara Mathews Brooks
Mr. and Mrs. John M. Bryan
S. H. Cowell Foundation
Fisher Family
The R. Gwin Follis Foundation
Ann and Gordon Getty Foundation
Walter and Elise Haas Fund
Mimi and Peter Haas
The William and Flora Hewlett Foundation
Cordell and Susan Hull
Lucy and Fritz Jewett
Estate of Mildred Johnson
Fred M. and Nancy Livingston Levin, the Shenson
 Foundation, in memory of Drs. Benand A. Jess
 Shensons
Louis R. Lurie Foundation
McBean Family Foundation
Mary and Paul Slawson
Suno Kay Osterweis and John S. Osterweis
 in honor of In Ju and Chung Hyang Kay
Union Bank of California
Joan and M. Glenn Vinson, Jr.
Daniel G. Volkmann, Jr.
Susan and Ian Wilson

Sponsors
Mr. and Mrs. Robert R. Ackerman, Jr.
Cynthia and Dan Banks
Peter B. and Kirsten N. Bedford in memory of
 Betty Bogart
Patricia and Edwin L. Berkowitz
R.J. Bertero Family Fund in memory of Betty Bogart
Kathy and Paul Bissinger
California Bank & Trust
Frank A. Campini Foundation
Estate of Lenette S. Caro
Harold K.L. Castle Foundation
Selina and Johnson Cha and C. M. Capital Foundation
ChevronTexaco Corporation
Cooper, White and Cooper
Mr. Alden W. Clausen
Timothy Dattels and Kristine Johnson
Mr. and Mrs. Reid W. Dennis
Mr. Ernest L. Go, Bank of the Orient

Martha Sam Hertelendy and Paul Hertelendy
 and Family
Hellmuth, Obata + Kassabaum, Inc.; LDA Architects,
 Inc.; and Robert B. Wong, Architects/Planners
J.P. Morgan Chase Foundation
James C. Hormel and Timothy C. Wu
Dorothy and Bradford Jeffries
NEC Electronics Inc.
Pacific Gas and Electric Company
Leanne and George Roberts
Louise and Claude Rosenberg
Richard F. Shelton in memory of
 Sydney Walton Shelton
Dr. Stephen A. Sherwin and Merrill Randol Sherwin
Lucretia and John Sias
Society for Asian Art
Drs. Jane and Sanford Tom
Toyota Motor Corporation
Wayne and Gladys Valley Foundation
Anonymous (2)

Patrons
Bauch Family and Burstein Family in memory of
 Robert H. Burstein
Betty and Bruce Alberts
Cynthia S. and Gary F. Bengier
The Bothin Foundation
Joyce H. Clark
Mr. and Mrs. Willard G. Clark
Louise M. Davies Foundation
Jo Anne and Jesse D. Erickson
Fleishhacker Foundation
Carlo S. and Dianne A. Fowler
Fujitsu America, Inc.
Evelyn and Walter Haas, Jr. Fund
Margaret and George Haldeman
Institute of Museum and Library Services
Mr. and Mrs. Peter M. Joost
Mr. and Mrs. William E. Larkin
May Lau in memory of Daniel Wu
Naja Pham Lockwood and David Lockwood
Consuelo and Robert McHugh
Russell R. Miller
Mr. and Mrs. John H. Robinson
Sony Corporation
Genevieve and Hart Spiegel

Donors
Amey and Hatsuro Aizawa
Kim Lam Beleson and Richard Beleson
Mr. and Mrs. John A. Berg
Jeffrey, Brenda, Brittany and Ian Bohn
Mary and David Bromwell
Shawn and Brook Byers

Cornelia and Alexander Calhoun Family
Barbara and John Callander
Mrs. Jesse Lawrence Carr
Daniel Carroll and Stasia Obremskey
Diana Chace
Amie Chang
Cynthia Chen and Adrian Chen
Julia K. and Leo Cheng
Drs. Stephen R. and Doris Sze Chun
Mr. and Mrs. Robert Dagley
Willis and Olive Rose Deming
Terri Dial and Brian Burry
Mr. and Mrs. Dixon R. Doll
Judith and Robert L. Duffy
Jared Ede
Edward Joseph Daly Foundation
Donald and Janice Elliott
Laura J. Enos in memory of Phyllis Shorenstein
Mr. and Mrs. Joseph M. Fee, Jr.
Charles R. Feldstein and Company, Inc.
Helga and Phillip Fleishman, Imari Gallery
Lilly Ong Hing Fong and Wing G. Fong
Drs. Thomas Ying Kit and Stephanie M. Lee Fung
 in memory of Mr. and Mrs. Kui Chee Lee and
 Wai Yan Ko Lee
William G. Gilmore Foundation
Yuen and Sandra Gin
Dr. and Mrs. Marvin L. Gordon
Gruber Family Foundation
Elizabeth Hambrecht and Robert Eu
Hanson Bridgett Marcus Vlahos and Rudy LLC
Hitachi America, Ltd.
Hitachi Data Systems Corporation
In Memory of Helen Soo Hoo and Ong Chun Hing
Mamoru and Yasuko Inouye
Michael R. Jacobson and Trine Sorensen
The JEC Foundation
Charles and Ann Johnson Foundation
Vickie and Bill Johnston
Choongja and Stephen Kahng
Mary and Bill S. Kim
The Michael K. Kim Foundation
Robert and Dorothy Kissick
Marian S. Kobayashi
Ellen and Charles LaFollette
Jeanne and Bill Landreth
Ambassador Bill and Jean Lane
Holden Lee in honor of Harry and Sophie Lee
Linda and David Lei
Alexandra and Dennis Lenehan
Teresa H. Lim and Family
In memory of Dunya Chernenko and C. Maya Lit
In memory of Chong and Gee Chung Jang Lowe
Lawrence and Gorretti Lui
Robert F. Kuhling, Jr. and Michelle Wilcox
Mr. and Mrs. Shailesh J. Mehta
Rhoda and Richard Mesker
Adrienne and Bruce T. Mitchell

Harold and Gertrud Parker
Providian Financial Corporation
Pamela and Richard Zell Rigg
Wilfred and June Arney Roadman
Sally and Toby Rosenblatt
Charles and Helen Schwab Family Fund
Frits and June Seegers
Dr. and Mrs. David Tai-Man Shen
Susan and Jitu Somaya
Sony Corporation of America
Robert L. Speer, John Wong and Ming C. Gee
Kay and Jackson Tai
Estate of Mary M. Tanenbaum
Pat Tseng
VISA U.S.A. Inc.
Eleanor and Ira G. Wong, M.D. Foundation
Timothy and Vanessa Wong

Contributors

J. Dennis Bonney
Mr. and Mrs. Edward Bransten
Ed and Jan Brown
James and Elaine Connell
Alice M. Corning
Carol G. Costigan in memory of Richard F. Shelton
Anne C. Diller
Ebara America Corporation
The Eldorado Foundation
Robert A. Ellis and Jane Bernstein
Florence Fang
Fuji Xerox Group
Mr. and Mrs. Andrew J. Goodman
Mary G. Harrison
Hitachi Semiconductor (America), Inc.
CJ and Brad Inman
ITOCHU International, Inc.
Mr. and Mrs. C. Nicholas Keating, Jr.
Kikkoman International, Inc.
Kinokuniya Bookstores of America
Mr. and Mrs. Robert C. Kirkwood
Ming Lee
Alice and Lewis Lowe
Matson Navigation Company
The Honorable Donald R. Meyer and
 Virginia L. Meyer
Forrest Mortimer and Stuart Harvey
Claudette M. and John F. Nicolai
Nora Norden
Ellen Oh in honor of Han Soo and Joann Oh
Ms. Marnay O'Neal
Charles H. Page
Jean and Jim Palmer
Mr. and Mrs. Magan C. Patel
Sally and Toby Rosenblatt
Ikuko Satoda in memory of Shinji and Yayoko Satoda
Mr. and Mrs. Max A. Schardt
Mr. and Mrs. Ellis M. Stephens
Mr. and Mrs. Charles M. Stockholm

Mr. and Mrs. James N. Sullivan
Sumitomo Corporation of America
United California Bank
Warren C. Wachs
William E. Weiss Foundation, Inc.
The Woodward Family Foundation Endowment Fund
 of the Marin Community Foundation
Wen-hsin Yeh and James C. Sha
Anonymous

Supporters

Mary Ann and Sam Aronson
Mr. and Mrs. Richard M. Barancik
Mr. and Mrs. Eugene A. Brodsky
Noel Callaghan
Dinny Winsor Chase
Mr. and Mrs. Douglas A. Christenson
Mr. and Mrs. Ransom S. Cook
Linda S. Dickason
Sally S. Dommerich
Mr. and Mrs. Cameron Dorsey
Mr. and Mrs. Kamal Duggirala
Mr. and Mrs. Christian P. Erdman
Joel E. Ferris Foundation
Mrs. William O. Glatz
Dr. and Mrs. Jun Hatoyama
Mr. and Mrs. Richard G. Heggie
George Hellyer
Louise and Donald Heyneman
Hitachi Computer Products (America), Inc.
The Hitachi Foundation
Hitachi High Technologies America
George and Beverly James
Frances Gay Joyce
Yoshiko Kakudo in memory of Glenn Glasow
Kurt Leswing and Elsa Leung Leswing
Marubeni America Corporation
Mr. and Mrs. Fillmore C. Marks
Isao Matsuura
Forrest McGill
Mary A. Mettler
Jan C. Michaels
Mitsubishi International Corporation
Mitsui & Co. (USA), Inc.
The Morton Foundation
J Mullineauxs
Nissho-Iwai American Corporation
Anders and Fumiko Noyes
Valerie and Mark Pechenik
Dan and Paula Rampe
Mr. and Mrs. Peter N. Rosenthal
Mr. and Mrs. Paul Sack
Jon and Nora Lee Sedmak
Mr. and Mrs. David K. Tu
Mr. and Mrs. Herbert B. Tully
Mr. and Mrs. John S. Wadsworth, Jr.
Eric Wesenberg
Mr. and Mrs. Art T. Wong

Acknowledgments

This book builds on the work of many colleagues and predecessors at the Asian Art Museum. Emily Sano offered helpful corrections and suggestions. Tim Hallman and Michele Dilworth provided materials on a range of subjects. Robin Jacobson strengthened the editorial content, and Jason Jose provided graphics support.

The gallery highlights sections were written by the museum's curatorial staff: Terese Tse Bartholomew (Himalayas, China), Tushara Bindu Gude (South Asia, West Asia), He Li (China), Kumja Paik Kim (Korea), Michael Knight (China), Forrest McGill (Southeast Asia, South Asia, West Asia, Loggia), Yoko Woodson (Japan), and Pauline Yao (China). Debra Baida, Hanni Forester, Elisa Kamimoto, Cathy Mano, Heather Polubinski, and Sharon Steckline provided assistance. Grateful acknowledgment is made to the magazine *Arts of Asia,* where previous versions of these texts appeared. The education section is condensed from an article by Deborah Clearwaters, Alina Collier, Brian Hogarth, and Stephanie Kao, with additional research and writing by Aubrey Wallace, especially on cultural outreach. The section on contemporary art is condensed from an article by Emily Sano. The original articles appeared in *Treasures,* the museum's members' magazine.

A few sources merit special mention. A twenty-fifth anniversary publication coordinated by Clarence Shangraw with contributions from Barbara Traisman and Elizabeth Ingalls contains useful information on the museum's history. *The Four Dimensions of Avery Brundage* by Heinz Schöbel (Edition Leipzig, 1968) is a standard starting place for information about the museum's founding donor. *One Hundred Years in Golden Gate Park: A Pictorial History of the M.H. de Young Memorial Museum* (Pamela Forbes, ed.; Fine Arts Museums of San Francisco, 1995) is a good resource on that museum. Articles by De Tran (*San Jose Mercury News*) and Vince Stehle (*Chronicle of Philanthropy*) were helpful on Chong-Moon Lee. The history of the library draws on *A Free Library in This City: The Illustrated History of the San Francisco Public Library* (San Francisco: Weldon Owen, 1996) by Peter Booth Wiley, who kindly reviewed that section in a manuscript version. The sections on historical features of the museum rely on a *Historic Structure Report* prepared by Frederic Knapp in 1998 for the Landmarks Board; Emily Sano contributed substantially to the section on the Piazzoni murals. The study referred to in the section "Varieties of Museum Experience" is "Exploring Satisfying Experiences in Museums" by Andrew J. Pekarik, Zahava, D. Doering, and David A. Karns (*Curator,* April 1999).

Lucy Loradich, J Mullineaux, Ellen Oh, Valerie Pechenik, John Stucky, and Cheri Woodward were among many others who were helpful. Dana Levy of Perpetua Press worked miracles with an impossible production schedule.

Illustration Credits

Like other Asian Art Museum publications, this book features the photography of Kaz Tsuruta. In addition to the object photographs in the gallery section (pp. 87–217, except 160), his photographs include: 2, 3, 10–11, 18, 21 left, 21 right, 22 left, 22 right, 23 bottom, 27 right, 28 bottom, 29 right, 30 top, 30 bottom, 32, 33 right, 34, 35 left, 35 right, 35 middle, 35 bottom, 36 left, 36 middle, 55, 57, 62 left, 62 right, 68 bottom left and right; 64, 65, 68 bottom left, 68 bottom right, 69, 70, 71, 72, 73, 74, 75, 77, 78, 80, 81 left, 81 right, 84 left, 84 top right, 84 bottom right, 85.

Additional sources include the Architectural Drawings Collection, Architecture and Planning Library, General Libraries, University of Texas at Austin: 46 left; the Avery Brundage archives: 16, 23 right; Arnaldo Burgos: 26; Thomas Christensen: 1, 15 right, 33 left, 36 right, 36 bottom, 40, 42, 43, 51 right, 76; G.H. Freyermuth: 12; Brian Hogarth: 23 right; Jason Jose: 56; Perretti and Park: 59 left, 59 right, 60 left, 60 right, 67 left, 67 right; Aislinn Scofield: 24 top, 25 left, 27 left; San Francisco Convention and Tourist Bureau: 45 top; San Francisco History Center, San Francisco Public Library: 14 left, 14 right, 15 left, 38 left, 38 right, 39, 44 left, 44 right, 45 middle, 45 bottom, 48 left, 48 right, 50 right, 51 left, 52 left, 52 right, 53 top left, 53 top right, 53 bottom right, 53 bottom left; and Eleanor Weinel: 46 right.

Produced in commemoration of the opening of the new
Asian Art Museum in Civic Center, San Francisco, spring 2003.

Text and editing by Thomas Christensen, with object commentaries by Terese
Bartholomew, Tushara Bindu Gude, He Li, Kumja Paik Kim, Michael Knight,
Forrest McGill, Yoko Woodson, and Pauline Yao. Copy editing by Robin Jacobson.

Featured photography by Asian Art Museum photographer Kaz Tsuruta.

Designed and typeset in Skia, Gill Sans, and Perpetua
by Dana Levy/Perpetua Press, Santa Barbara.

Printed on 128 gsm Raicho Matte Coated paper and bound by
Toppan Printing Company, Japan.